IMAGES
of America

STANLY COUNTY

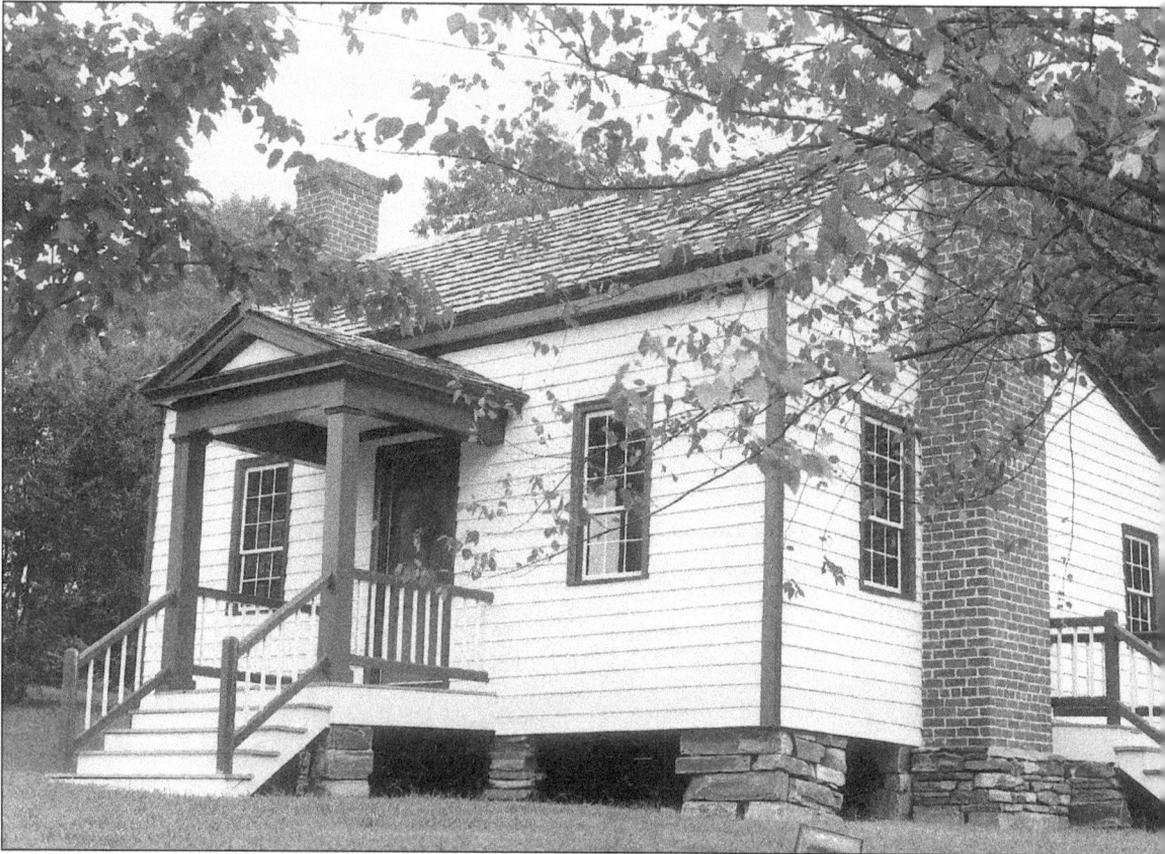

Legacy of a vanished North Carolina, the 1847 Marks House links modern-day Stanly County to its antebellum past. Today the restored home is a prized artifact of the Stanly County Museum in Albemarle. (Stanly County Museum.)

IMAGES
of America

STANLY
COUNTY

D. Douglas Buchanan
Stanly County Museum

ARCADIA
PUBLISHING

Copyright © 2000 by The Stanly County Historic Preservation Commission
ISBN 9781531601805

Published by Arcadia Publishing
Charleston, South Carolina

Library of Congress Catalog Card Number: Applied for.

For all general information contact Arcadia Publishing at:
Telephone 843-853-2070
Fax 843-853-0044
E-Mail sales@arcadiapublishing.com
For customer service and orders:
Toll-Free 1-888-313-2665

Visit us on the Internet at www.arcadiapublishing.com

Special thanks to all those who contributed to the publication of this book,
including Lessie Huneycutt, Geraldine Bolton, Dotty Plyler, Ellen Miller,
Vicki Coggins, the Weekly Post, the Oakboro Regional Museum of History,
Mr. James Kendall, and Mosaic Images.

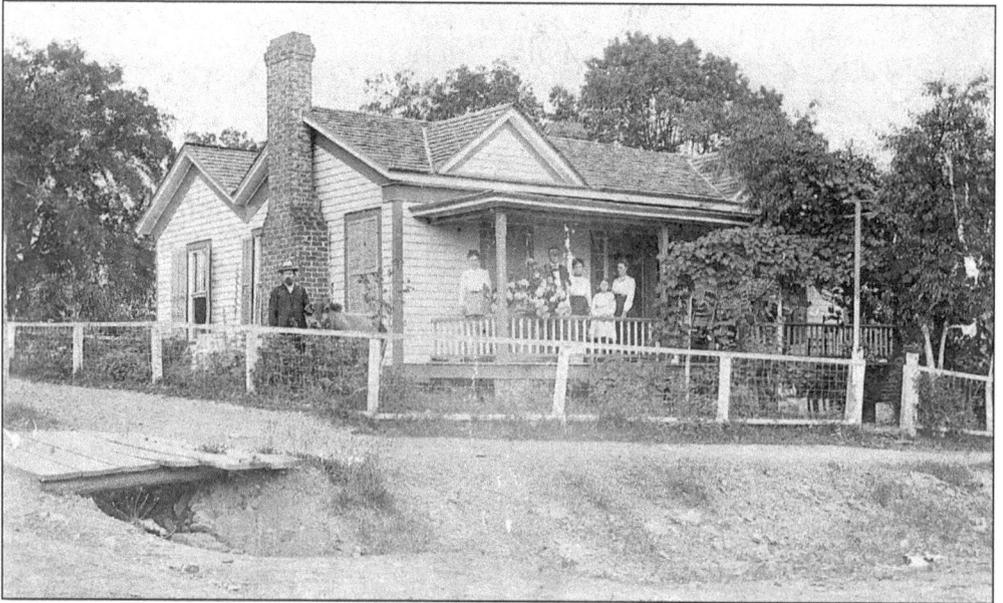

While members of his family pose together on the porch of their Albemarle home, patriarch Noah Pennington (in hat) elects to stand with the family cow. (Stanly County Museum.)

CONTENTS

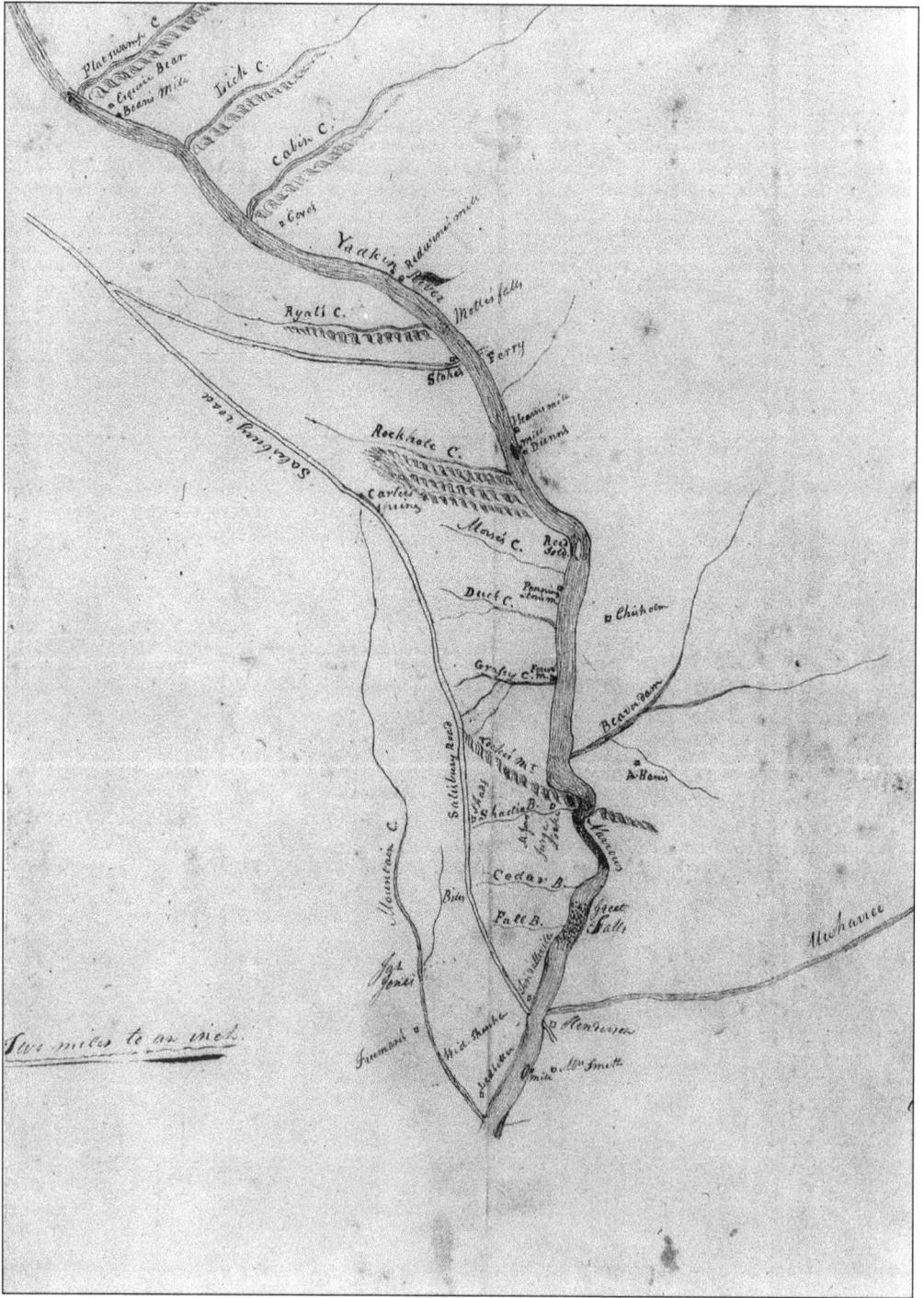

Spindly creeks flow into the Yadkin-Pee Dee River along present-day Stanly County's eastern edge in this undated map. The Salisbury Road, seen here running diagonally, made the future Stanly County an important colonial transportation corridor, linking the North Carolina Piedmont to Georgetown and other important South Carolina ports. (Stanly County Museum.)

INTRODUCTION

For generations, many of the following images sat forgotten in shoeboxes and crumbling photograph albums. Some, no doubt, spent decades in Stanly County attics—roasting in the summertime, freezing in winter. Despite such extremes, most remain amazingly well preserved; some are as sharp and clear as they were a century ago. Regardless of condition, the images reprinted here provide the people of Stanly County with a window to their common past. Hopefully, many will spark long discussions between older and younger generations. Others may rekindle forgotten memories of people and places long gone. Each image is a silent testament to the profound impact of photography on our society's collective memory of the past.

The survival of the photographs featured in this book has been far from accidental. With but five exceptions, all are from the collection of the Stanly County Historic Preservation Commission, a public agency of the government of Stanly County. Since the commission's humble origins in 1973, its staff and volunteers have worked to ensure the Stanly County story is preserved and passed on to future generations. From Native American arrowheads to a stately nineteenth-century cottage, the commission's museum of county history in Albemarle has slowly accumulated artifacts large and small, famous and obscure.

Perhaps no other artifacts in the Stanly County Museum are as valued as its historic photographs. Some of the images selected for this work are considered local classics, printed from time to time in county books and newspapers. Others are published here for the first time, and may themselves become future favorites. To thumb through the glossy images in this book, however, is a very different experience than handling the frail originals themselves. Many are true antiques, yellowed and musty as they emerge from the museum's fireproof cabinets. For the production of this book, more than 1,500 images were considered, though space constraints limited the publication of fewer than 200. Museum staff carefully packed, sealed, and shipped the winners to South Carolina for publication—farther from home than most had probably ever been.

Any work of history is at best only a fragmentary glimpse of the past. This is especially true of a pictorial history. There are, of course, no photographs of prehistoric Native Americans who knew Stanly County by another, now forgotten, name for thousands of years. Long before Columbus arrived by accident in the Caribbean, Native American cultures flourished in North Carolina's rich Pee Dee River valley; religious temples, thriving villages, and cultivated fields dotted the prehistoric Piedmont. This ancient civilization quickly ebbed, however, with the arrival of new peoples from across the Atlantic. By the mid-eighteenth century, Europeans and Africans in south-central North Carolina were hard at work laying the foundation for modern Stanly County.

Over the decades, the now-familiar shape of North Carolina solidified as political boundaries were laid, disputed, and re-laid. Bladen, Anson, and Montgomery Counties each in turn claimed the land that became Stanly County in 1841. By 1860, with its county seat of Albemarle recently incorporated, the county boasted 7,801 residents, nearly all of whom were farmers. Though hardly a plantation culture, slavery took root in Stanly County much as it had in other parts of the state; in the year of the election of Abraham Lincoln, more than 15 percent of the county's residents lived in bondage as slaves. With the defeat of the Confederacy came a form of quasi-freedom for African Americans in Stanly County—a liberty from bondage, but not from poverty or discrimination.

Nearly all benefited though from the county's most explosive era of growth, an industrial revolution precipitated by the construction of the Yadkin Railroad in 1891. In that last decade of the nineteenth century, the county seat grew by tenfold. Rural crossroads became boomtowns as new railroads crisscrossed the county in 1911 and again in 1913. On the heels of the railroads came textile mills, hydroelectric dams, an aluminum plant, cotton gins, banks, and hotels. Yet the county's rural beauty and small-town ways stubbornly persisted. As recently as 1940, nearly nine in ten county residents lived in rural hamlets or on farms, much as their grandparents had. Families stayed put, and change generally came at a pace well suited to country life. Agriculture remained, as it always had, the mainstay of the county's economy.

Now well into the electronic age, today's Stanly County farmer fears the encroachment of suburban sprawl from neighboring counties. As growth pressures squeeze available land resources, Stanly County will find its agricultural heritage in increasing jeopardy. Saving a farmer's field from development may become as important a victory for county preservationists as rescuing an antique mill from a wrecker's ball.

Accelerating growth in the North Carolina Piedmont will make institutions like the Stanly County Historic Preservation Commission and its museum increasingly valuable to the people of Stanly County. The grassroots appeal of its simple mission is also spreading. New museums in the communities of Oakboro, Badin, and Norwood are now in the works, the creations of citizens energized by a passion for their heritage. The result will be a countywide network of individuals working together to preserve the richness of a common past.

This book then, represents only the tip of a very large iceberg: a sampling from one collection of many housed in a single museum—which itself belongs to a growing community of similar institutions. Nevertheless, for those ready to explore their Stanly County roots, this collection may provide an enjoyable introduction. Given the current direction of historic preservation in Stanly County, there will be no shortage of such works—or of interested readers—in the years to come.

Doug Buchanan
Albemarle, North Carolina
August 1999

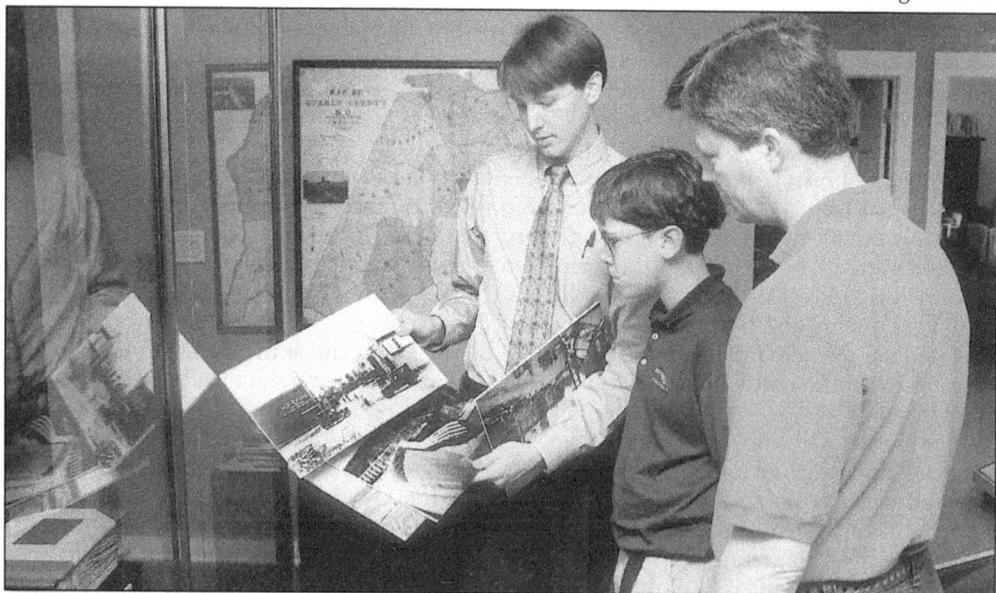

Staff and visitors examine historic photographs at the Stanly County Museum in Albemarle. From left to right, museum director Doug Buchanan stands with visitors Eric Rhodes and Andrew Napier. (The *Weekly Post*.)

One

THE COUNTY SEAT
ALBEMARLE, NORTH CAROLINA

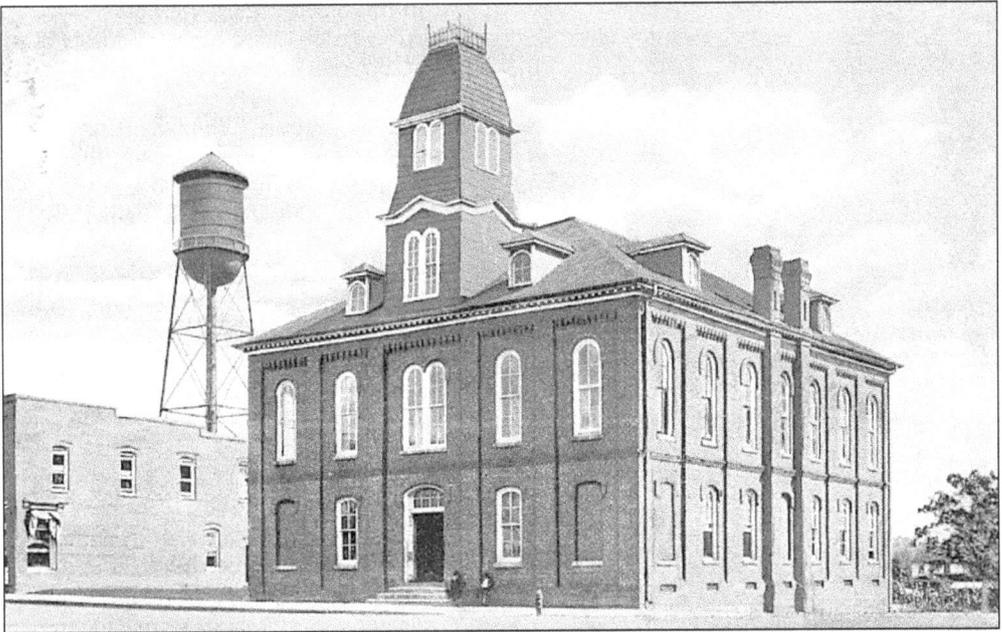

A solid presence at the corner of Main and Second in Albemarle for generations, the second of Stanly County's three courthouses was built in 1893. The county took its name from John Stanly, a popular legislator in early North Carolina. Albemarle, named for the British Duke of Albemarle, became the county seat in 1841 and was incorporated in 1857. (Stanly County Museum.)

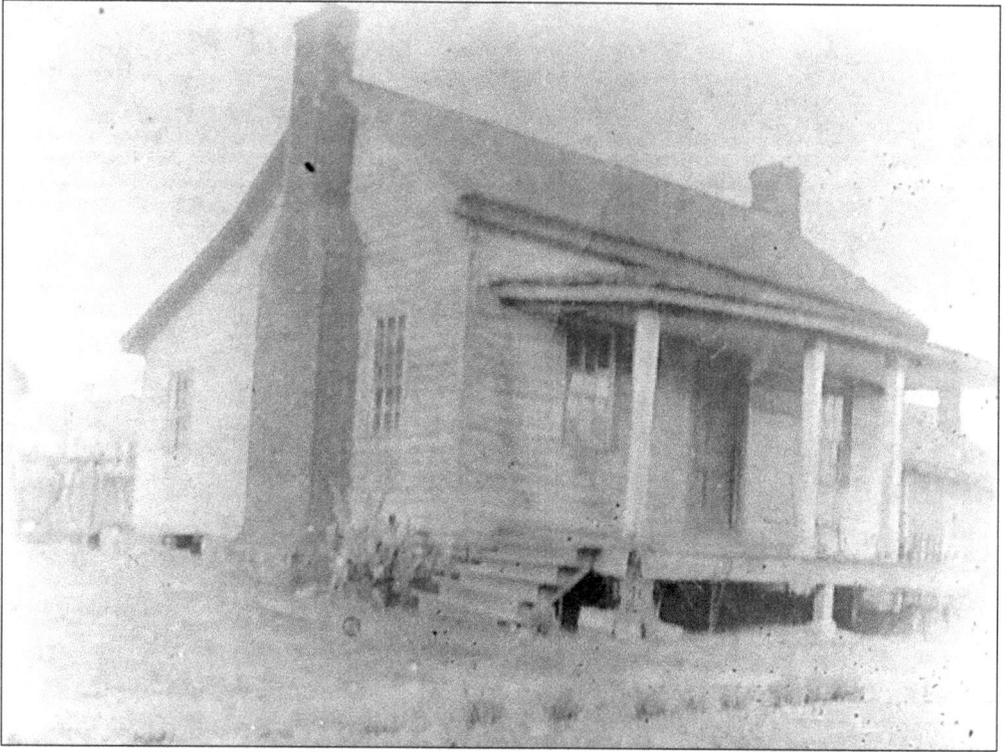

In this oldest known view of Albemarle's oldest home, the 1847 Marks House presents an unassuming facade in this early-twentieth-century portrait. Originally built by merchant Daniel Freeman, the home derives its present-day name from the Marks family, its owners from 1884 to 1975. Compare this view with that opposite the title page. (Stanly County Museum.)

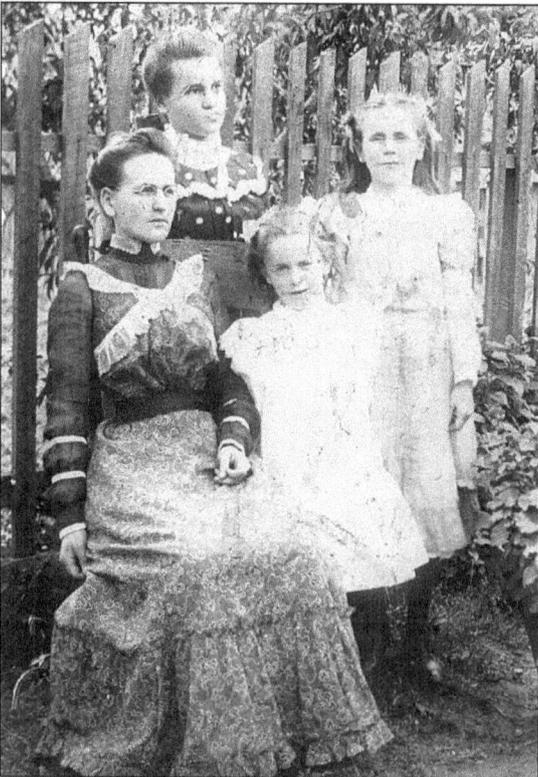

Members of the Marks family gathered for this portrait about 1900. From left to right are Mrs. Whitson Marks, her daughter Patty Marks, granddaughter Jo Dunn, and daughter Sally Marks. Future educators Patty and Sally Marks were both born in the Albemarle home that today bears their family's name. (Stanly County Museum.)

Patriarch Isaiah W. "Buck" Snuggs casts a serious gaze in this 1885 portrait of Stanly County's ninth sheriff and his family. As a Confederate soldier, Snuggs lost a leg at Spotsylvania Courthouse—his famed replacement is visible here. From left to right are son Henry; Isaiah; daughters Bertie and Mary; his wife, Ellen; and son Ed. (Stanly County Museum.)

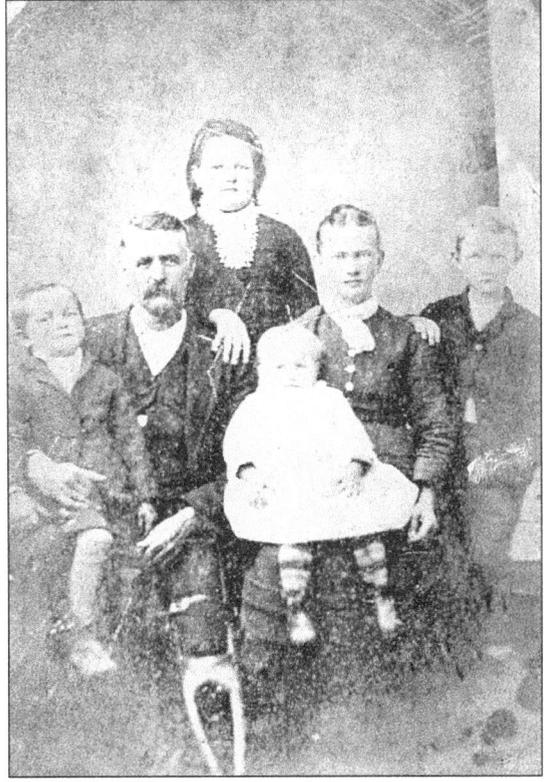

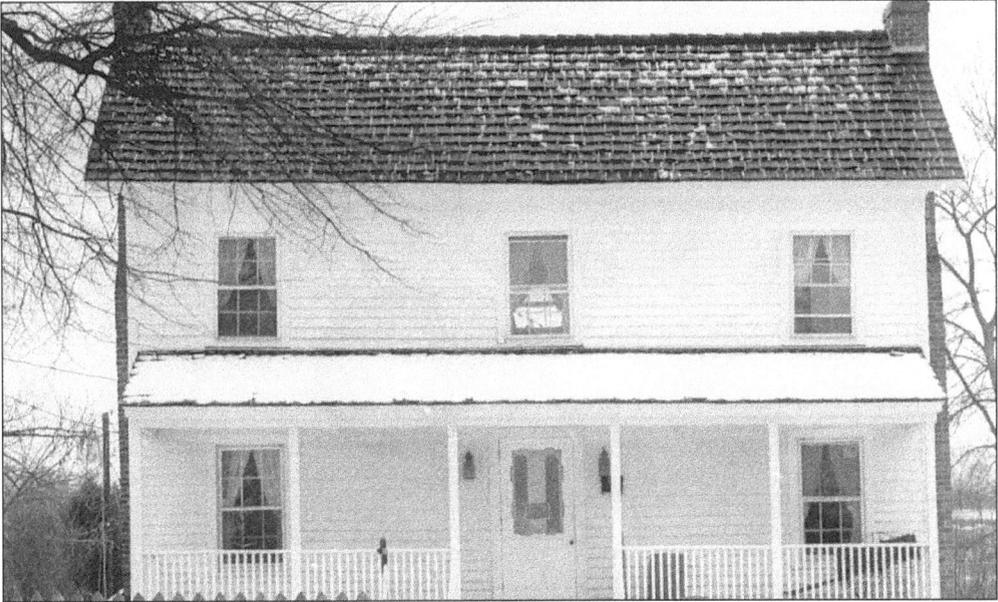

A blanket of snow covers the restored Snuggs homestead in this image from the 1980s. Originally built as a single-story log cabin in the early 1850s, the house was greatly enlarged in 1873. Though no Snuggs lived in the home after 1910, it stayed in family hands until its purchase in the 1970s by the Stanly County Historic Preservation Commission. Today the house is part of the Stanly County Museum. (Stanly County Museum.)

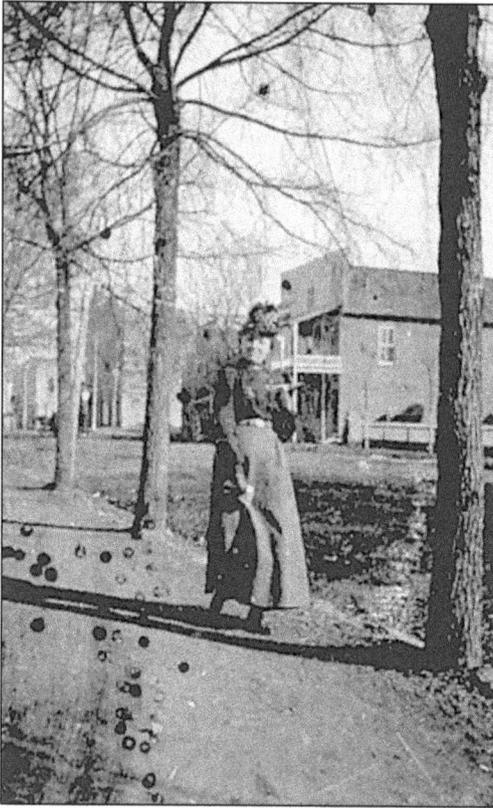

Clad in Victorian finery, Nora Spinks strolls down Albemarle's Second Street about 1900. Behind her on the left, the newly-opened Central Hotel signals Albemarle's rising status as a destination for visiting businessmen and merchants. (Stanly County Museum.)

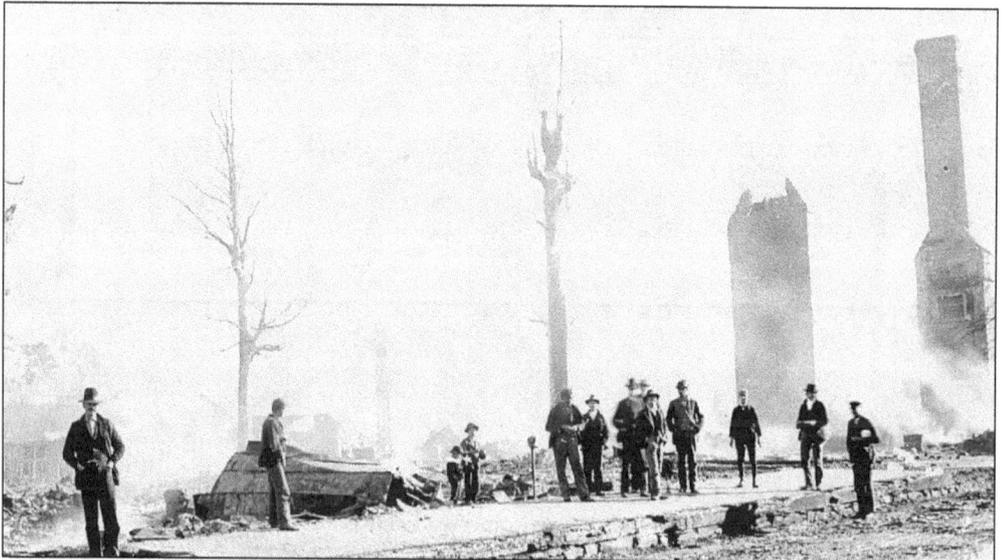

The charred remains of the Marshall Hotel on Second Street smolder following Albemarle's "Great Fire of 1899." First spotted in a block of wooden stores, the blaze engulfed the town's post office, a grocery store, and a boutique before being extinguished. (Stanly County Museum.)

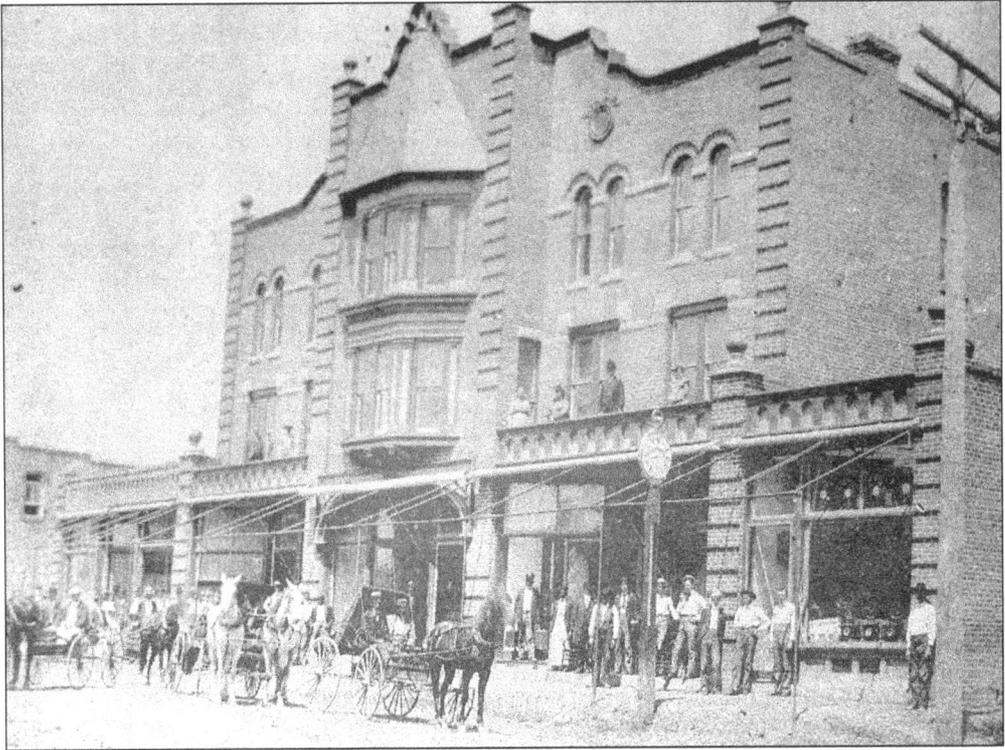

A string of horse-drawn carriages pauses before the Central Hotel. Built on Second Street at the turn of the last century, the building was razed in 1969 to make way for the county's present courthouse. (Stanly County Museum.)

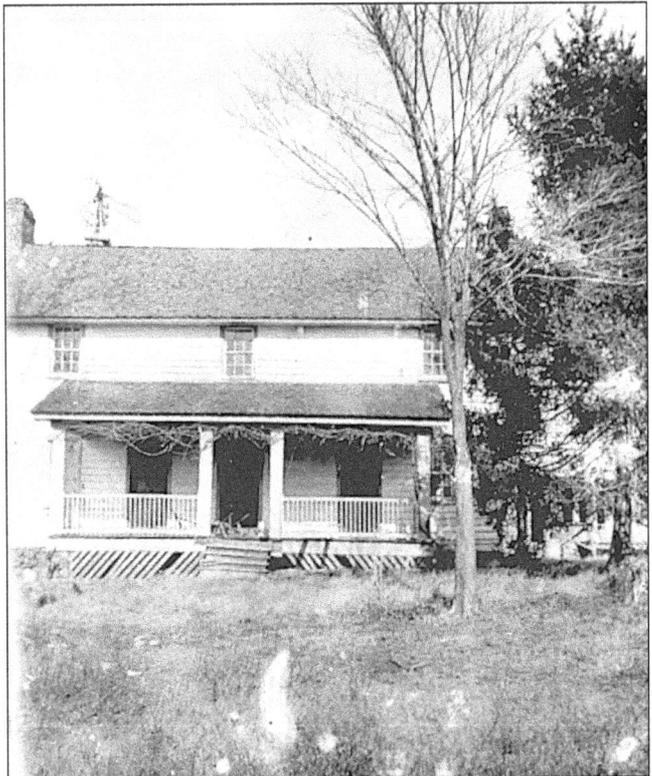

A windmill peeks over Albemarle's original Hearne homestead in this undated image. Before the county's first courthouse was completed, court sessions were held here. (Stanly County Museum.)

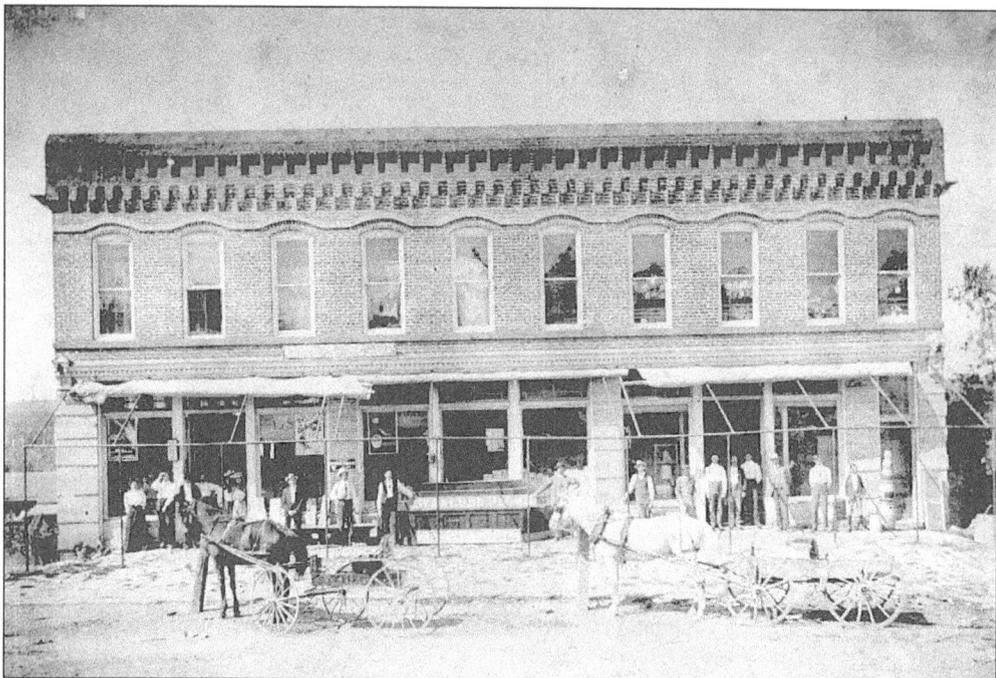

Customers pose against the handsome backdrop of the second Morrow Brothers & Heath store about 1902. The building—restored in the late 1990s—still stands at the corner of Main and First Streets. (Stanly County Museum.)

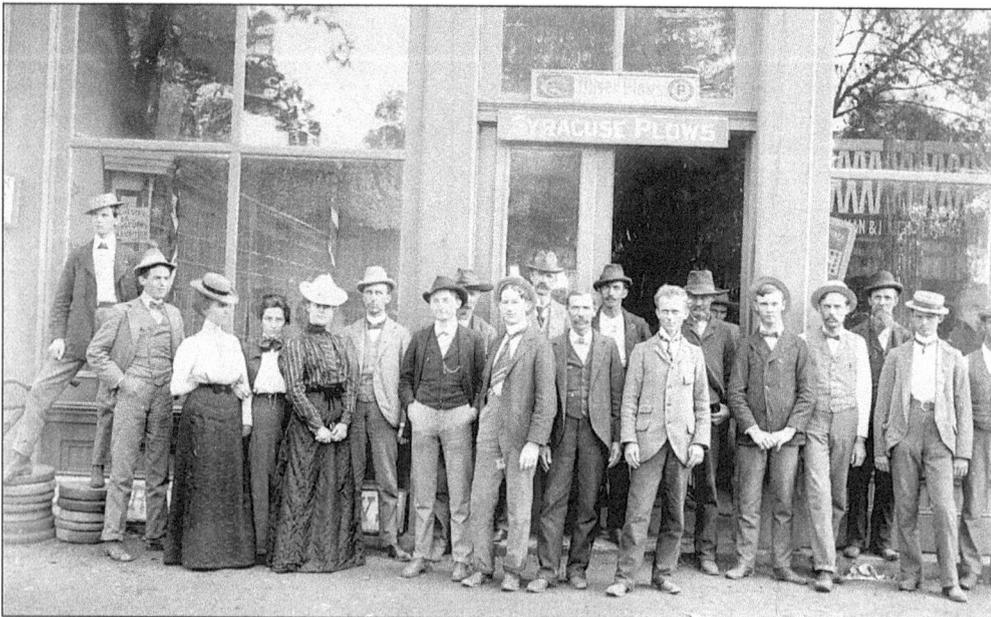

Hats and neckties are the order of the day in this snapshot taken on South Street about 1900. Pictured left to right are Ed Smith, Henry Pemberton, Sallie Heath, Bessie Miller, Mamie Hearne, John Heath, Fred Palmer, Martin Efird, Clarence Betts, Jim Morrow, Albert Lentz, unidentified, P.J. Huneycutt, unidentified, Henry Freeman, John Boyett, William Hearne, Henry Milton, and unidentified. (Stanly County Museum.)

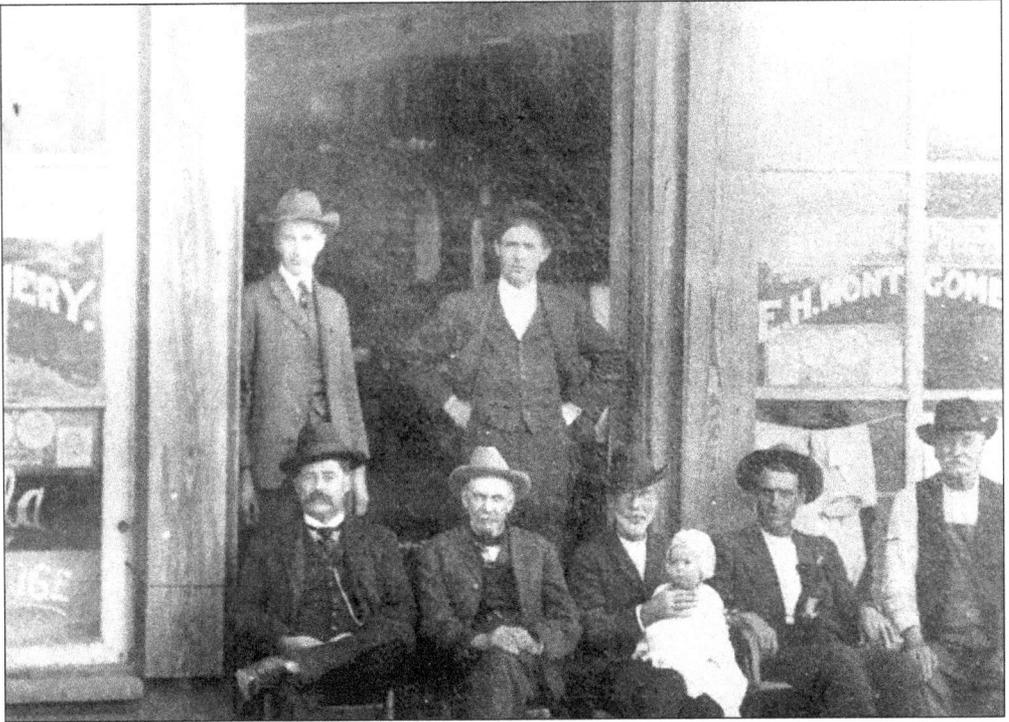

Townsmen pose with a very young companion outside E.H. Montgomery's General Store in north Albemarle about 1905. (Stanly County Museum.)

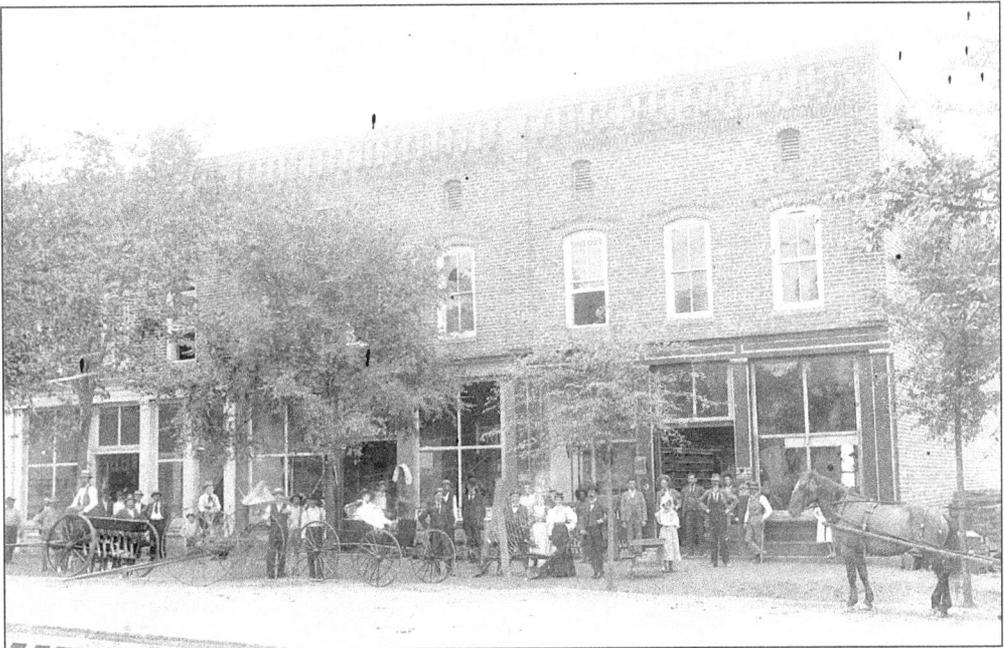

A photographer brings turn-of-the-century traffic to a momentary halt in front of the original Morrow Brothers & Heath store. The historic building—minus its east wing—remains on South Street in Albemarle. (Stanly County Museum.)

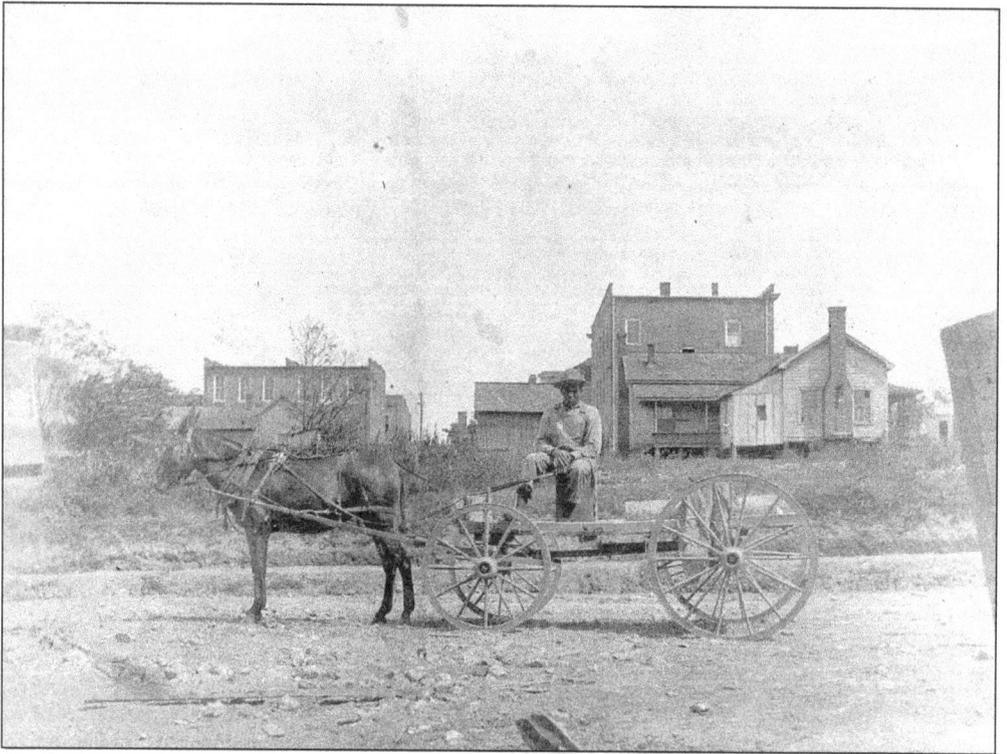

An African-American driver brings his mule-drawn wagon to a stop. The photo is thought to have been taken in the vicinity of the Albemarle town square, *c.* 1900. (Stanly County Museum.)

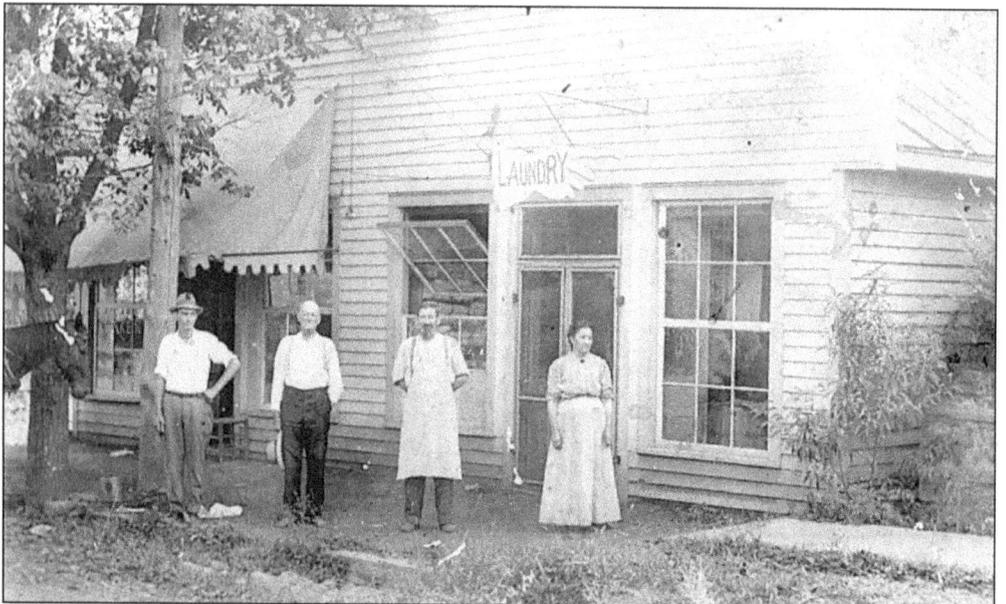

A hand-painted sign points the way to Albemarle's "Chinese" Laundry & Harness Shop on Second Street in this image from the early 1900s. Owner Noah J. Pennington stands second from right. (Stanly County Museum.)

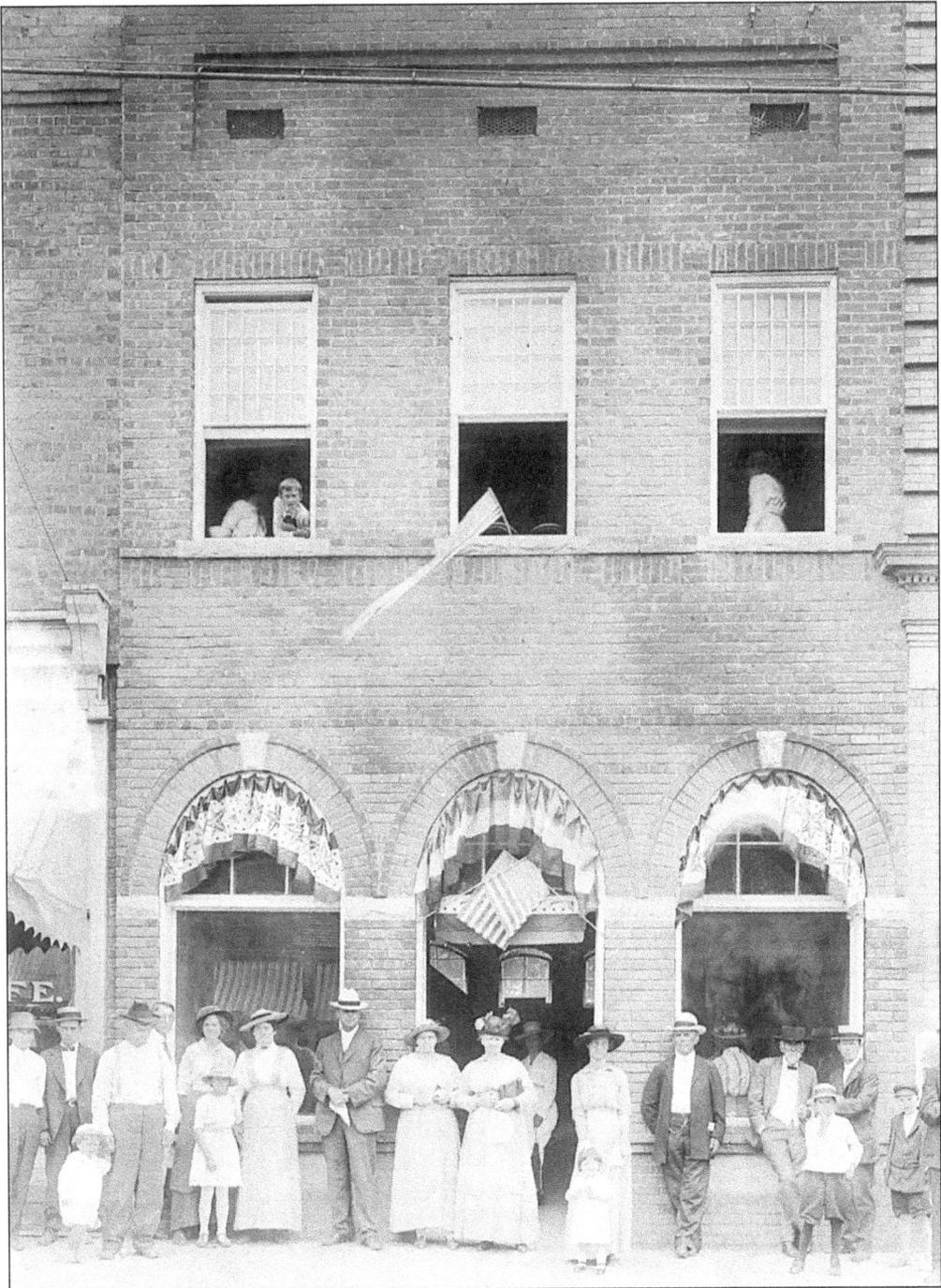

Trimmed with American flags, Albemarle's community building on Second Street opens on a festive day in June 1915. The facility was built for the convenience of county women spending the day in town, reportedly the first of its kind in North Carolina. The building later housed the town's first library. (Stanly County Museum.)

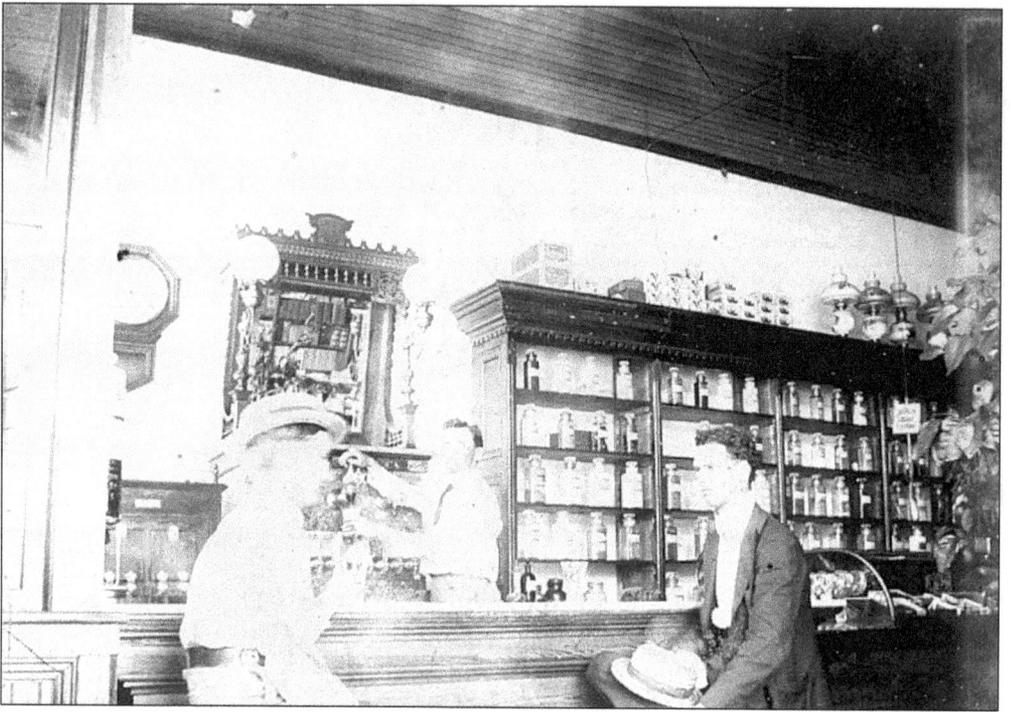

Customers gather in an Albemarle drugstore about 1920. From left to right are Henry Milton, Hoyle Kluttz, and Ed Snuggs. (Stanly County Museum.)

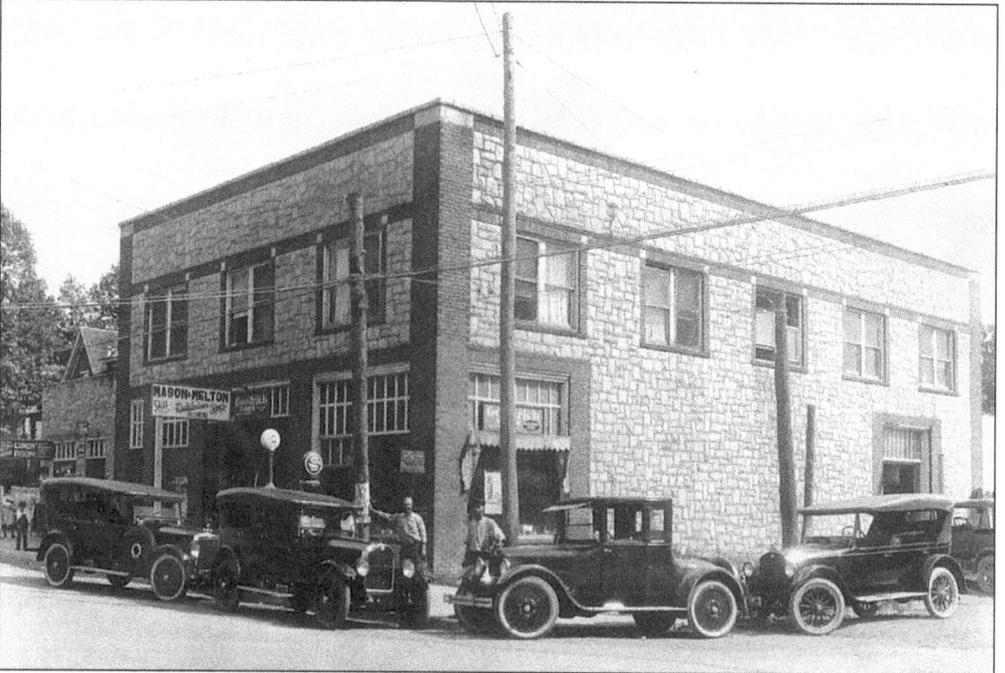

Vintage autos line up in front of Mason & Melton's Studebaker dealership in this 1923 scene. Though the Studebakers have long since gone, the old building still stands at the corner of East Main and Fourth Streets. (Stanly County Museum.)

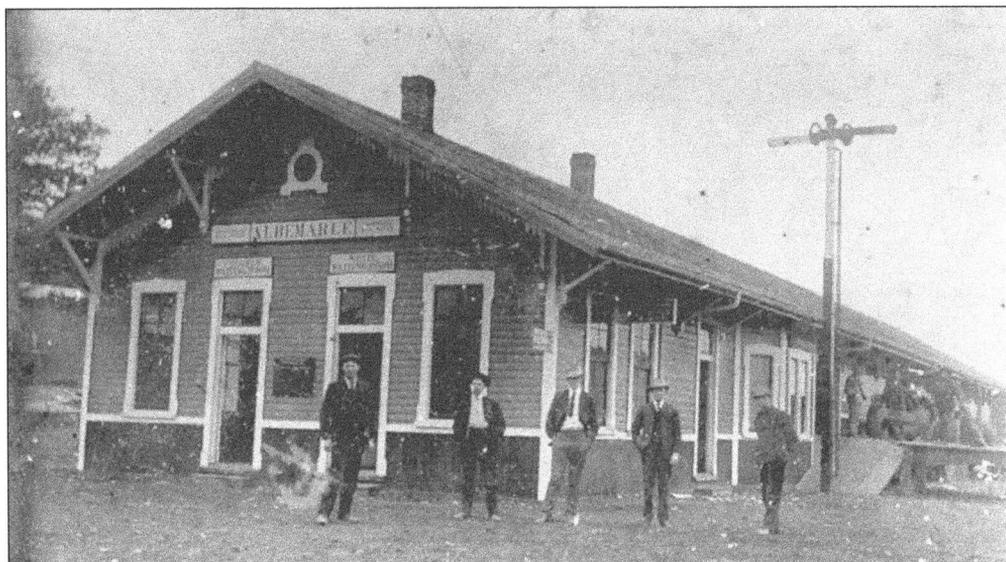

The Yadkin Railroad first brought the iron horse through Stanly County in 1891. Here, passengers loiter in front of Albemarle's Yadkin line station, *c.* 1915. Common to the place and time, signs over the doorways denote separate waiting rooms for white and black passengers. (Stanly County Museum.)

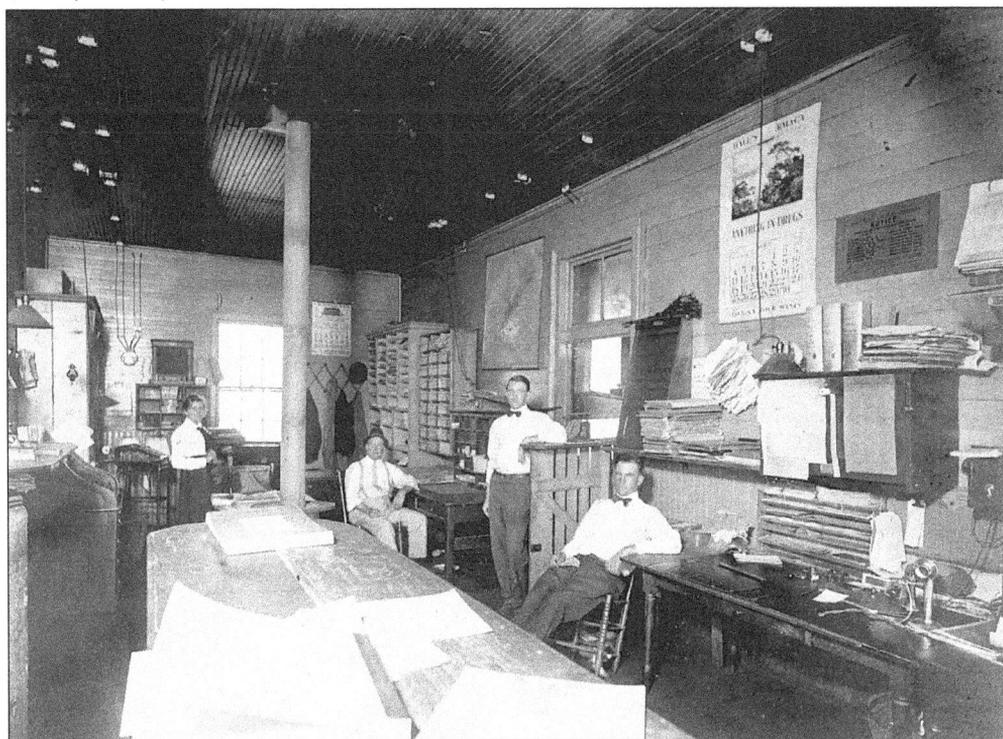

Papers, ledger books, and an iron stove crowd the interior of Albemarle's Yadkin Railroad depot in this 1915 scene. The line was by this time part of the burgeoning Southern Railway system. From left to right are Mary Ella Austin, L.S. Whitworth, O.D. Shoe, and an unidentified man. (Stanly County Museum.)

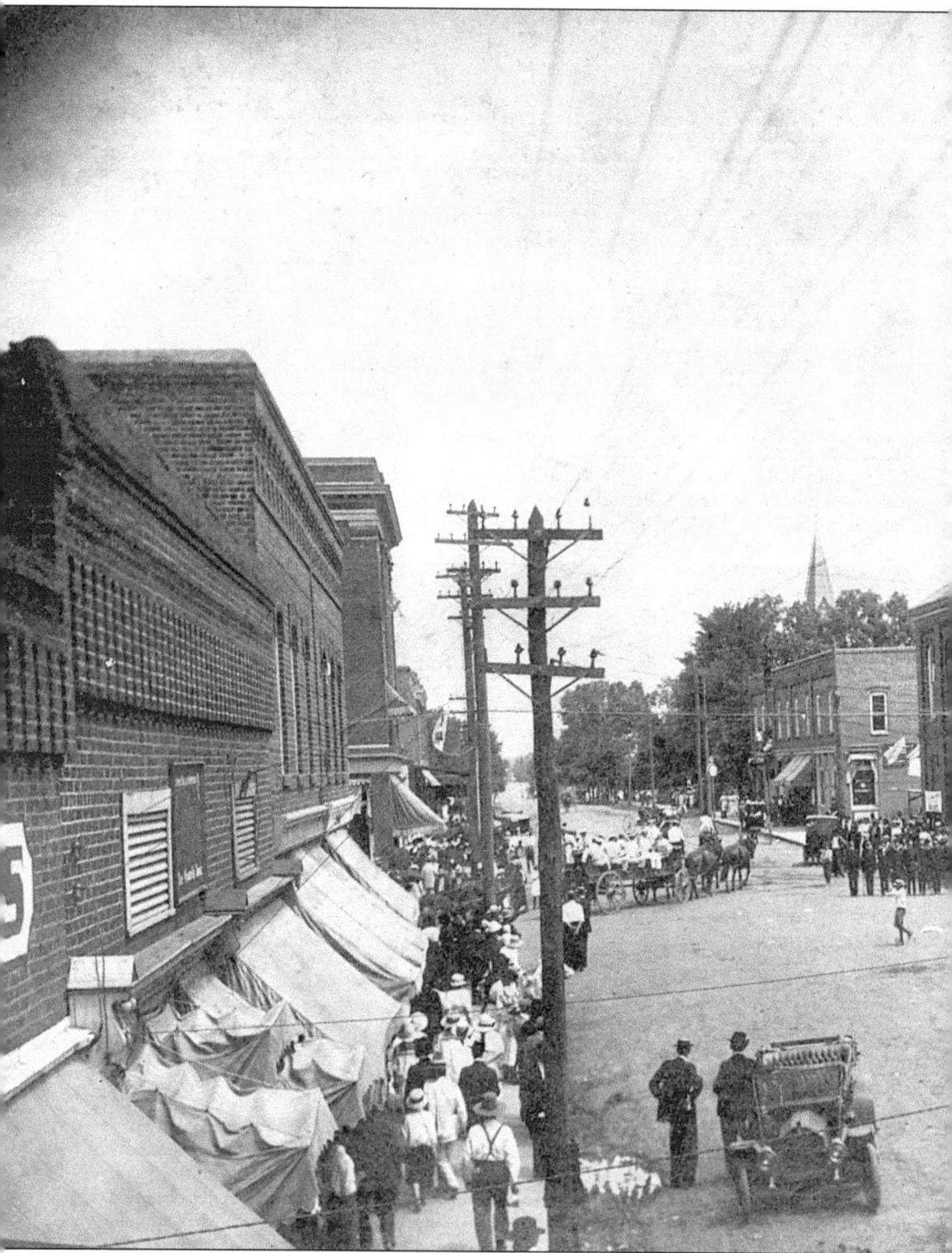

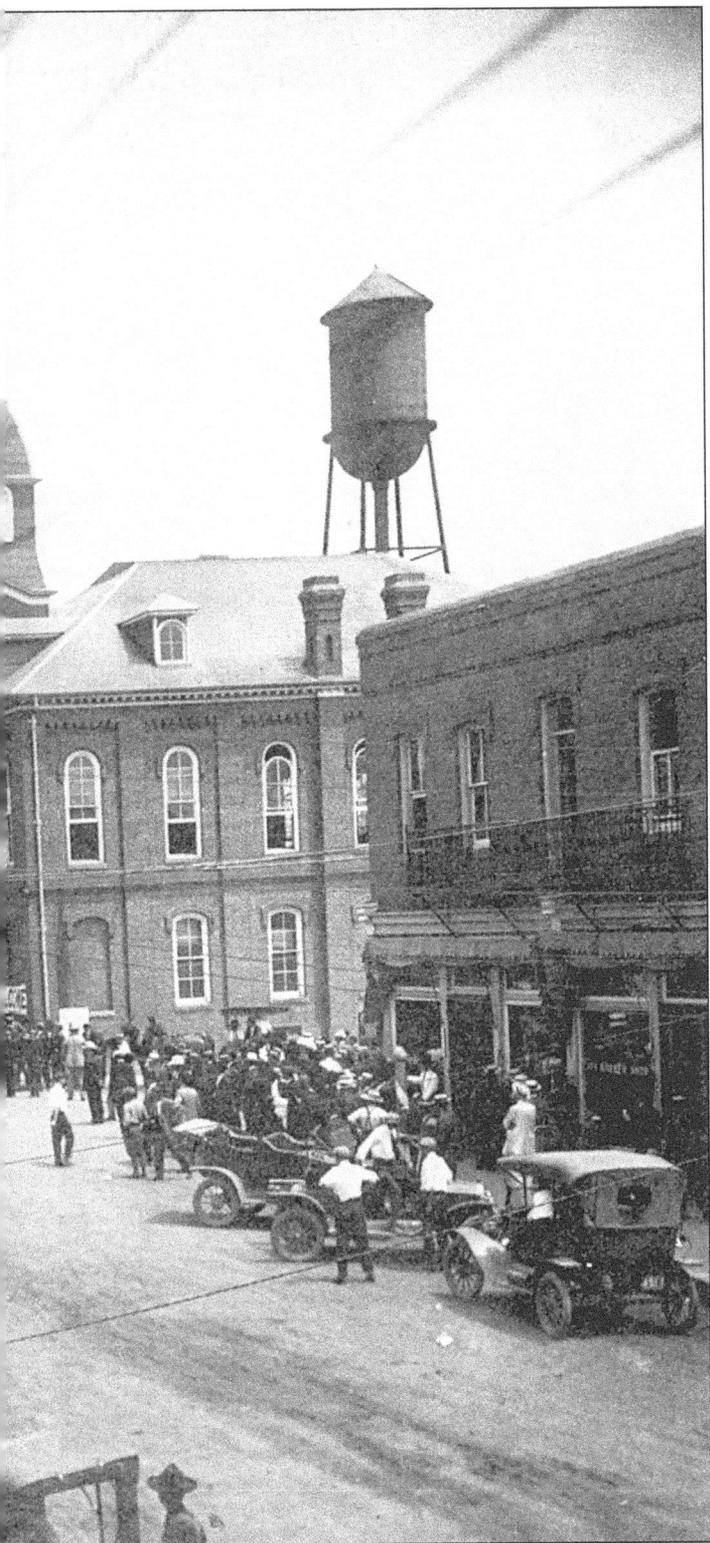

Laden with revelers, a horse-drawn wagon rumbles onto Second Street from Main on July Fourth, 1912. The county's nineteenth-century courthouse—with cupola at right—observes the scene; its windows stand open in the summer heat. On Second Street below, horse-drawn carriages compete for space with newfangled automobiles. Times are booming in Stanly County, North Carolina. The previous year saw a new railroad laid across the county; the following year will see another. World War I is still two summers away. (Stanly County Museum.)

21

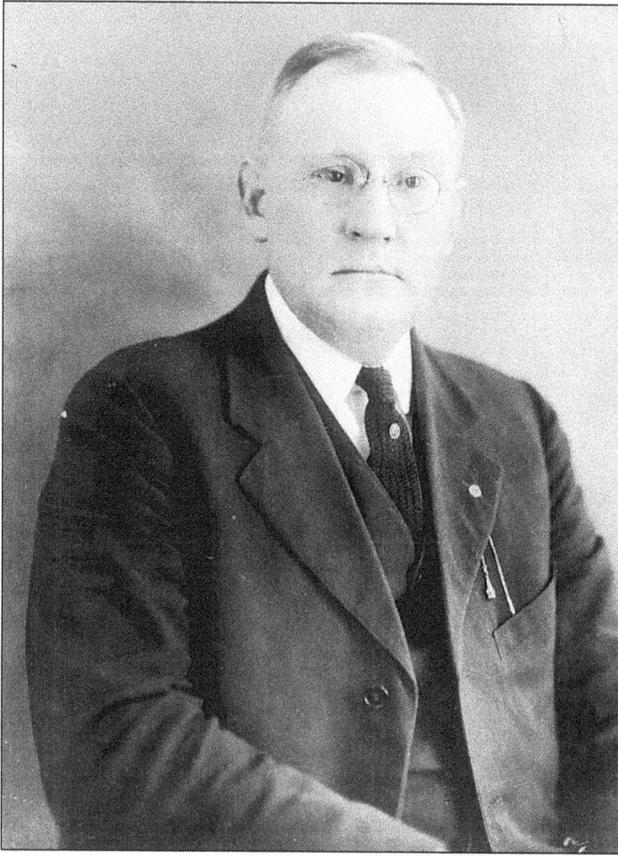

Dr. J.C. Hall practiced medicine in Albemarle between 1906 and 1930. His home on Second Street has survived, as has the building that housed his downtown pharmacy. (Stanly County Museum.)

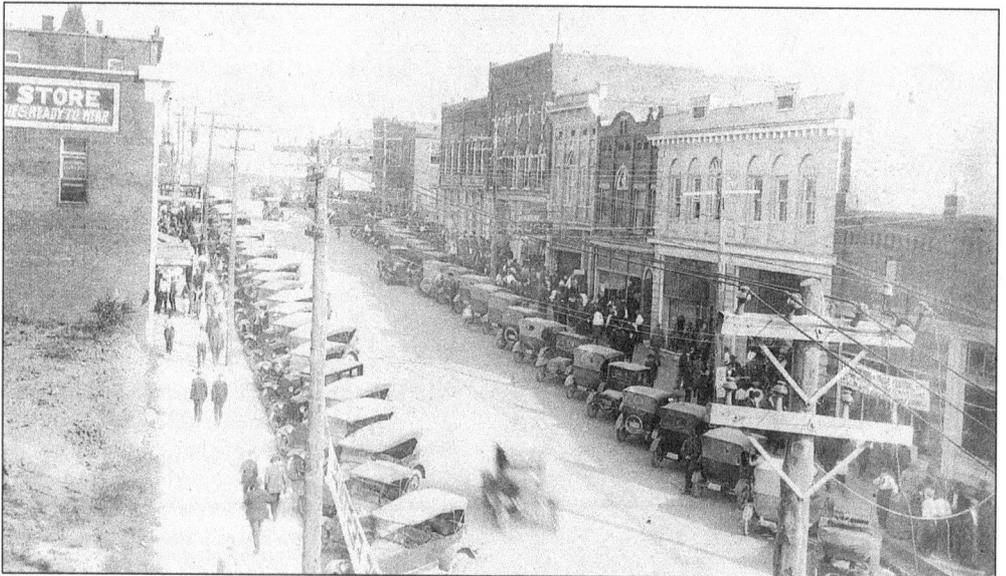

The ascendancy of the automobile over the horse is evident in this Main Street scene dating to the 1920s. Dr. J.C. Hall's drugstore—restored in the late 1990s—stands as the fourth building from the right. (Stanly County Museum.)

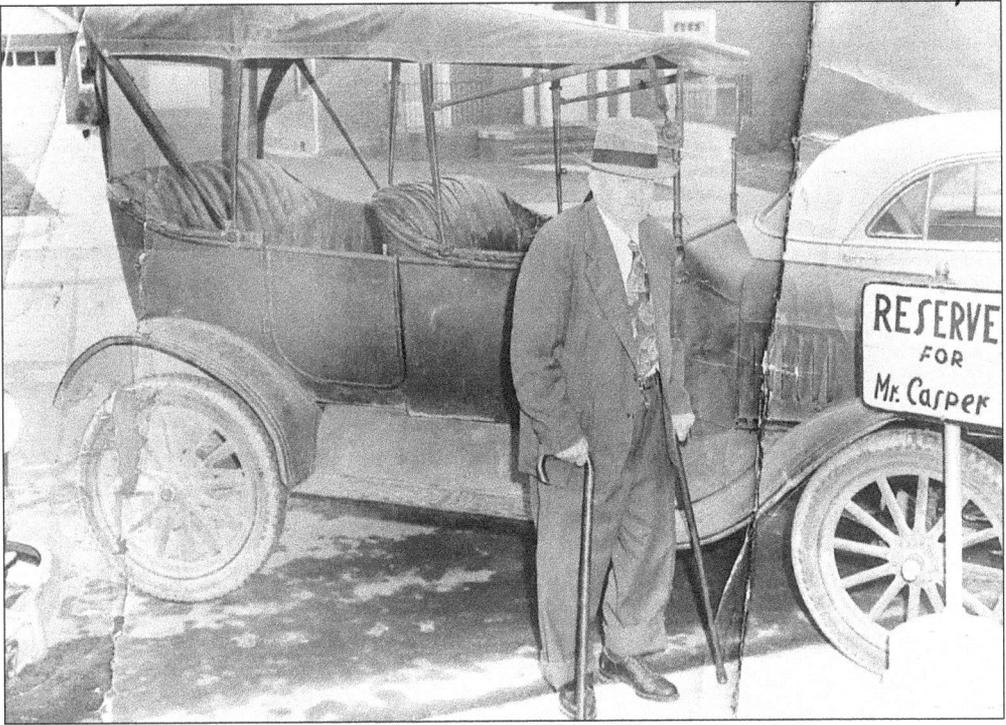

There was always space for old Mr. Casper's Model T Ford by Albemarle's First Baptist Church. (Stanly County Museum.)

Two dogs and their friends—Elwood and Bryce Hatley—pose near Five Points on East Main Street in the early 1920s. The county courthouse sits on the town square in the distance. (Stanly County Museum.)

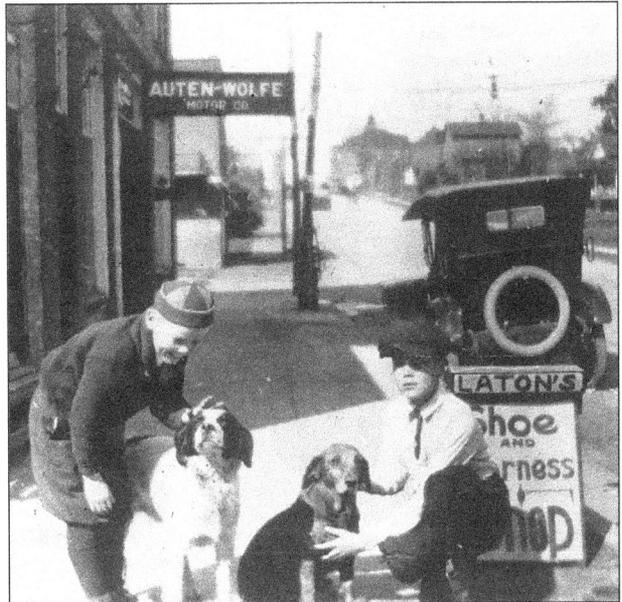

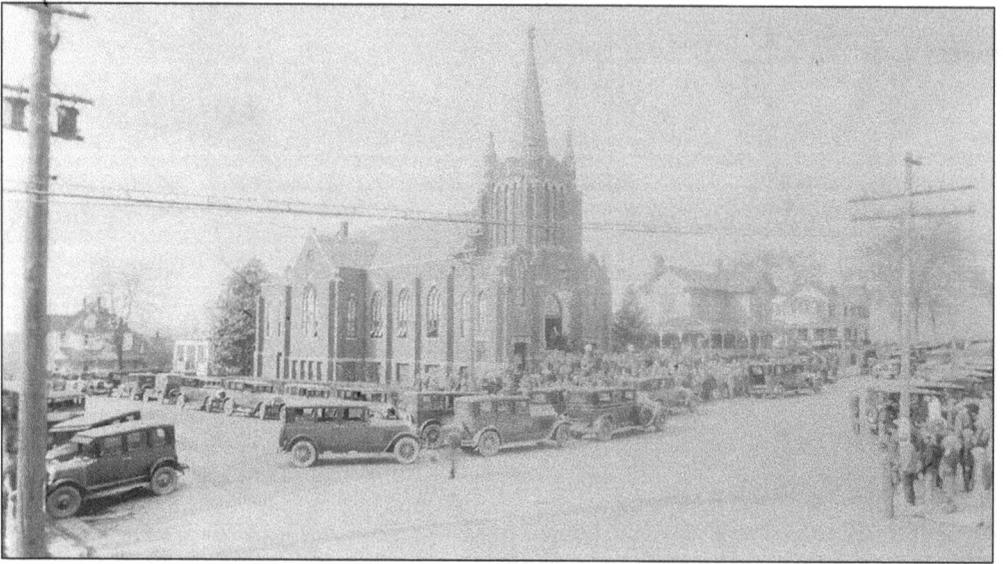

The 1927 funeral of John S. Efird draws mourners to Albemarle's First Lutheran Church. The handsome church and the historic King House, seen here on the far right, still stand. (Stanly County Museum.)

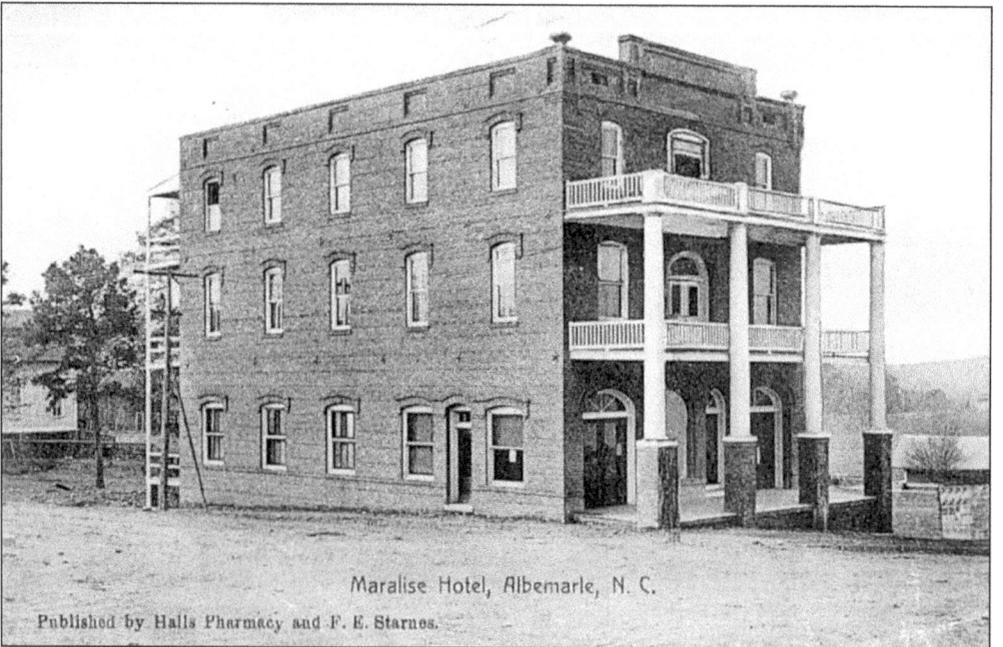

Maralise Hotel, Albemarle, N. C.

Published by Halls Pharmacy and F. E. Starnes.

Jimmy Stewart is said to have stayed at Albemarle's famed Maralise Hotel on the corner of First and Main. Built in 1908, the hotel's wide porches provided a good spot to catnap on hot summer days. A parking lot now occupies the site. (Stanly County Museum.)

24

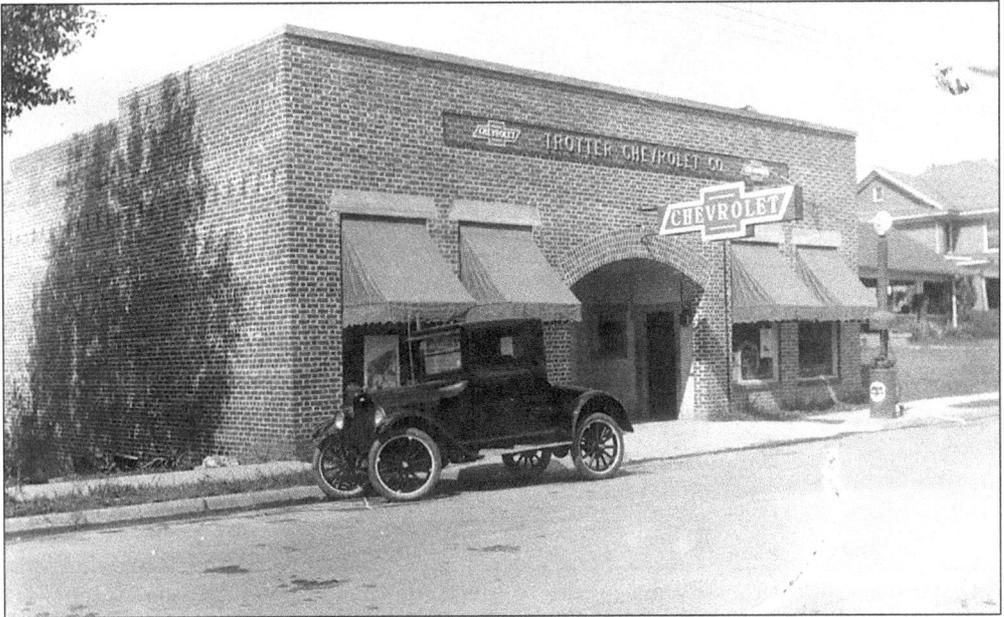

A handsome black coupe stands ready for a drive outside Trotter's Chevrolet dealership on Albemarle's West Main Street. The year is 1923. (Stanly County Museum.)

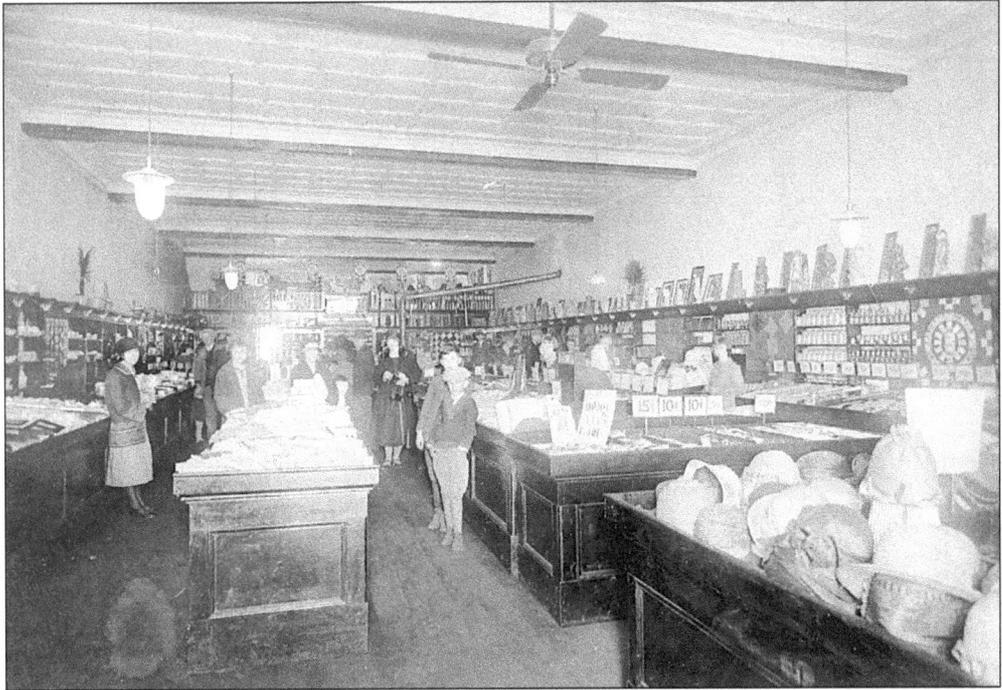

Customers browse for hats and housewares inside McEwen's Novelty Store on West Main Street in this scene from the mid-1920s. Seen here on the far left is Nora Wall; Luron Russell stands behind the cash register. Thelma Forrest leans against a counter on the far right. The building still stands. (Stanly County Museum.)

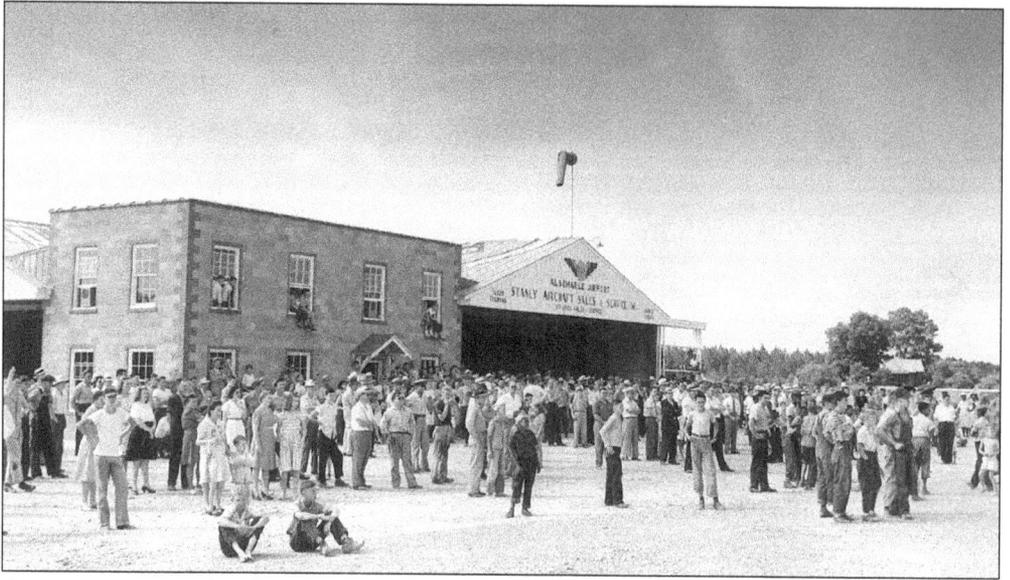

An expectant crowd gathers for the opening of Albemarle's new airport in the summer of 1947. An air show featuring acrobatic displays and military aircraft made the heat bearable. (Stanly County Museum.)

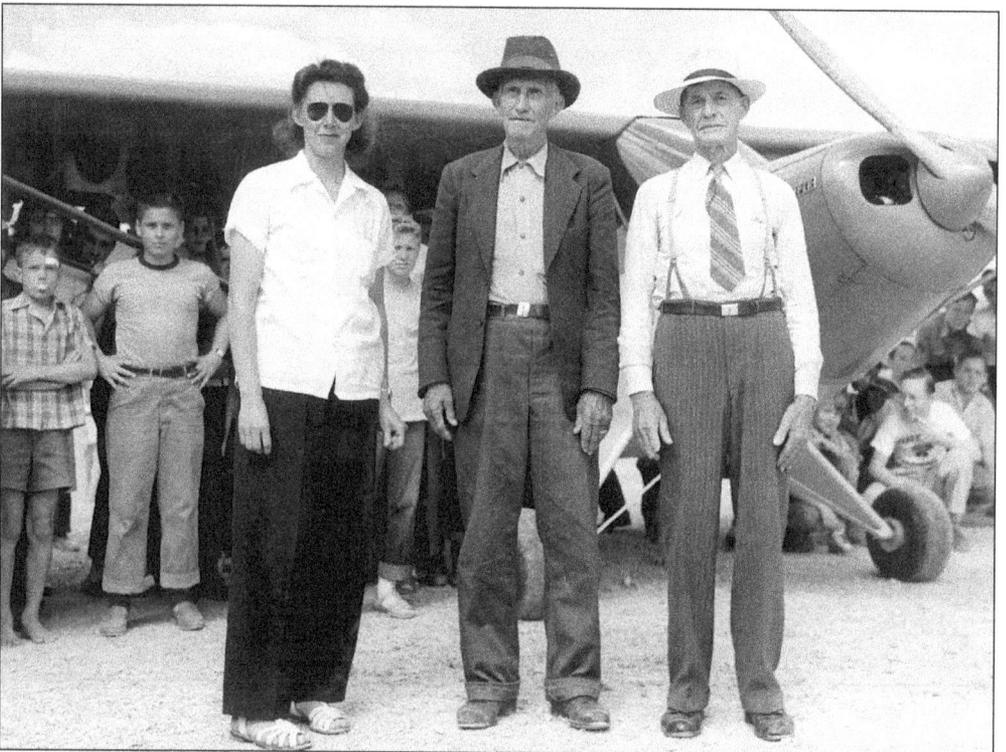

These lucky attendees to the 1947 air show were remembered as contest winners. A ride over Stanly County in the classic Piper behind them would have made for a fine prize. (Stanly County Museum.)

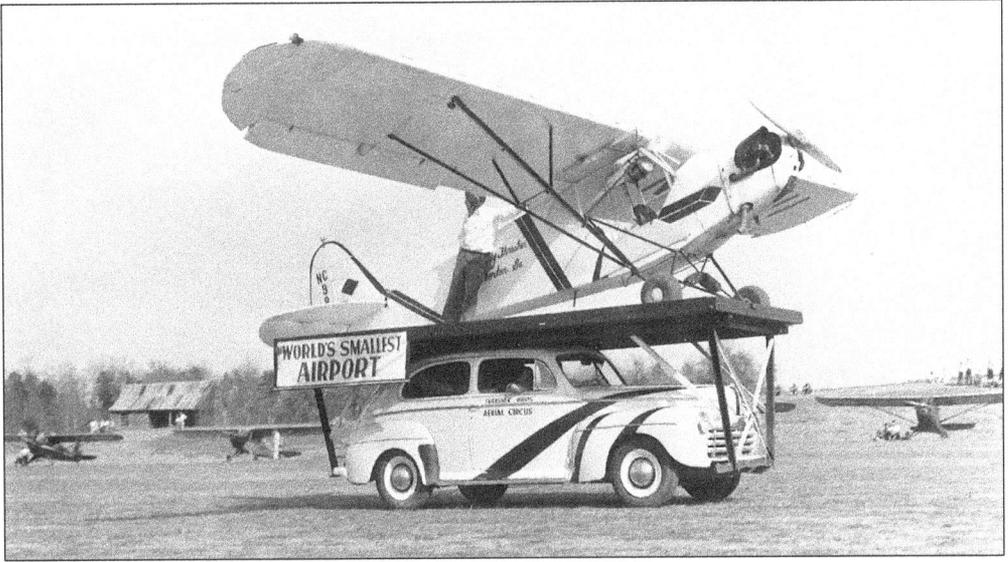

Pilot above and drivers below await their cue to perform a daring takeoff and landing from the "World's Smallest Airport" during the 1947 air show. (Stanly County Museum.)

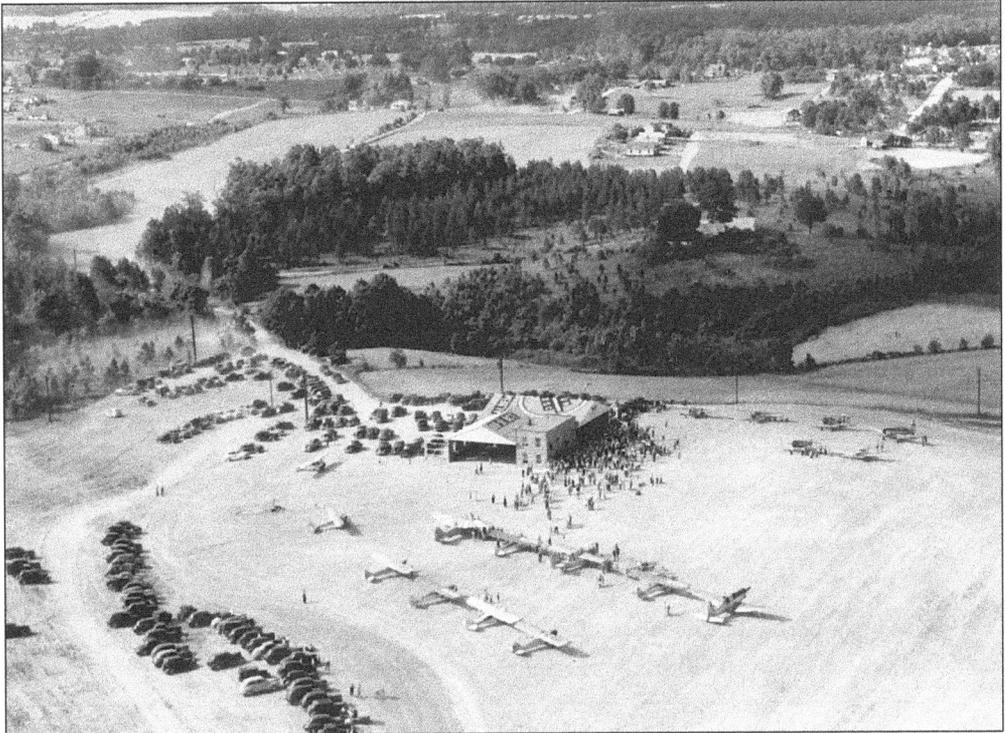

Cars, crowds, and flying machines converge for Albemarle's 1947 air show in this aerial view. Symbols painted on the hangar roof gave navigational information to passing planes. A shopping mall now sprawls across the site. (Stanly County Museum.)

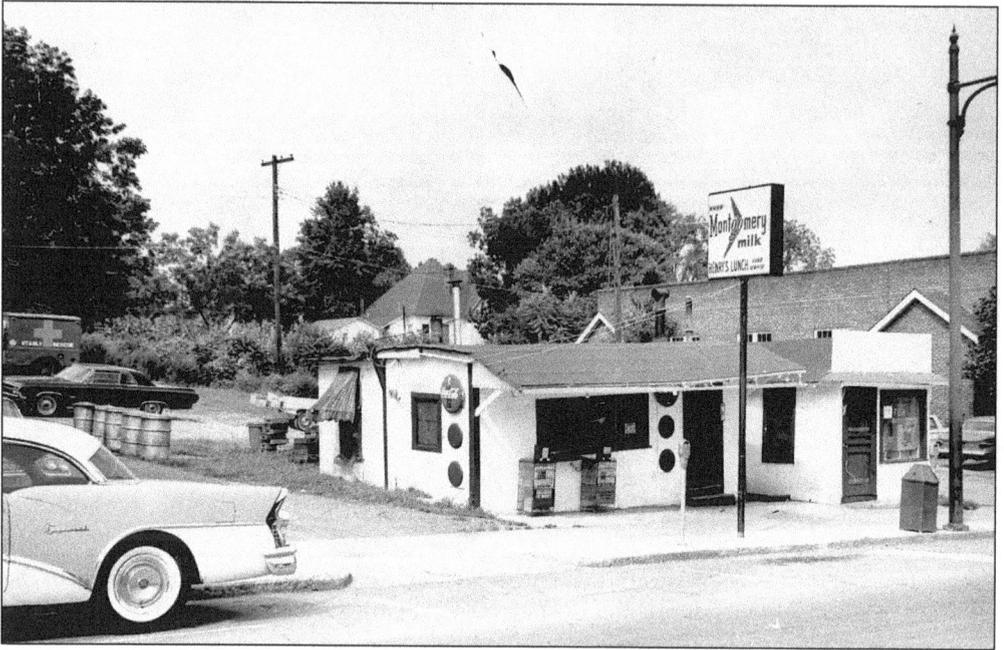

Henry's Lunch on East Main was an Albemarle institution. Torn down in the 1970s to make way for a new library, the humble café lives on in a well-known painting by Stanly County artist Roger Thomas. (Stanly County Museum.)

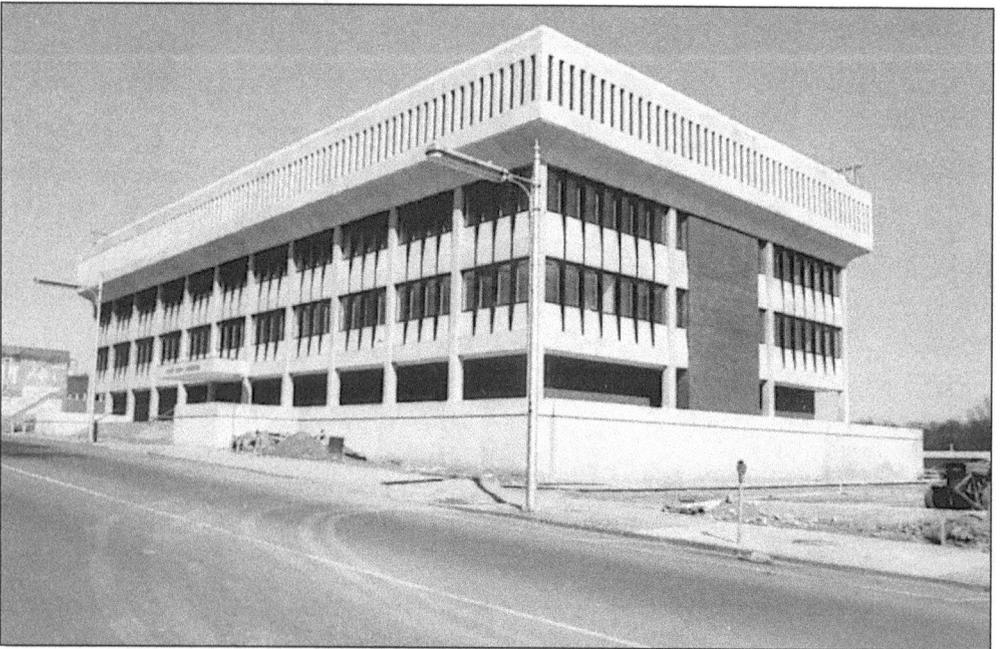

Changing tastes and the genuine need for a new courthouse brought down an entire block of Albemarle's old business district in the late 1960s. The county's third courthouse, seen here under construction, now dominates the site of the old Central Hotel pictured on page 13. (Stanly County Museum.)

Two

Rural Communities

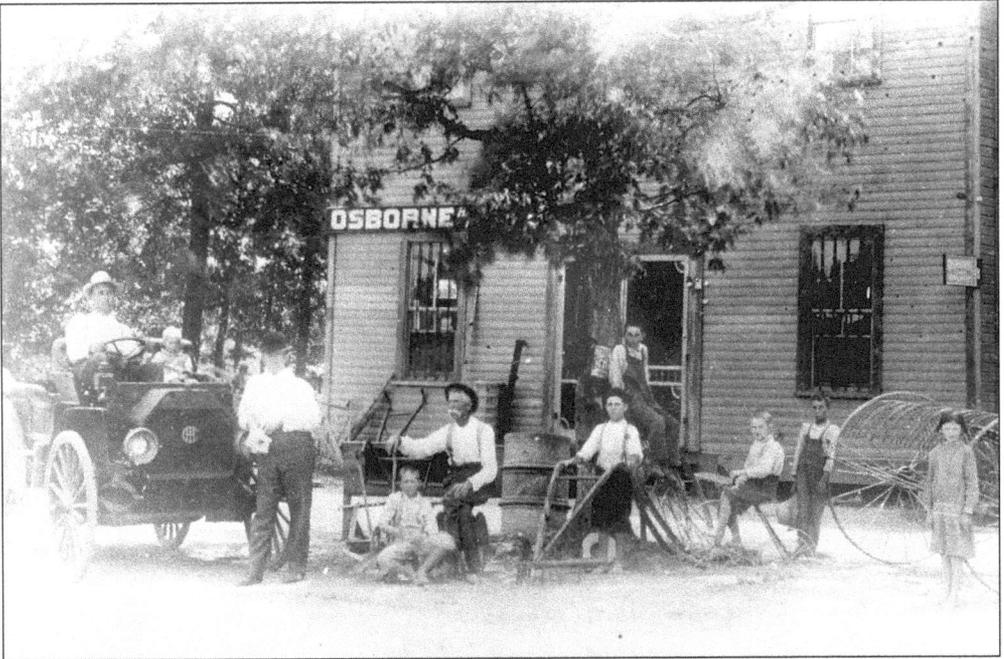

About 1920, when a photographer captured this image in rural Big Lick, 90 percent of the county's population lived on farms or in small communities. After being bypassed by a new railroad in 1912, once prosperous Big Lick began a quiet decline. Professor Black's old academy building, seen here behind local residents, found new use as a farm equipment dealership. (Stanly County Museum.)

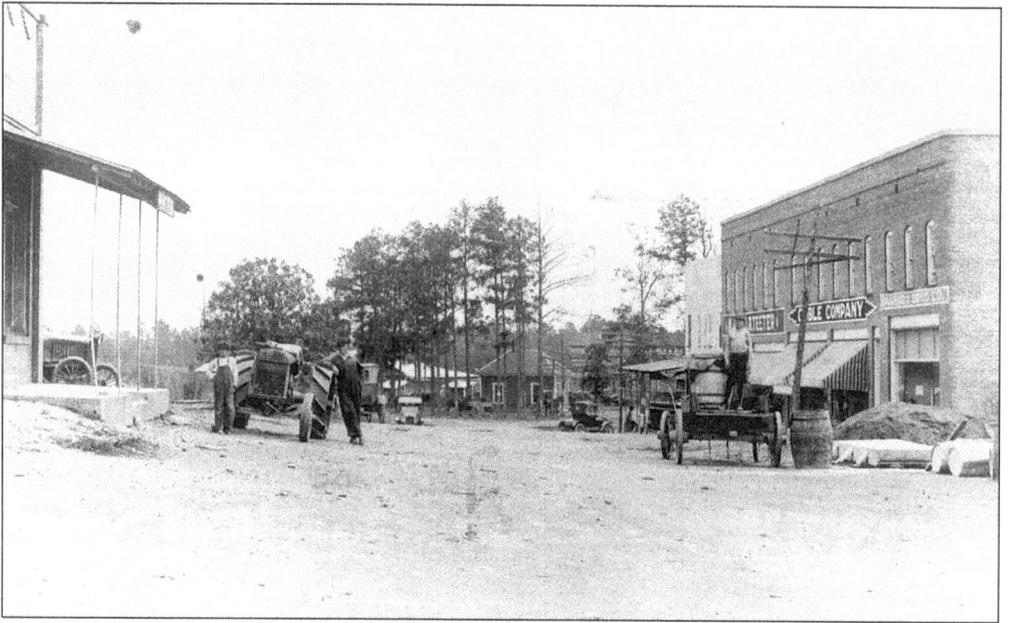

South Main Street in Oakboro presents a quintessential Stanly County scene in this view, c. 1920. Incorporated in 1915, Oakboro sprang up along the Norfolk & Southern's rail line from Charlotte to Raleigh. J.M. Burns's general store stands at left; leaning against his tractor is Luther Little. Ralph Teeter poses atop a wagon at right. (Stanly County Museum.)

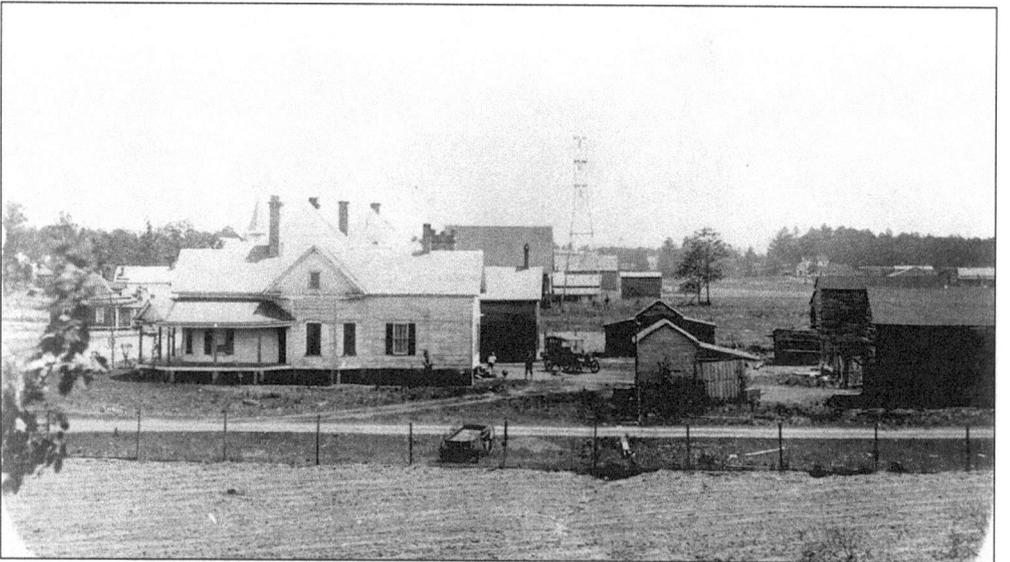

Oakboro's West Eighth Street stretches across the foreground in this image dating from the 1920s. The Hartsell's whitewashed home sits at left center; visible beyond is the Oakboro Presbyterian Church. (Stanly County Museum.)

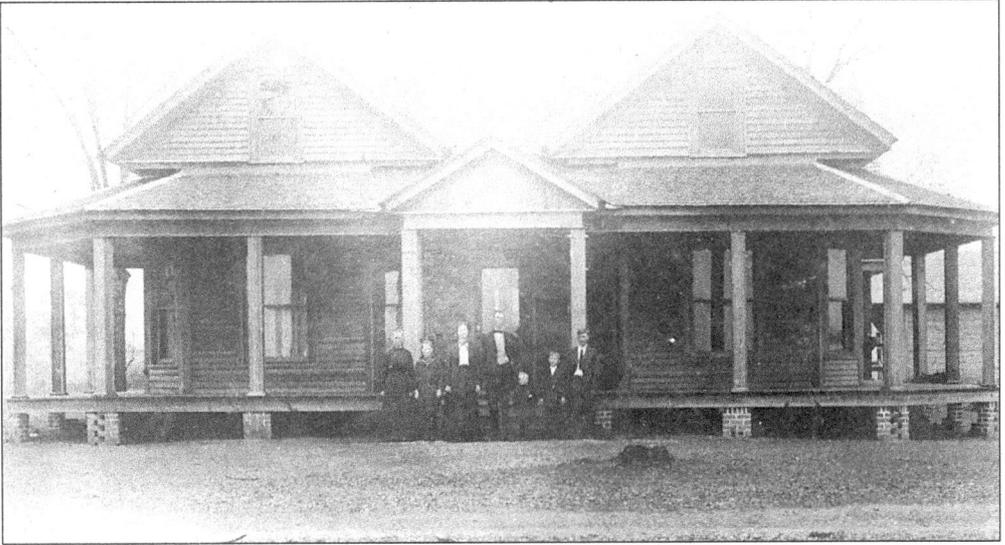

Members of the James family pose on the porch of their Oakboro home in this undated image. (Stanly County Museum.)

A straw hat keeps the sun off postman Martin James as he makes his rounds in the Oakboro vicinity about 1915. (Oakboro Regional Museum of History.)

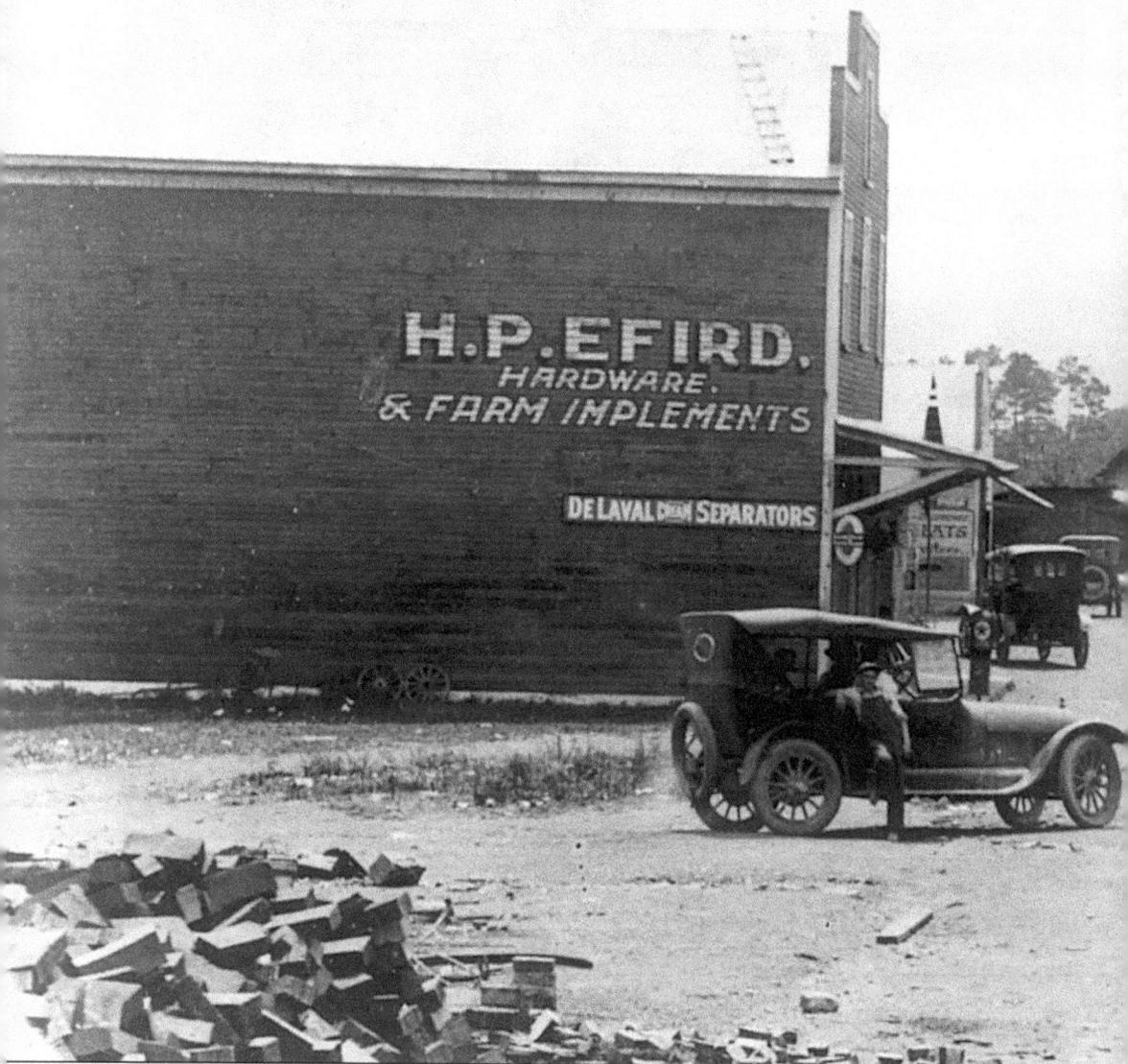

Activity on Oakboro's West Second Street pauses for a snapshot in this image from the 1920s. The town already had a name when railroad officials offered five dollars to anyone who could

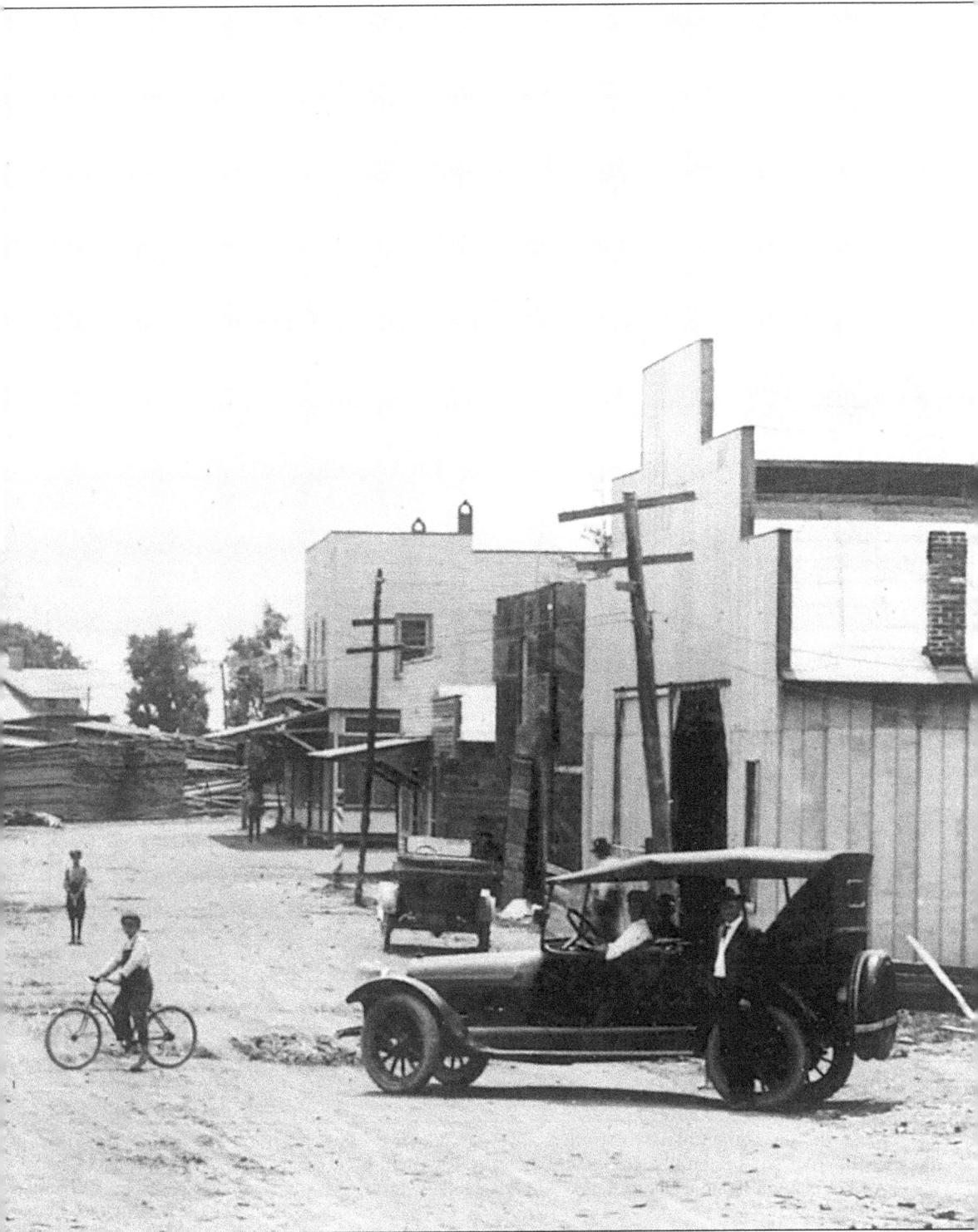

come up with a new one. It seemed the town's original moniker—Furr City—just didn't have the right ring. Oakboro it was. (Stanly County Museum.)

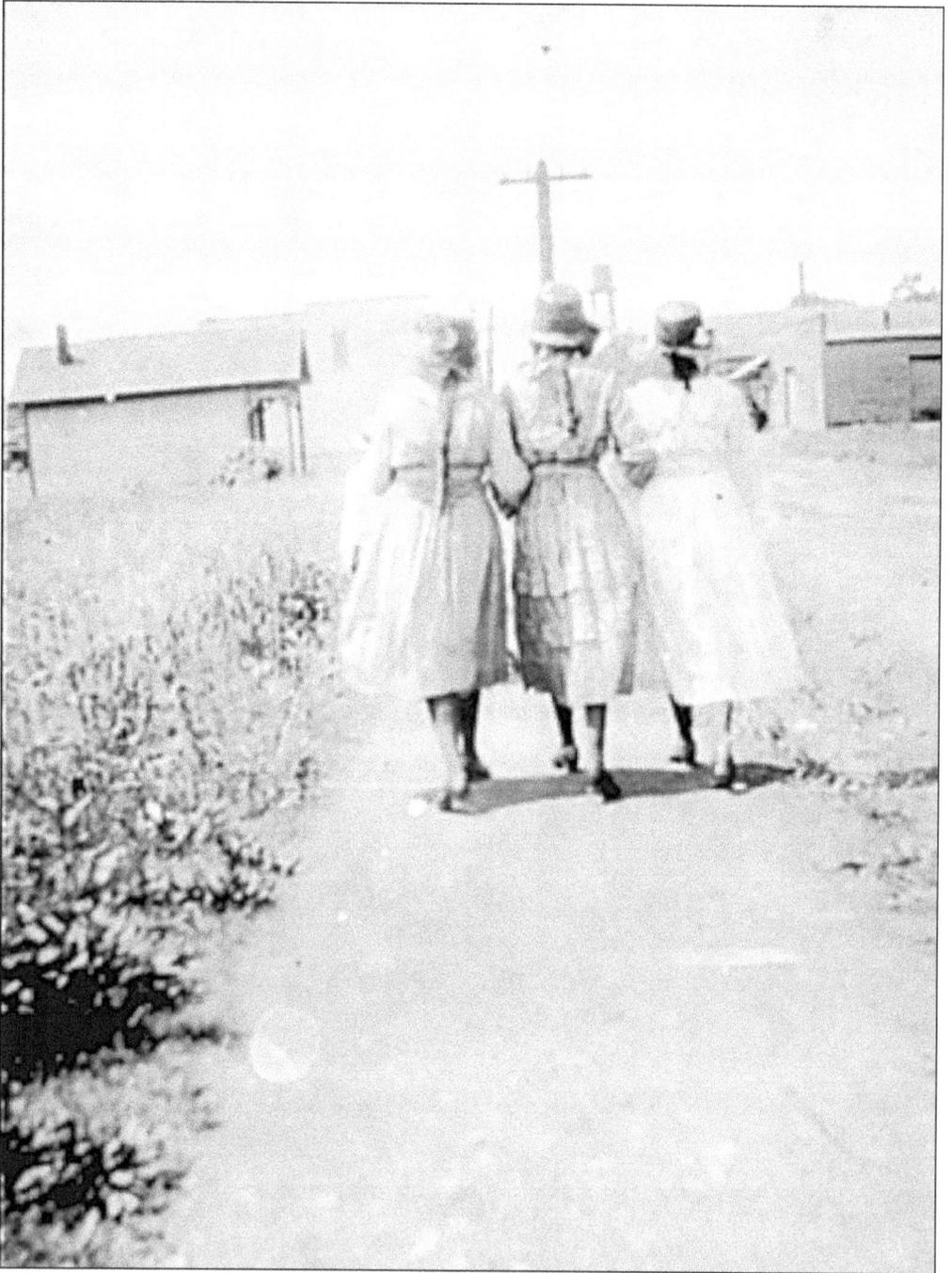

Arm in arm, three unknown strollers enjoy a walk in Richfield about 1915. Named for the prosperous Ritchie family, turn-of-the-century Richfield boasted a shirt factory, a sawmill, a casket plant, a steam roller mill, and a livery stable. (Stanly County Museum.)

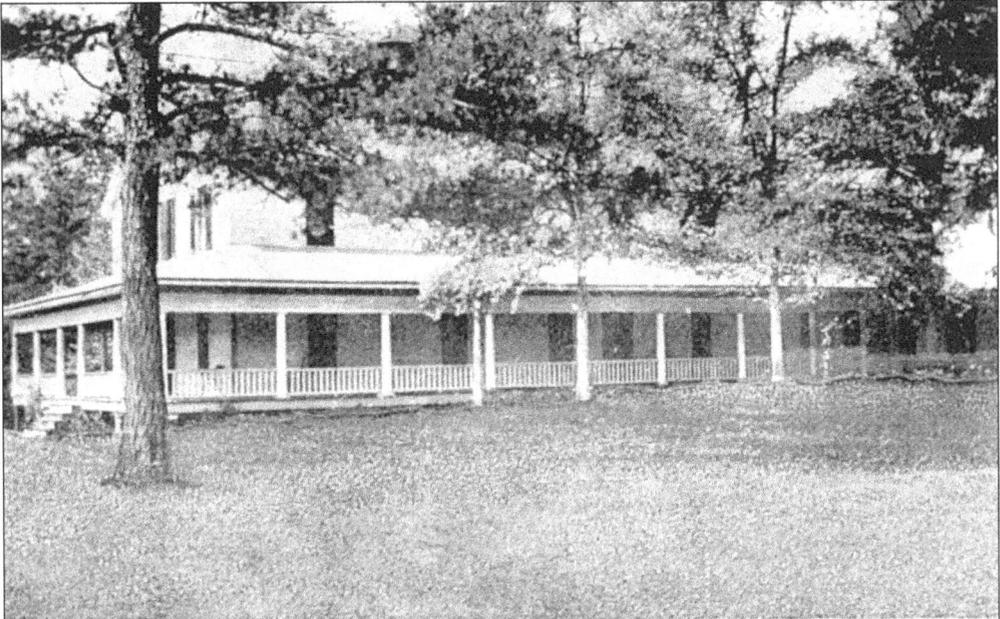

Carolina White Sulphur Springs Hotel, Richfield, N. C.

Richfield's famed Carolina White Sulfur Springs Hotel stands freshly painted in this 1920 postcard. The year's tourist season opened June 17th with a square dance. (Stanly County Museum.)

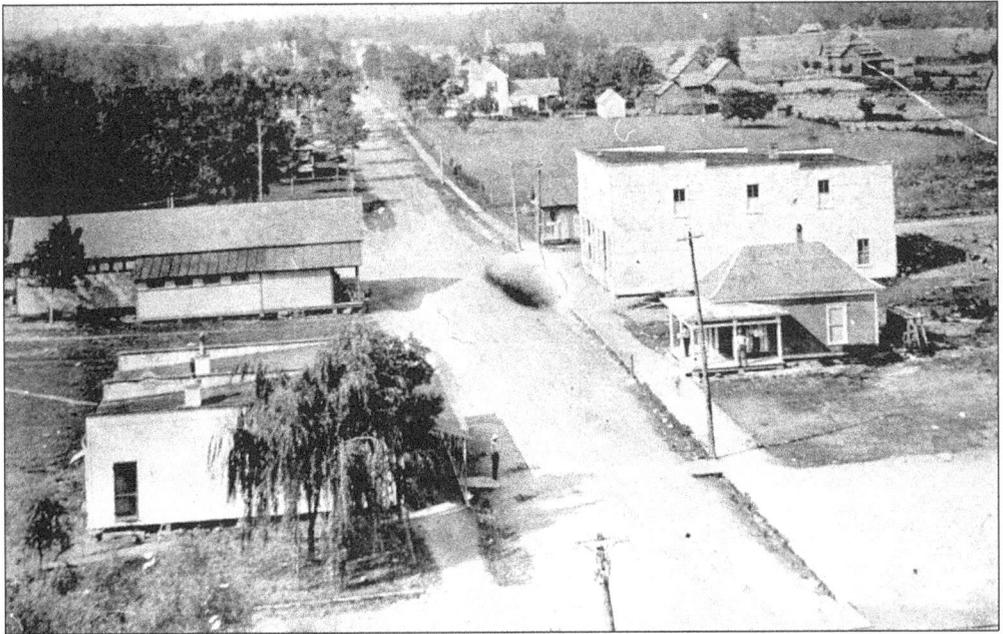

The Yadkin Railroad is visible in the foreground of this undated view of Richfield's Main Street. Like many of the county's rural communities, Richfield was railroad powered. News of the approaching iron horse prompted members of the Ritchie family to invest heavily in the area. When the Yadkin Railroad was completed in 1891, the town prospered. (Stanly County Museum.)

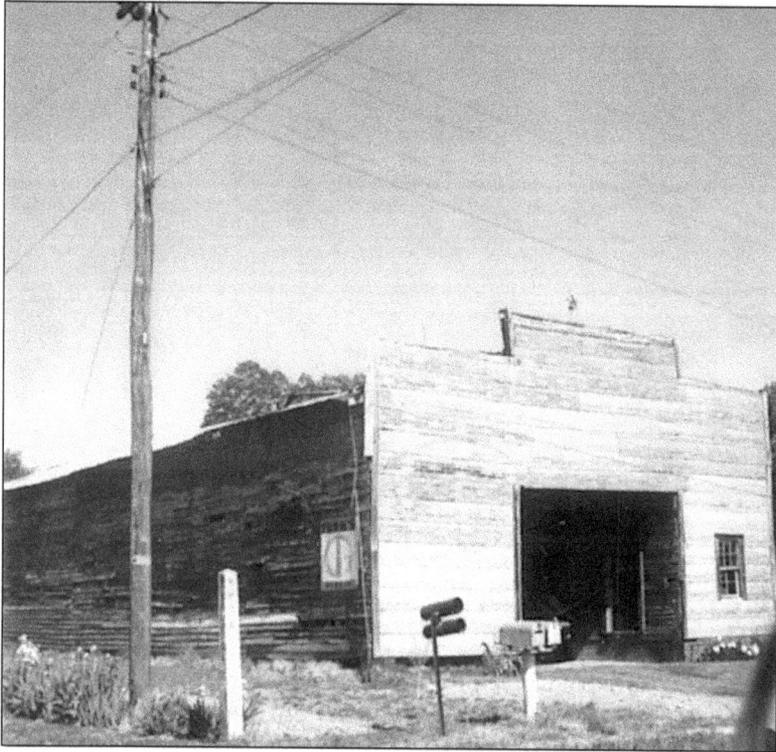

Livery barns like this example in Stanfield were once a common sight in farming communities across Stanly County. Another railroad boomtown, Stanfield grew by leaps and bounds following the completion of the Norfolk & Southern's rail line in 1913. (Stanly County Museum.)

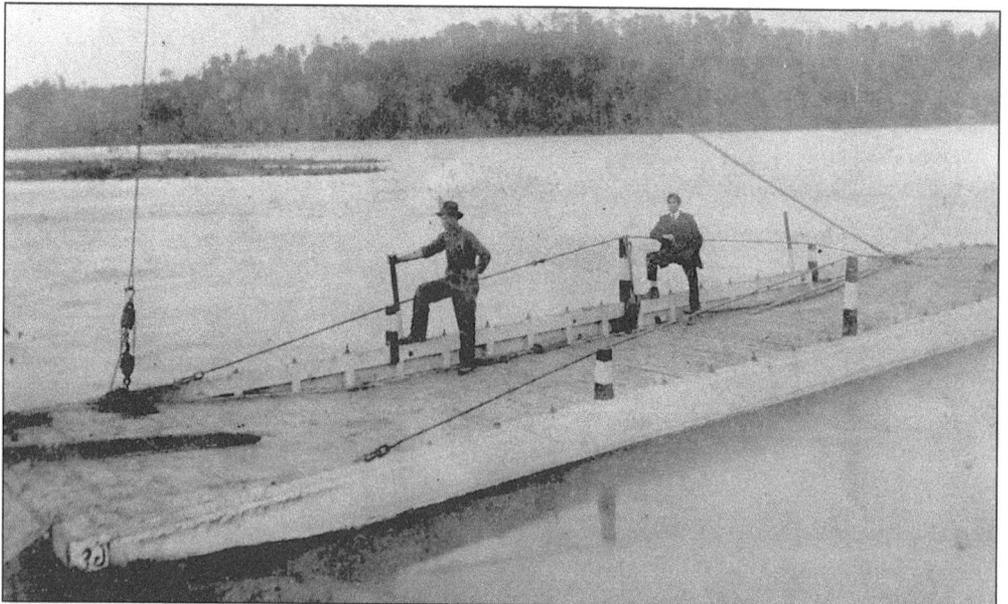

A ferryman transports a lone passenger across the Pee Dee River near Norwood about 1920. Though railroads eased the situation, transportation in early-twentieth-century Stanly County remained hampered by a lack of infrastructure. (Stanly County Museum.)

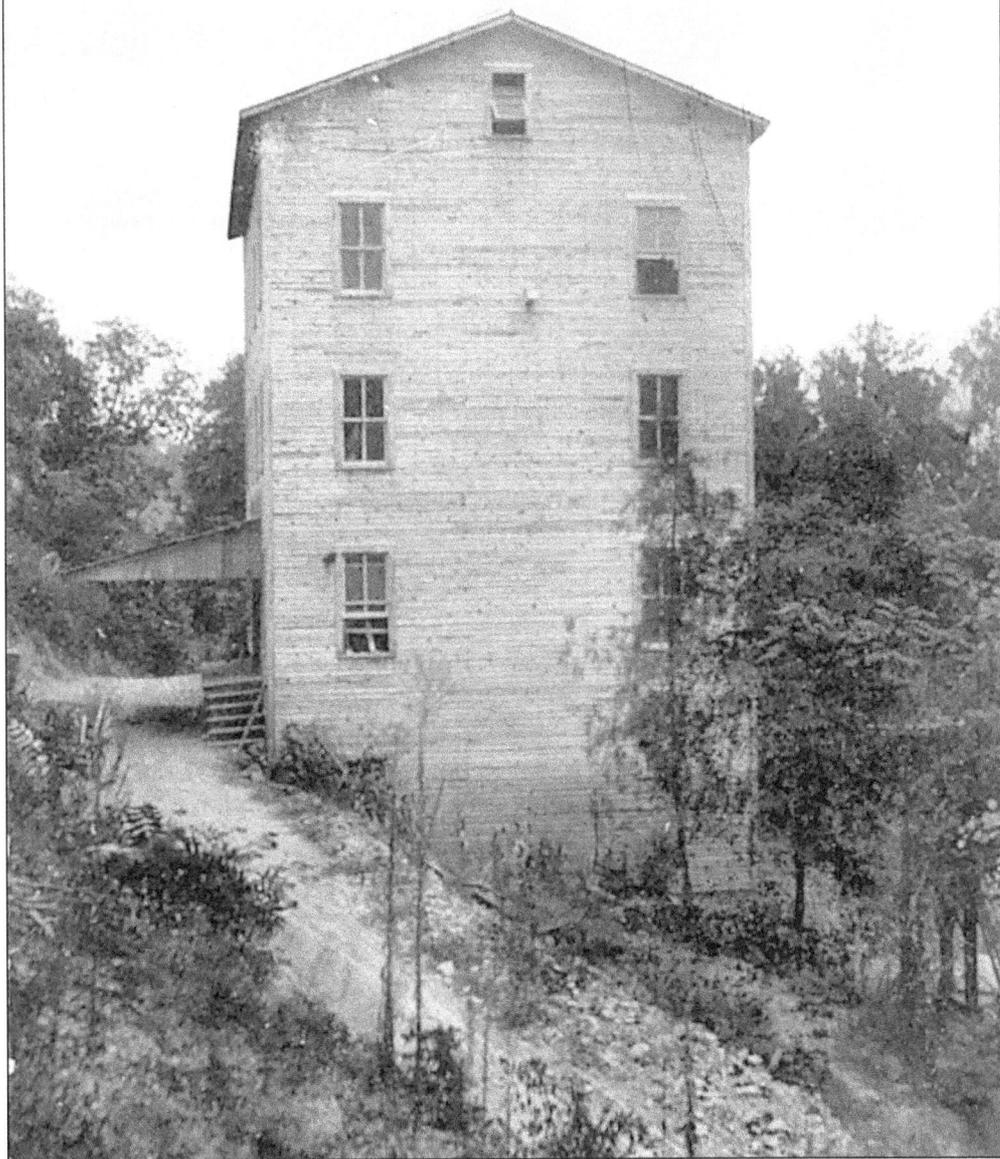

RIVER VIEW MILL, NORWOOD, N. C.

Norwood's River View Mill towers over the banks of the Pee Dee River on this undated postcard. Among Stanly County's oldest communities, Norwood prospered as the hamlet of Allenton in the early 1800s. Moved to higher ground to escape disease and rising river waters, Allenton was renamed Norwood in 1881. (Stanly County Museum.)

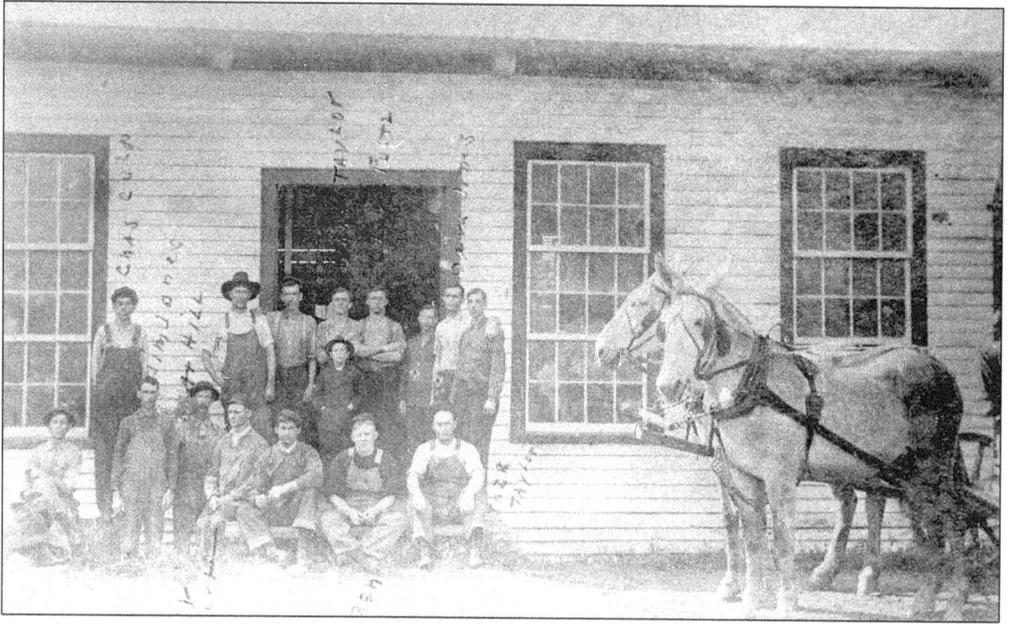

A well-harnessed team of horses stands idle as laborers at the Tucker & Carter Rope Company in New London pose for a turn-of-the-century portrait. New London was founded as Bilesville in the 1870s, and its early growth was spurred by the discovery of gold in northern Stanly County. (Stanly County Museum.)

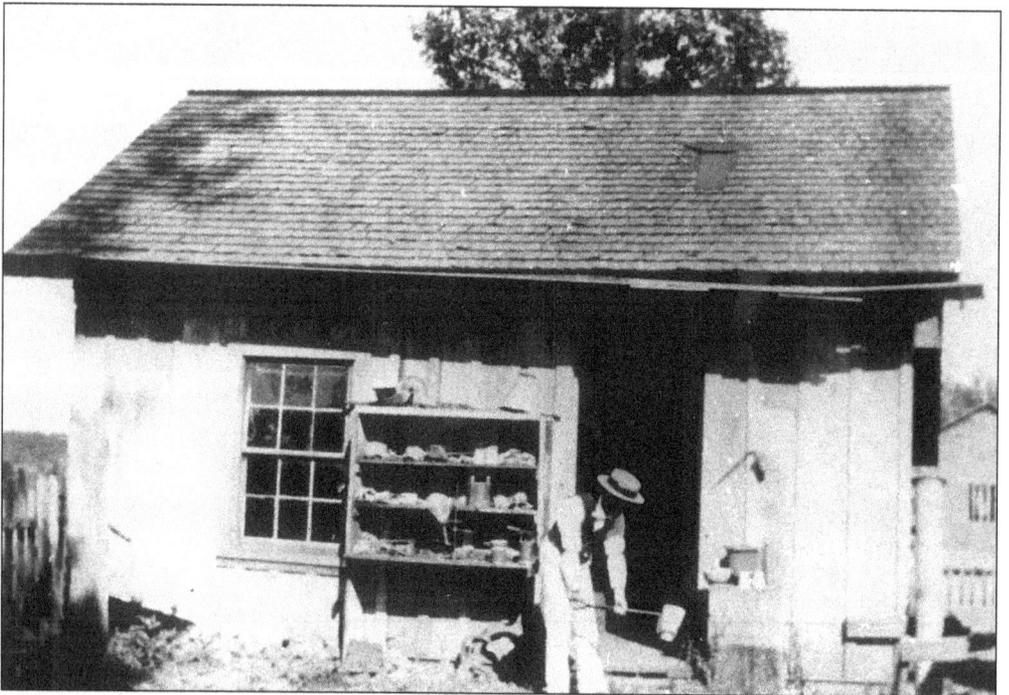

A well-dressed agent pours an ingot outside New London's gold assay office. The town's reputation as a mining center attracted investors from as far away as Great Britain. (Stanly County Museum.)

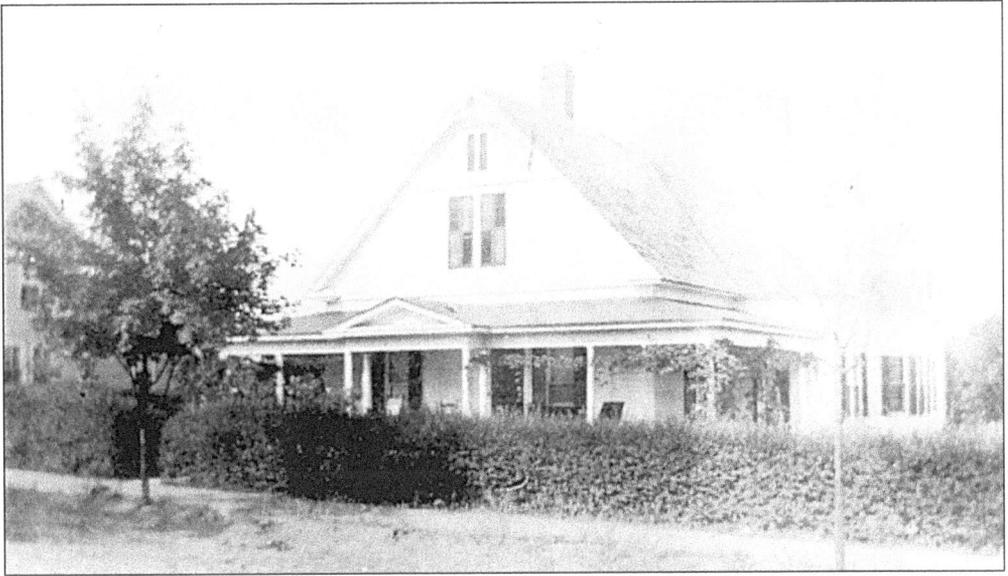

Respected Dr. J.A. Allen built this handsome residence along New London's North Main Street in 1905. Allen developed a reputation for charity by distributing free flour to needy New Londoners during the Great Depression. His home still stands. (Stanly County Museum.)

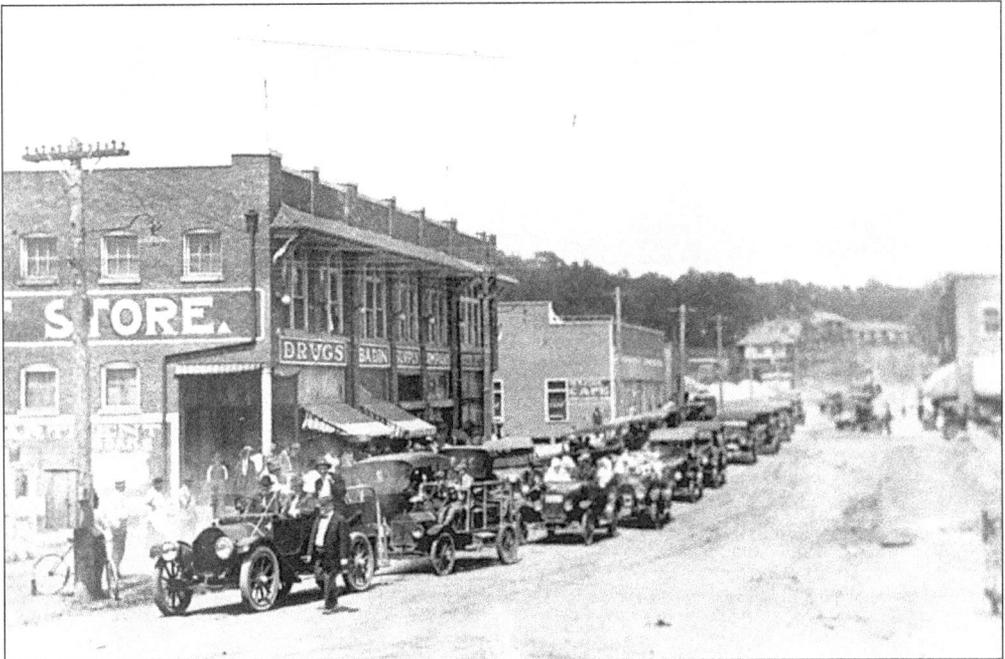

Passing traffic stirs up clouds of dust along Falls Road in 1920s Badin. Named for French industrialist Adrien Badin, the town was laid out in 1913 to accommodate French engineers and American laborers at work on the famed Yadkin hydroelectric dam. (Stanly County Museum.)

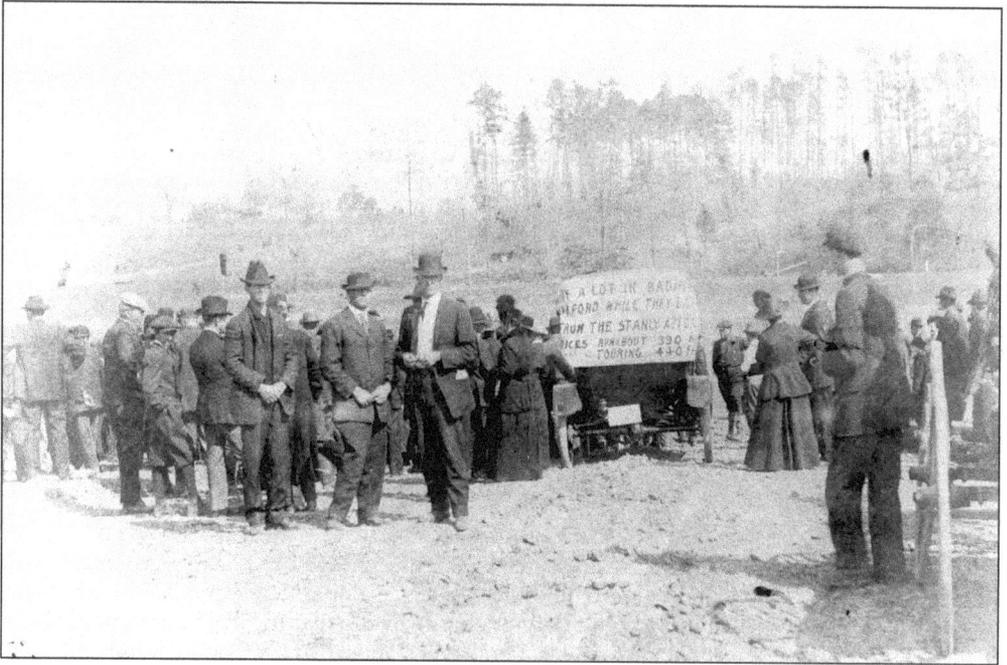

The prospect of undeveloped land for sale draws big crowds to Badin in this 1921 image. Land buyers were eligible to drive off in a new Ford at a discount. Though county residents appear ready to embrace the auto age, the county's roads still seem better suited to the horse-and-buggy. (Stanly County Museum.)

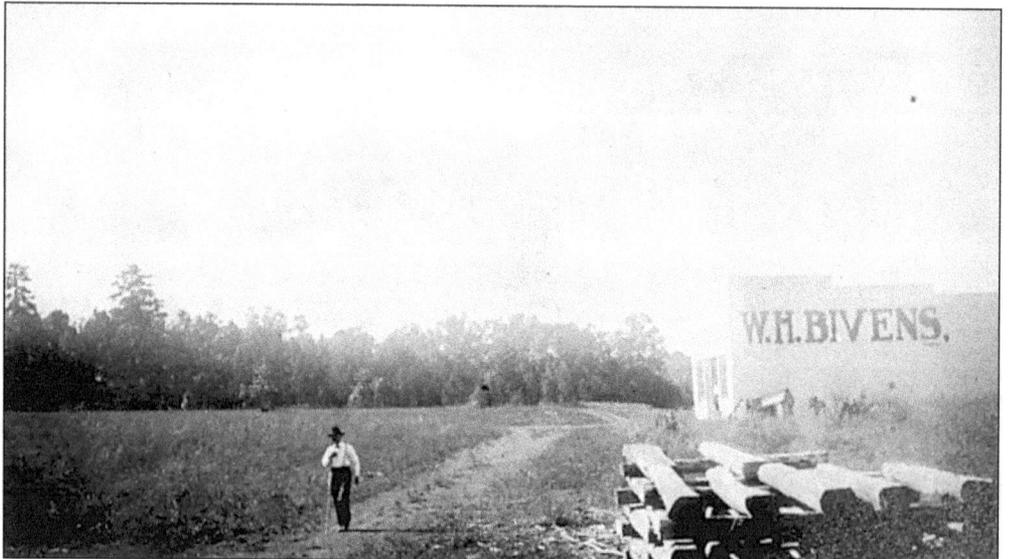

On a bright day in 1913, a lone pedestrian makes his way past W.H. Bivens's store near Aquadale in southern Stanly County. The community took its name from the recuperative springs that once flowed nearby. (Stanly County Museum.)

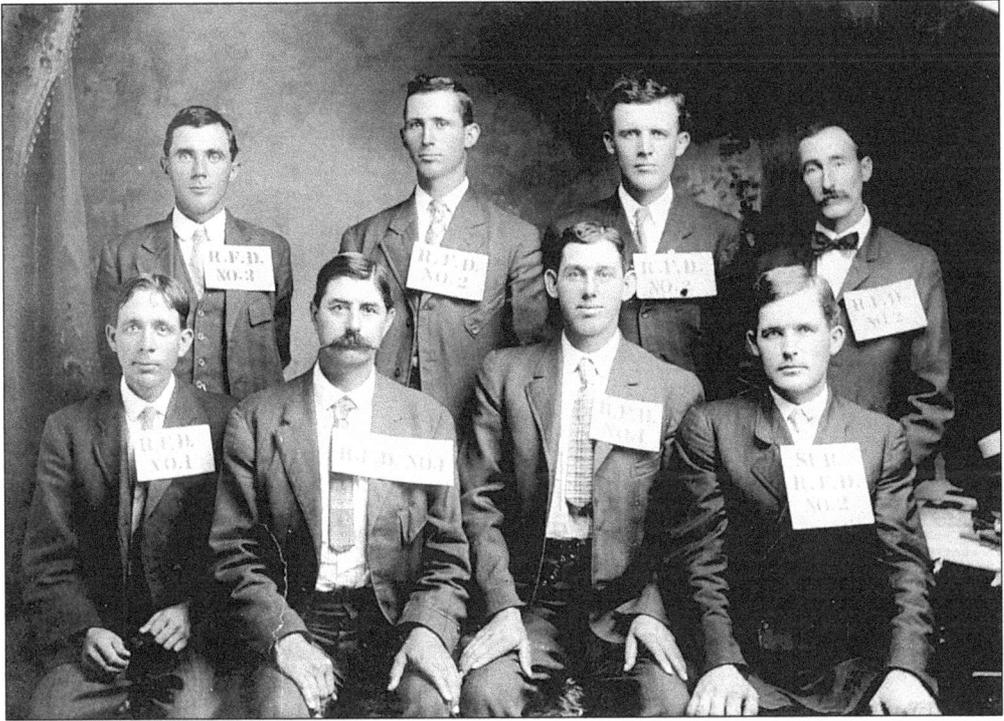

Routes proudly pinned to their lapels, Stanly County's rural mail carriers assemble for a group portrait in 1913. They are, from left to right, as follows: (seated) Ernest Ritchie, unidentified, George Pickler, and unidentified; (standing) unidentified, Garrett Pickler, unidentified, and Luke Ritchie. (Stanly County Museum.)

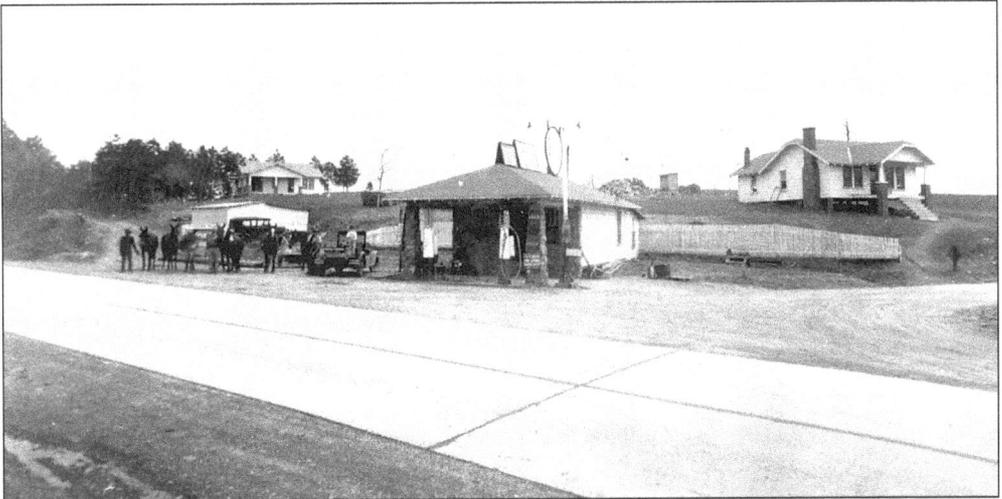

Country stores were once a common sight throughout rural Stanly County. Will Vicker's Esso station just off the Badin Road served local folks and travelers alike until 1964. (Stanly County Museum.)

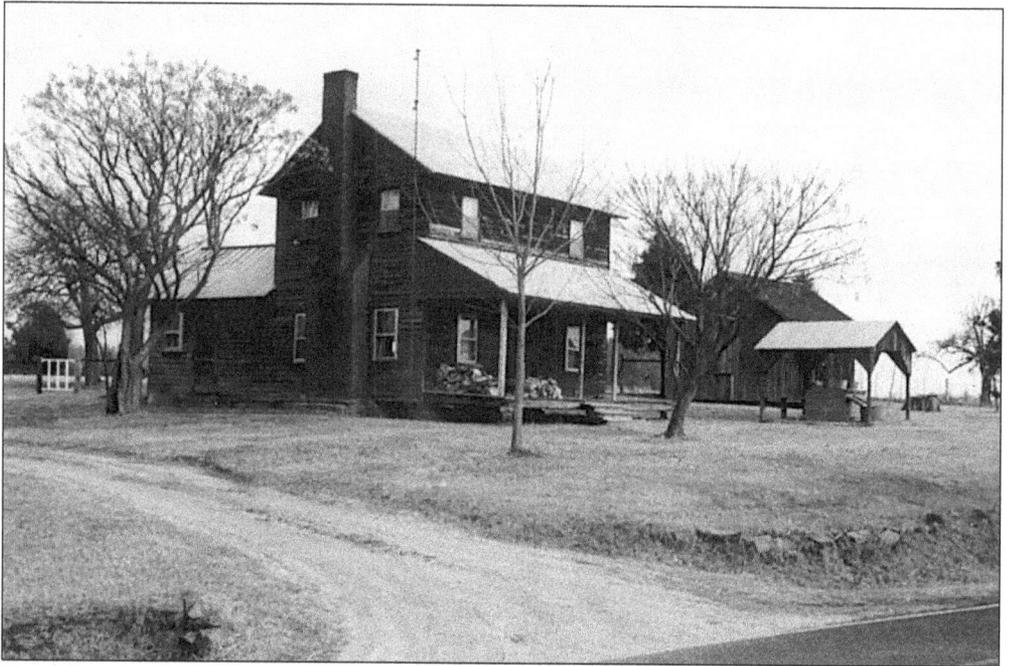

Symbol of a more self-sufficient age, the Brattain Farm near Locust is among the county's dwindling number of authentic nineteenth-century farmsteads. William Brattain and his neighbors cooperated to raise the home in 1892. (Stanly County Museum.)

A vanishing icon of the rural South, nineteenth-century log barns are all but extinct in an age of suburbs and supermarkets. This example, located near Ridgecrest on the farm of Donald E. Misenheimer, survives for the time being. (Stanly County Museum.)

Three

STANLY COUNTY
AT WAR

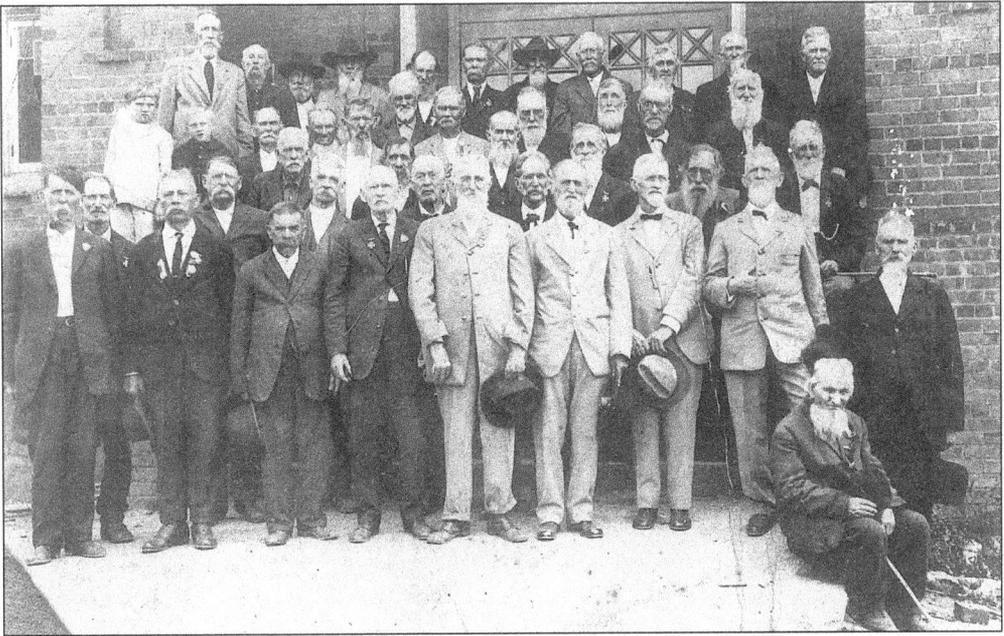

Lapels hung with medals, Stanly County's surviving Civil War veterans pose on the steps of Albemarle's Central School in this undated portrait. Although the county initially voted against secession, organizers eventually raised six companies of local men for the Confederate cause. (Stanly County Museum.)

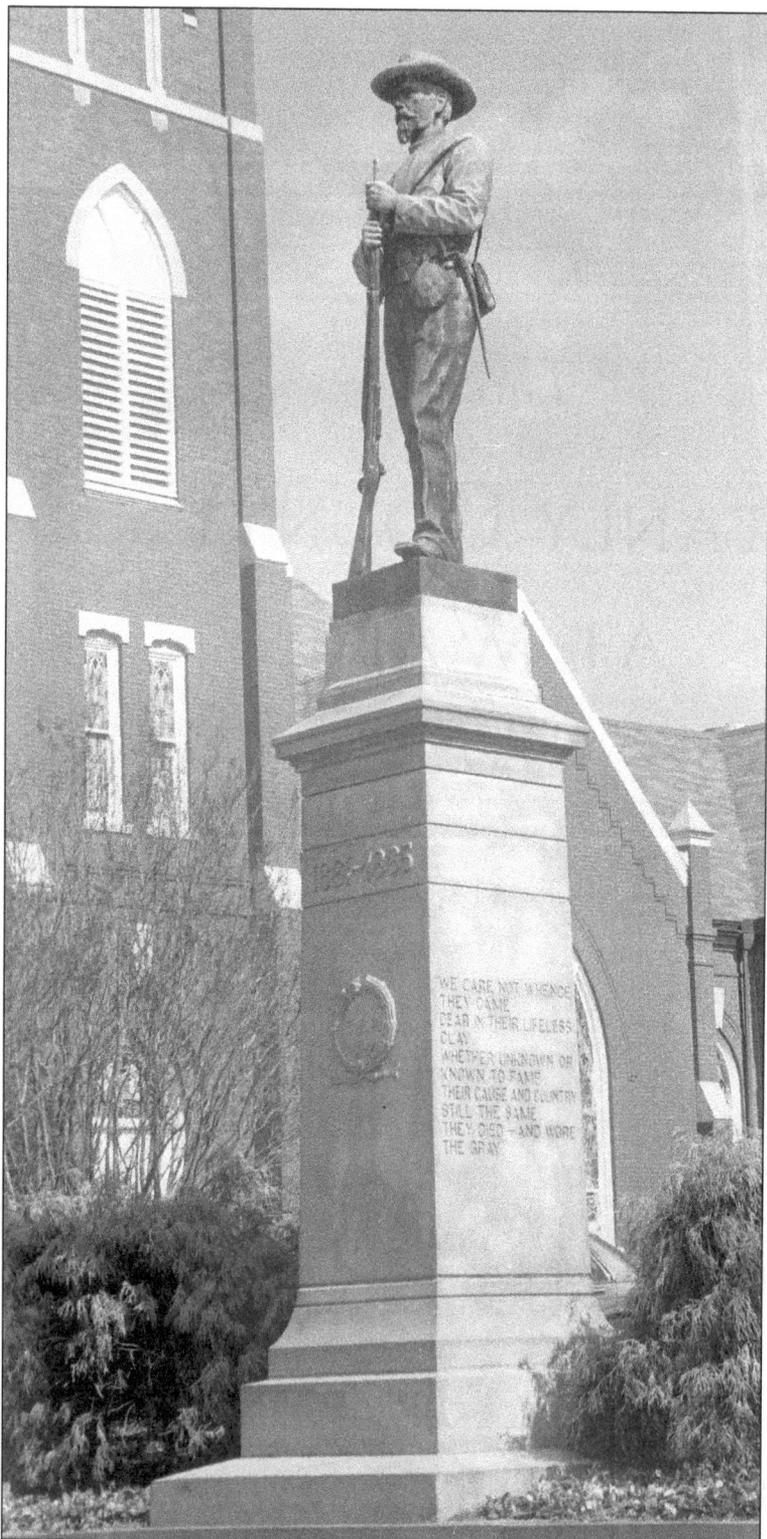

Local sponsors raised and dedicated this monument to the county's Confederate dead in 1925. A Stanly County man, Confederate Sergeant Ivy Ritchie, was said to be among the last to fall at Appomattox. (Stanly County Museum.)

Dr. Freeland McGruder practiced medicine in Albemarle before serving overseas in World War I. The county contributed over 1,700 men to the war effort. Twenty-two did not return. (Stanly County Museum.)

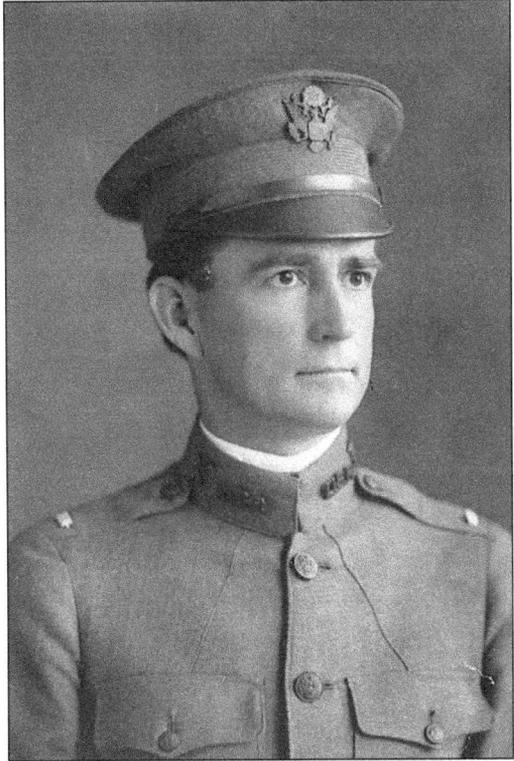

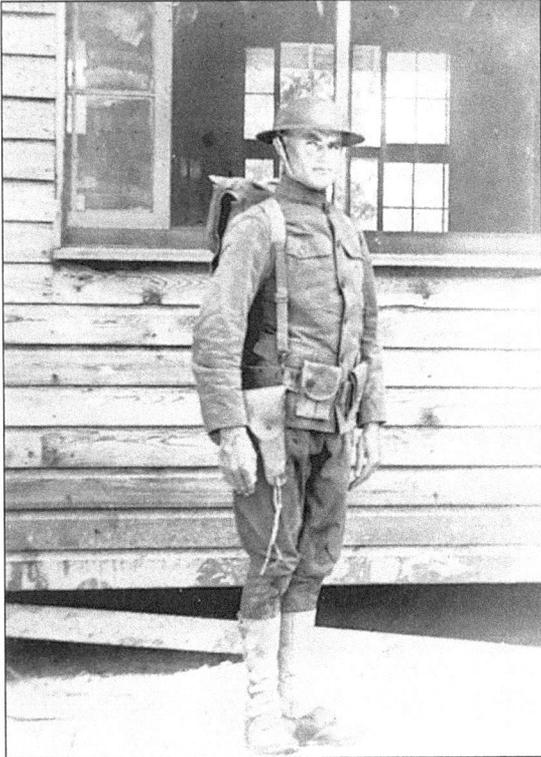

A barracks provides a fitting backdrop for this World War I–era postcard photo of Jason Springer. (Stanly County Museum.)

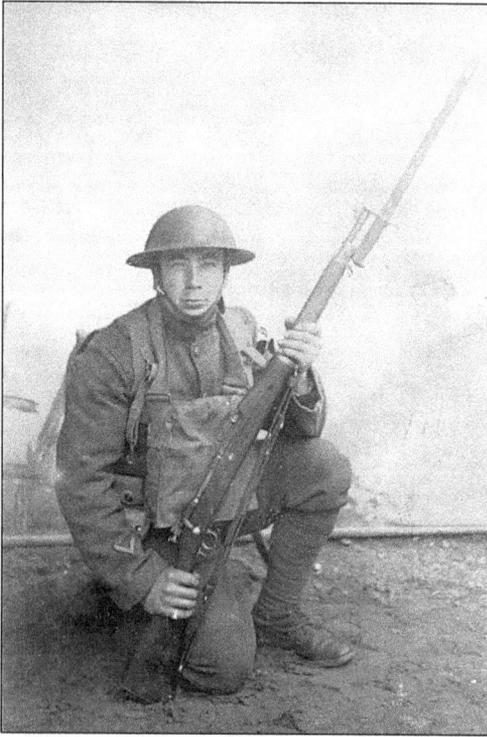

Rifle at the ready, U.S. Marine Samuel Raymond Boyce poses for a portrait to send home to Stanly County. Boyce's son later followed in his father's footsteps by serving as a Marine in World War II. (Stanly County Museum.)

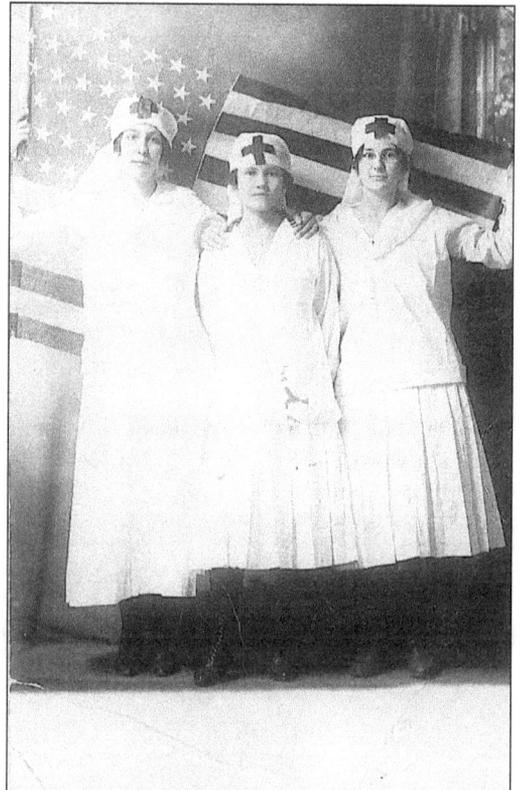

Stanly County's women also found ways to serve their county during World War I. Nurses Esther Kimball, Bertha Glover, and Daisy Arie pose before a patriotic background in this 1917 portrait. (Stanly County Museum.)

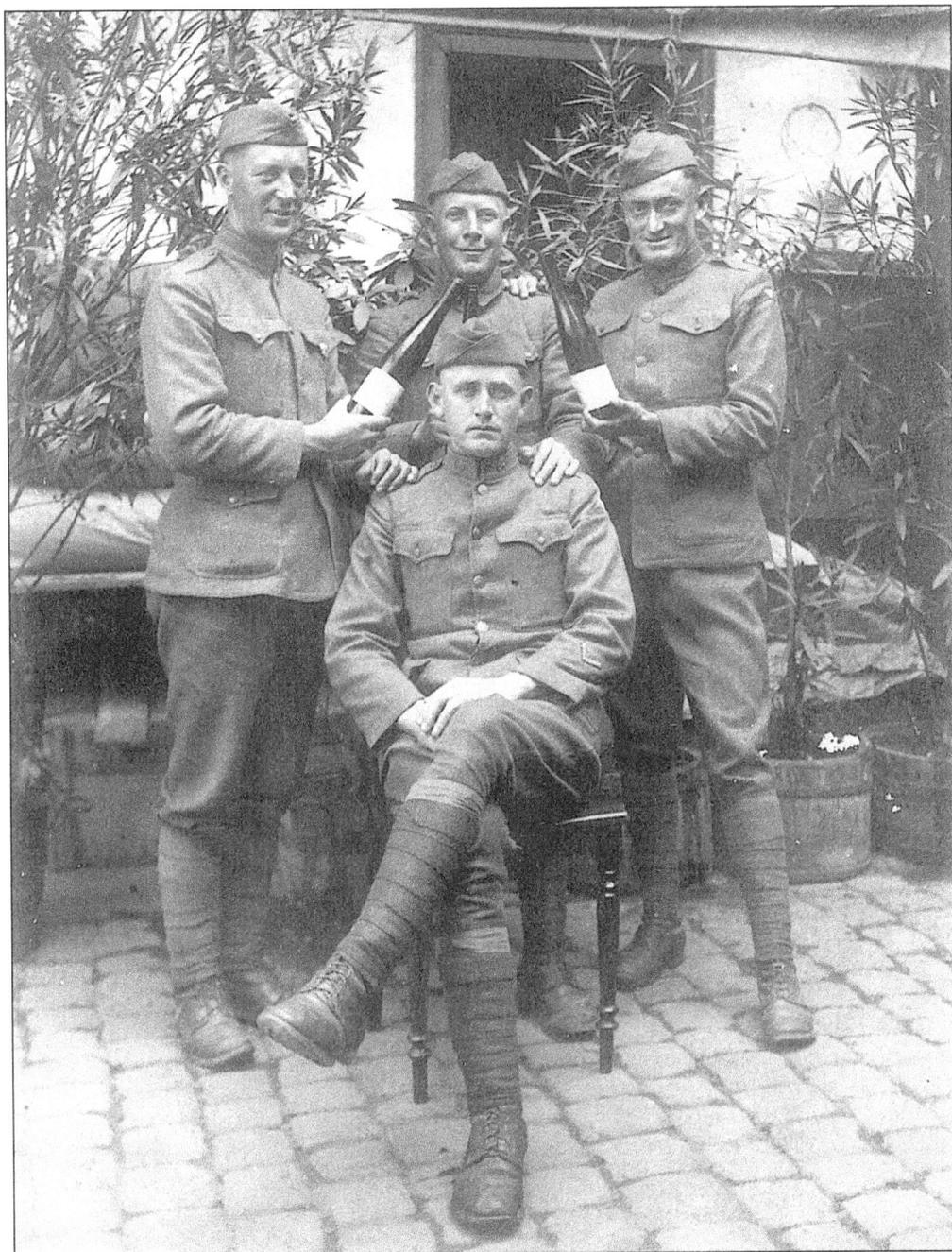

Norwood native David T. Singleton—seated at center—survived a World War I German gas attack to return home to Stanly County. On the home front, county citizens raised $11,000 for the war effort through a saving stamps campaign. (Stanly County Museum.)

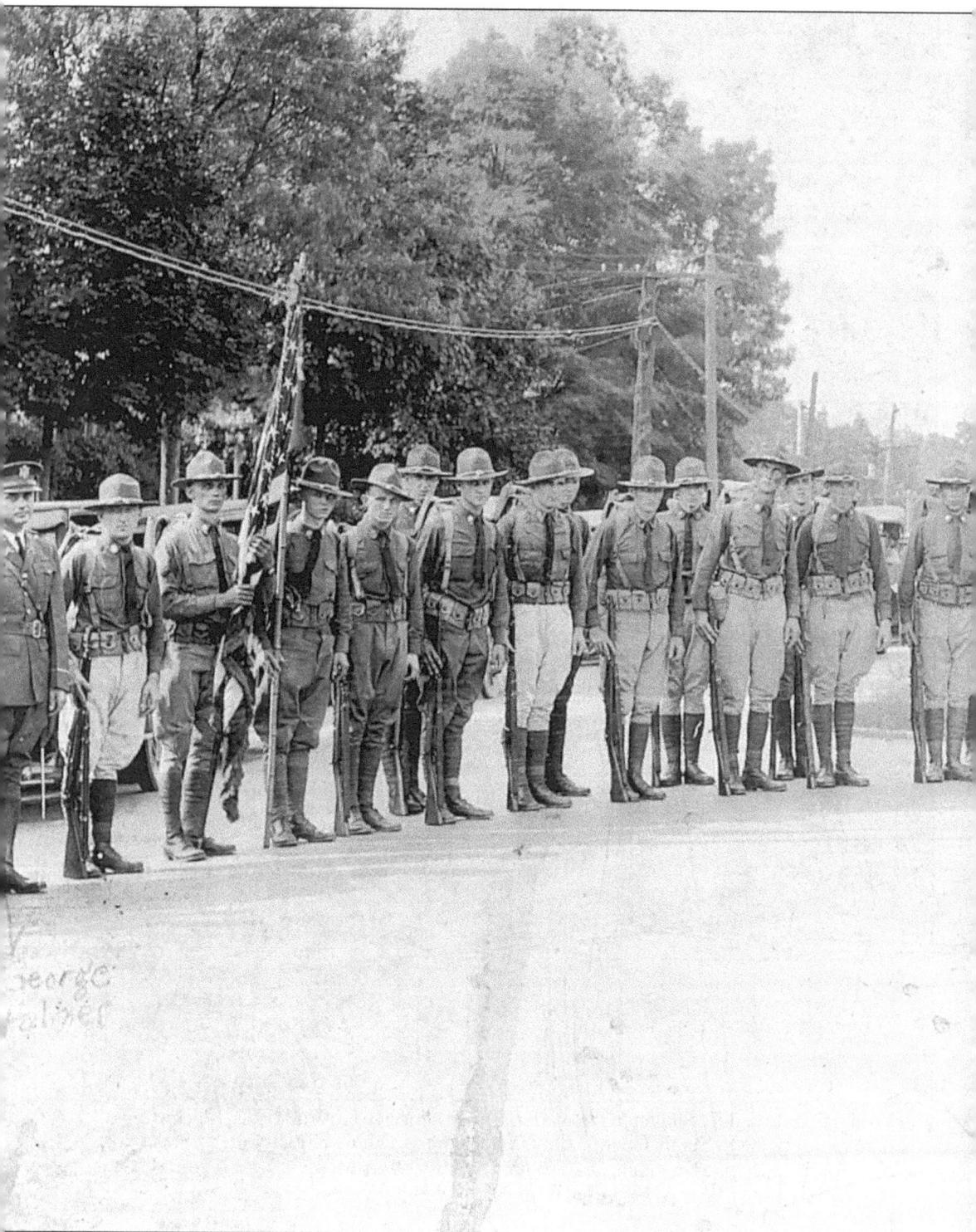

World War II is still nearly a decade away as Stanly County's National Guard unit assembles on Albemarle's First Street in this 1930 image. The Confederate Monument behind them would

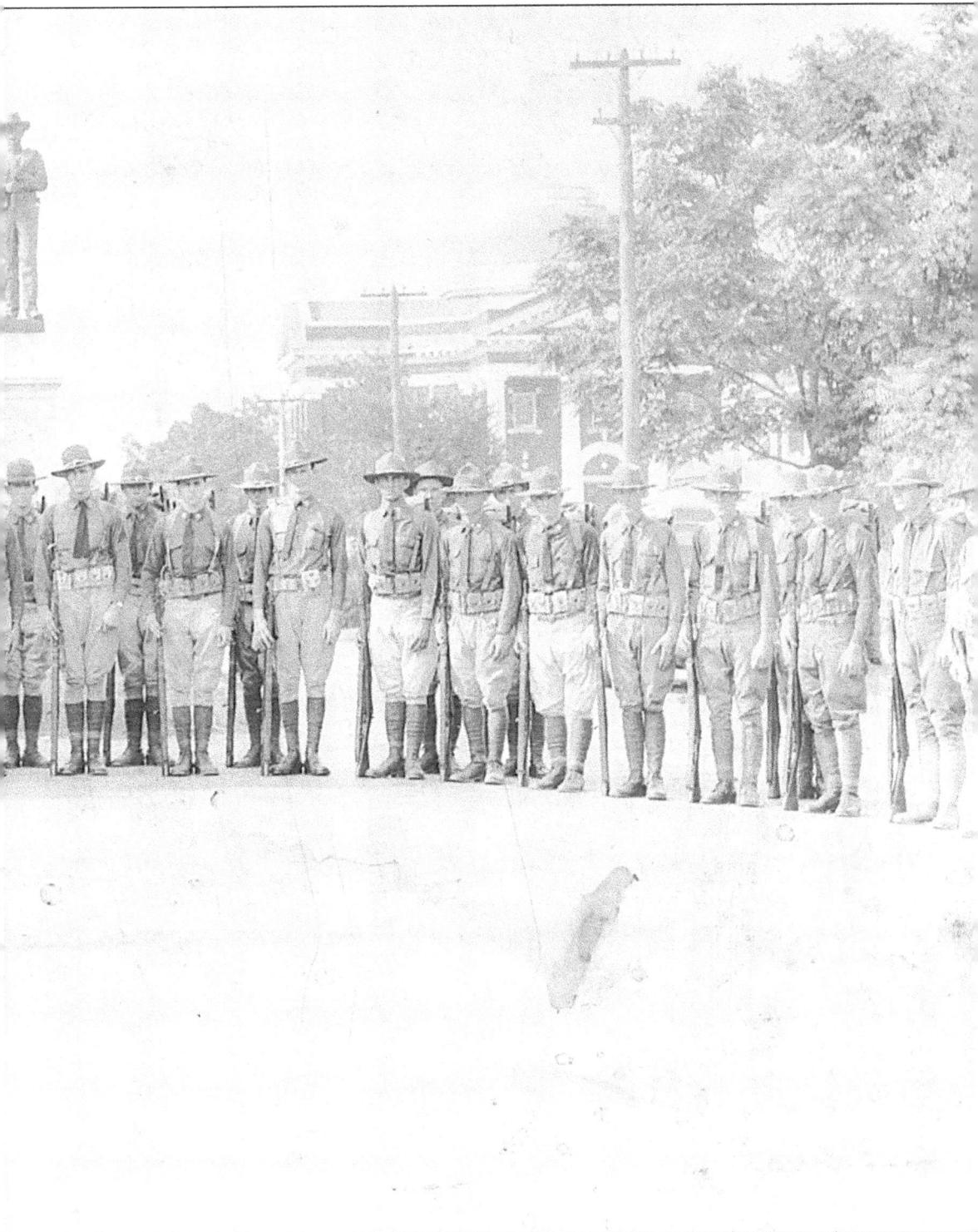

later be moved to Albemarle's Central School, and still later to its present position on Second Street. (Stanly County Museum.)

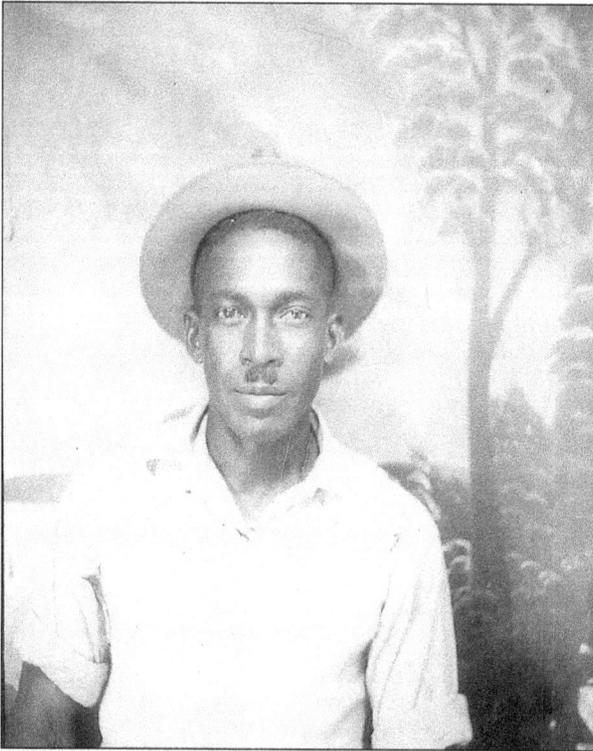

Holder of draft number 158, Norwood native Robert L. Lindsey was the first man tapped for service in World War II–era Stanly County. Due to a surplus of willing volunteers, Lindsey was released from his duty to serve. (Stanly County Museum.)

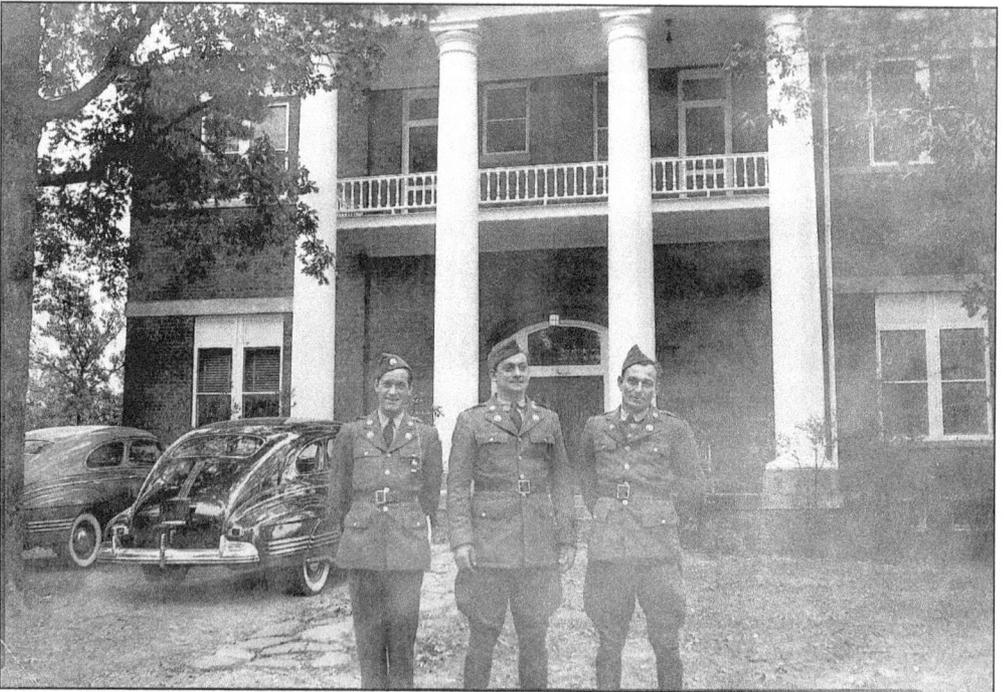

Three unidentified soldiers stand at ease in front of Albemarle's Normal & Industrial Institute. With 3,500 Stanly County men and women in uniform during World War II, visiting soldiers were a common wartime sight. (Stanly County Museum.)

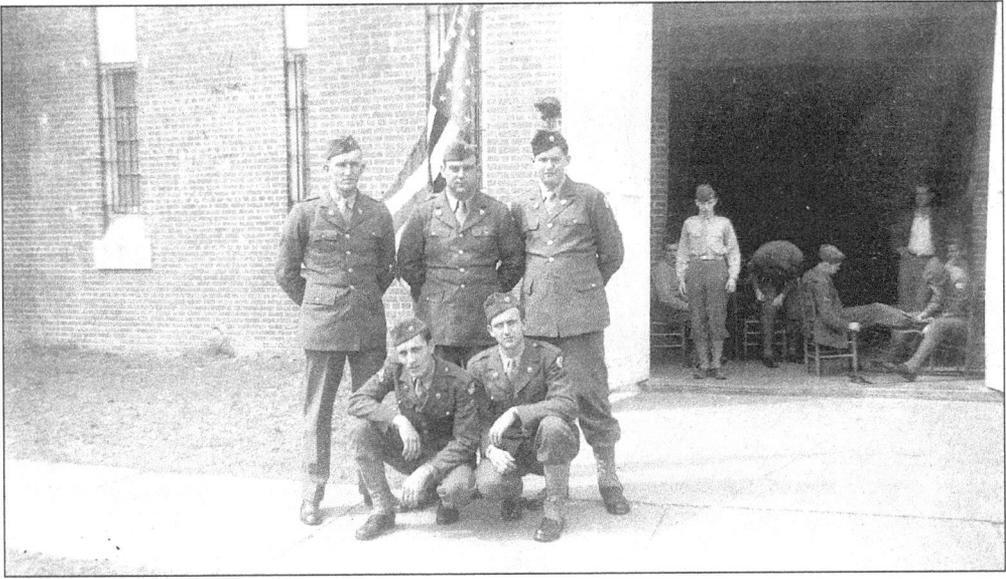

Behind these soldiers is Albemarle's National Guard Armory, constructed by the Works Progress Administration (WPA) in 1937. The fortress-like building, since converted to a senior citizens' center, still stands on North Third Street. (Stanly County Museum.)

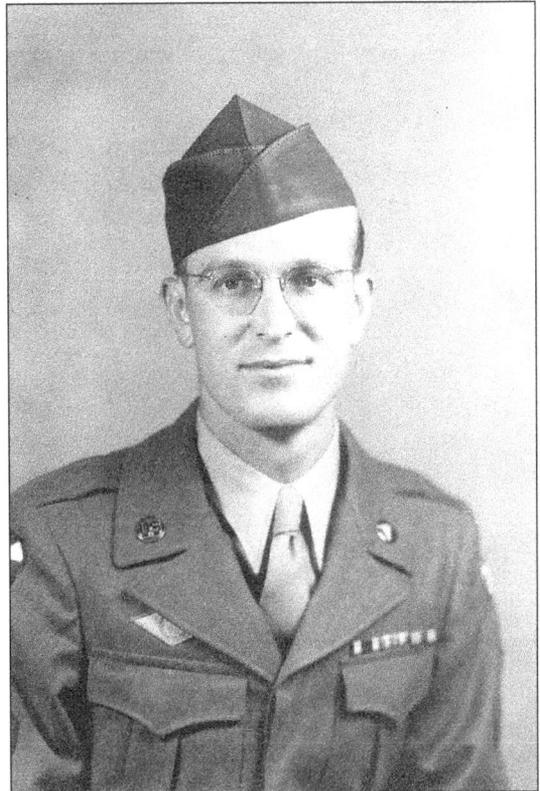

Stanly County native Boyce Lee Griffin was awarded the Bronze Star for meritorious service in the Pacific Theatre of Operations. After the war, Griffin remained in Japan on occupation duty. (Stanly County Museum.)

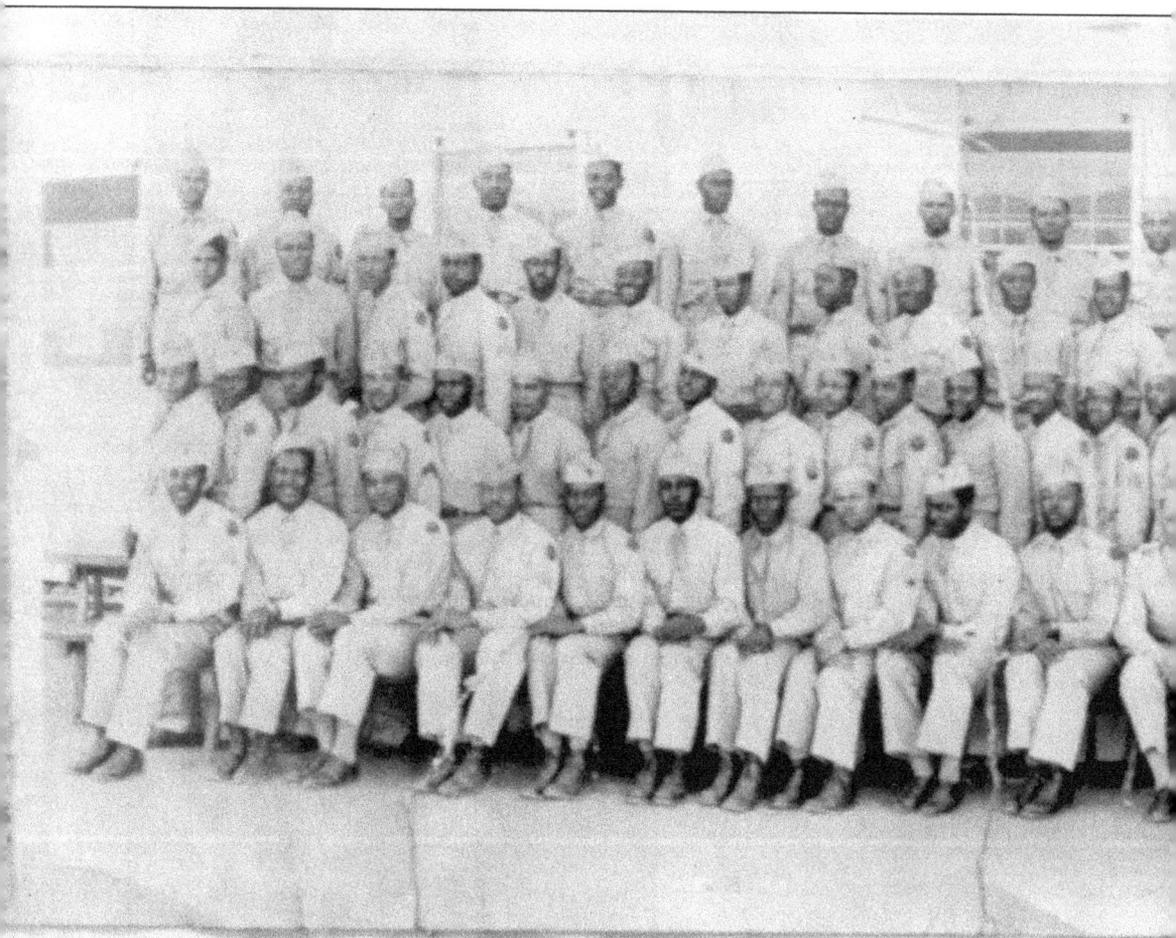

Segregation excluded African Americans from white units but did not stop them from serving their country during World War II. Here, men of the 827th Tank Destroyer Battalion & Field Artillery pose at Fort Hood, Texas, in 1943. Among their ranks is Stanly County native

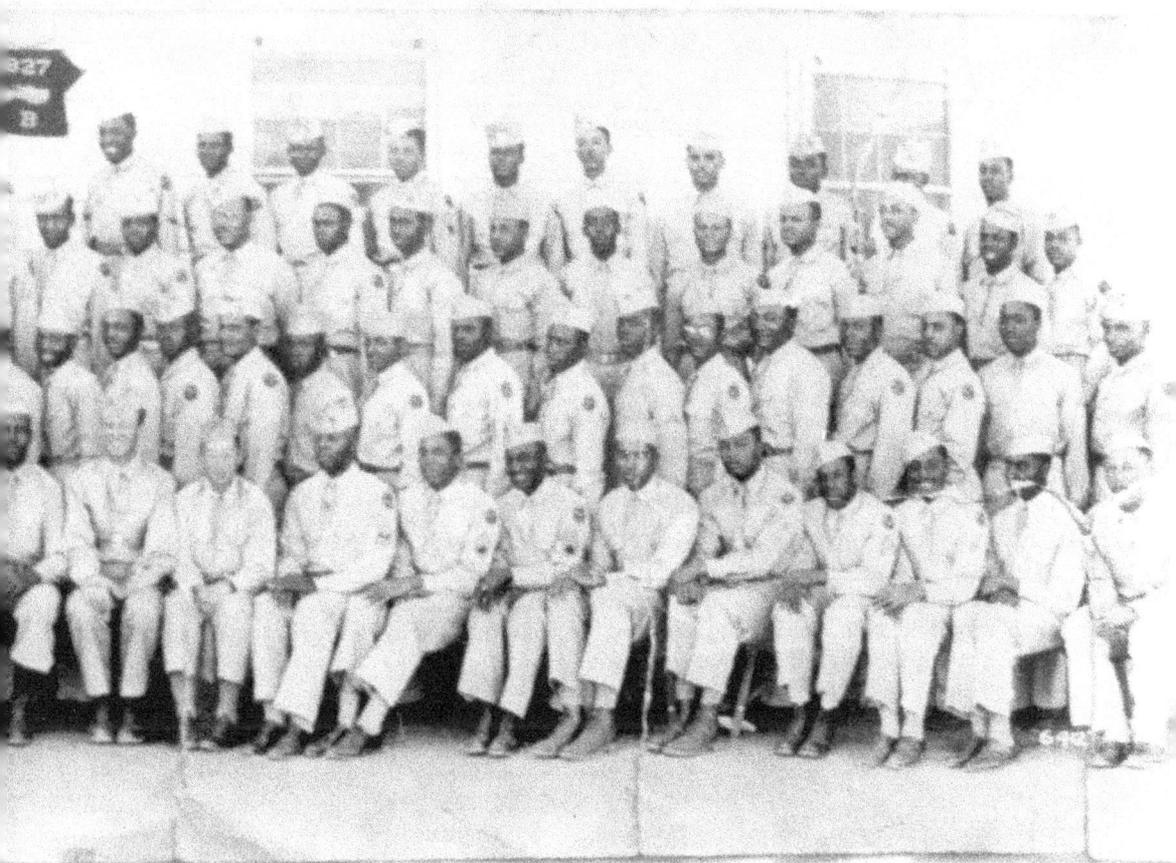

Sergeant James Kendall. Born in Porter, Kendall served as an instructor and later saw combat in the European Theatre of Operations. Sergeant Kendall stands on the second row back at far right. (James Kendall.)

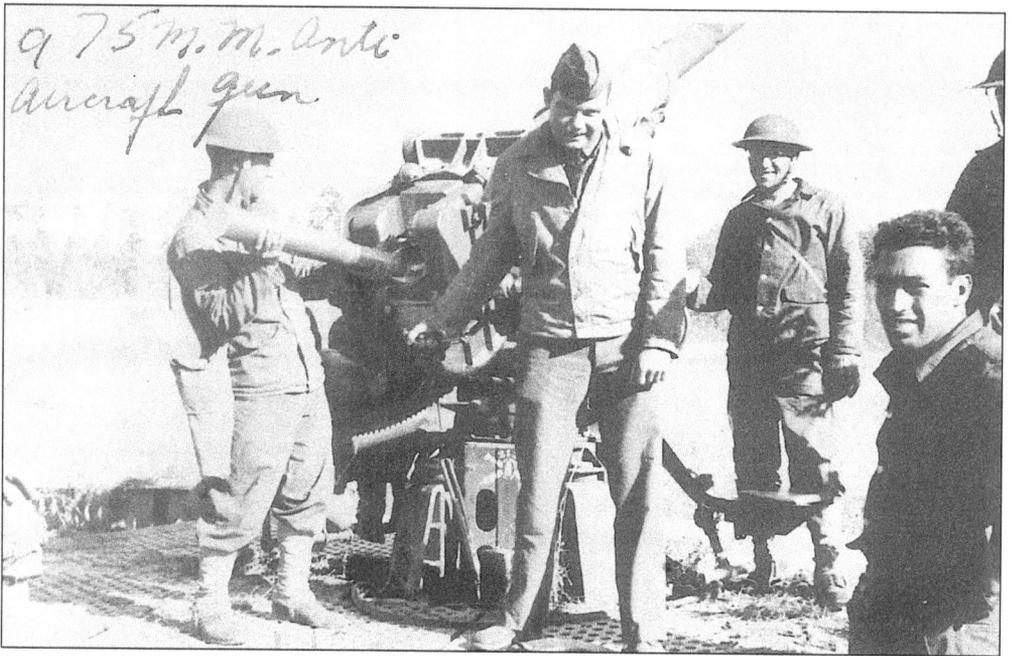

a 75 m.m. Anti Aircraft gun

Stanly County boomed with military activity even before Pearl Harbor. Here a gun crew readies their 75mm field piece for action near the Pee Dee River during army maneuvers in the fall of 1941. (Stanly County Museum.)

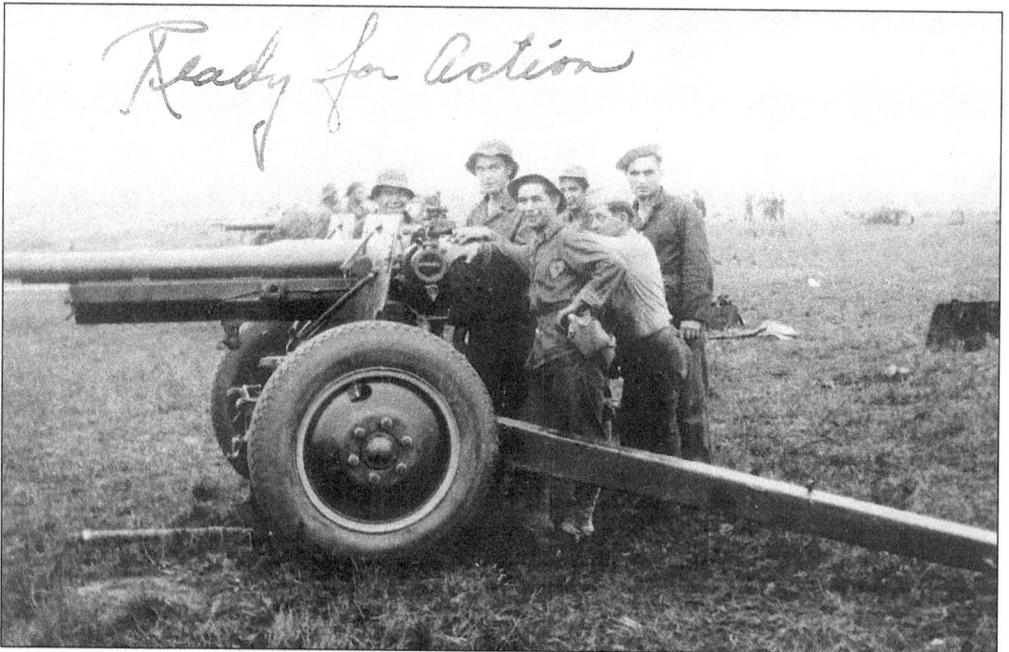

Ready for Action

A farmer's field becomes a makeshift artillery range for this 75mm cannon and its crew during the 1941 exercises. Pre-war maneuvers saw more than 100,000 soldiers pass through Stanly County. (Stanly County Museum.)

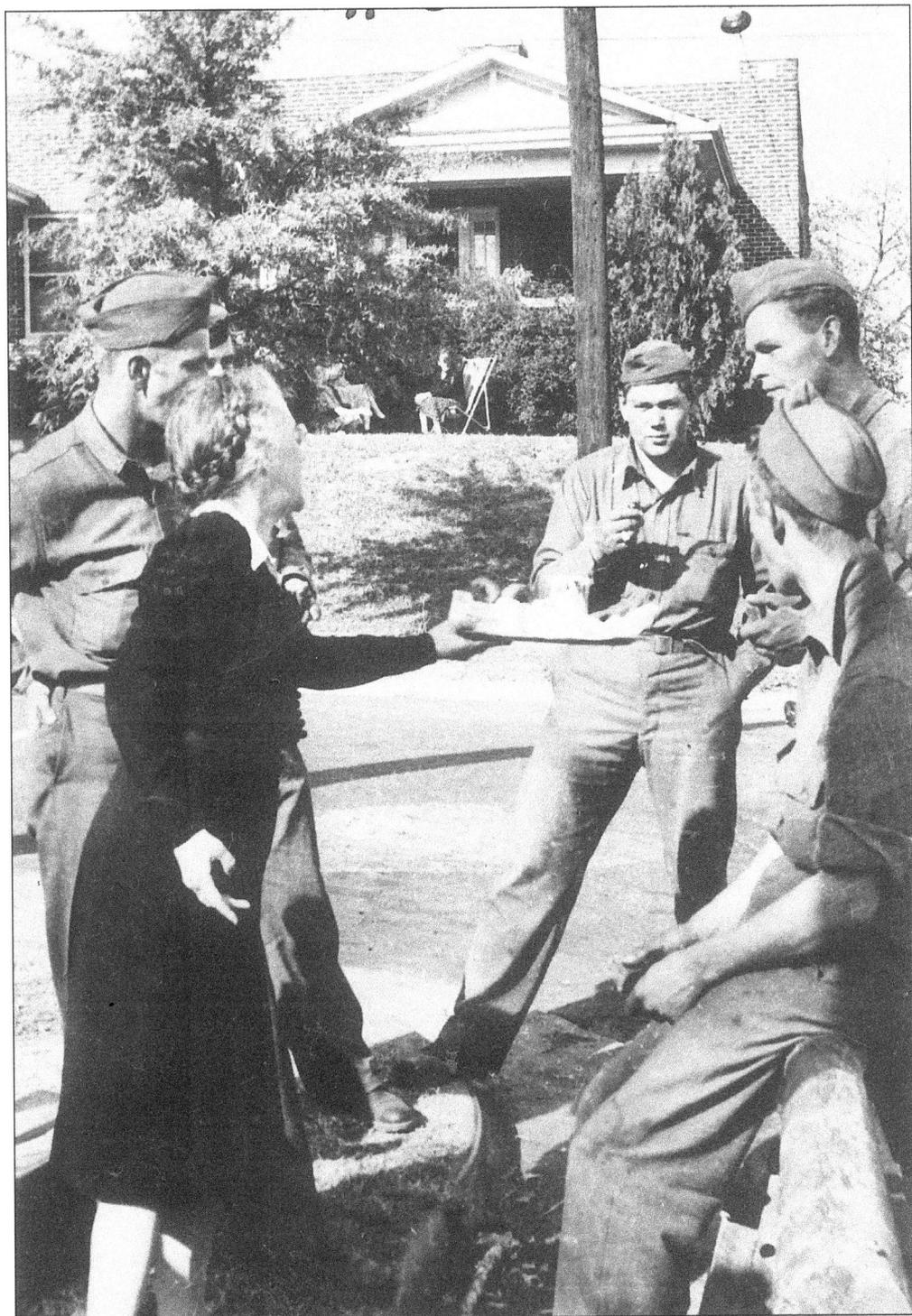

Soldiers passing through Albemarle enjoy a handout from local resident Mary Ellen Patterson. Also pictured are Privates Pritchard, Eldred, Ptacek, and Sergeant Cox. (Stanly County Museum.)

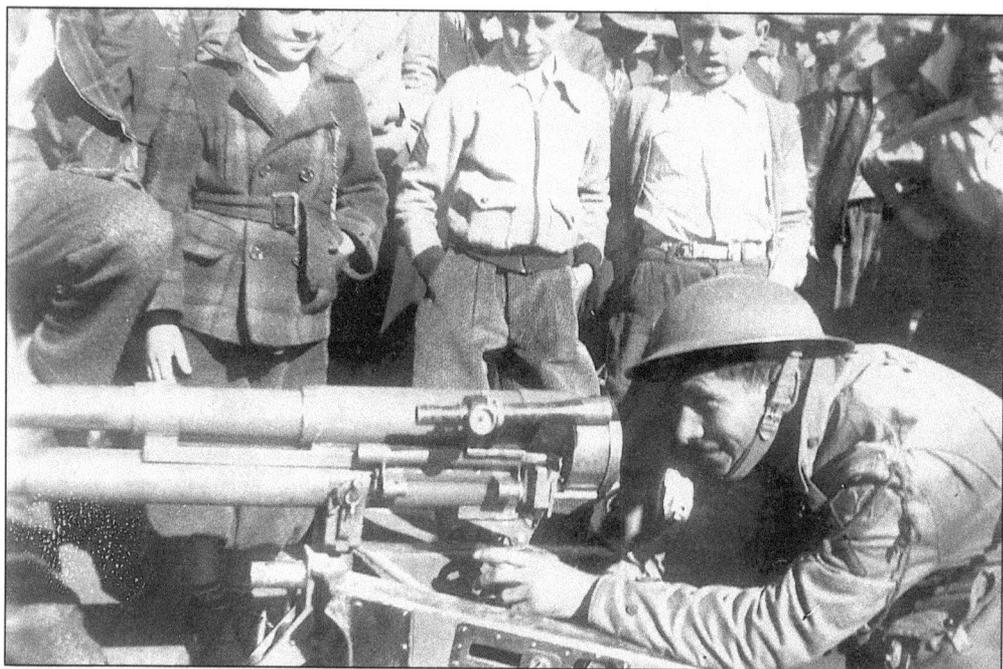

A soldier draws envious looks from a group of local boys in this 1941 scene. (Stanly County Museum.)

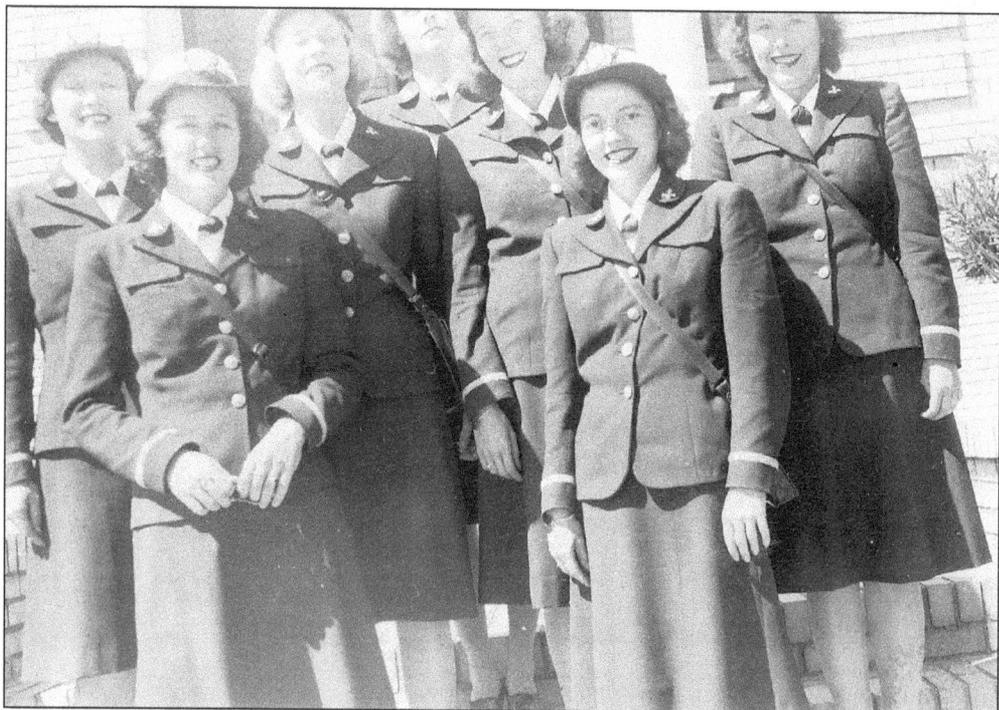

Stanly County women found new roles and new opportunities in wartime America. Patricia Ross of Albemarle, seen here second from right, joined the U.S. Navy as part of the WAVES program. (Stanly County Museum.)

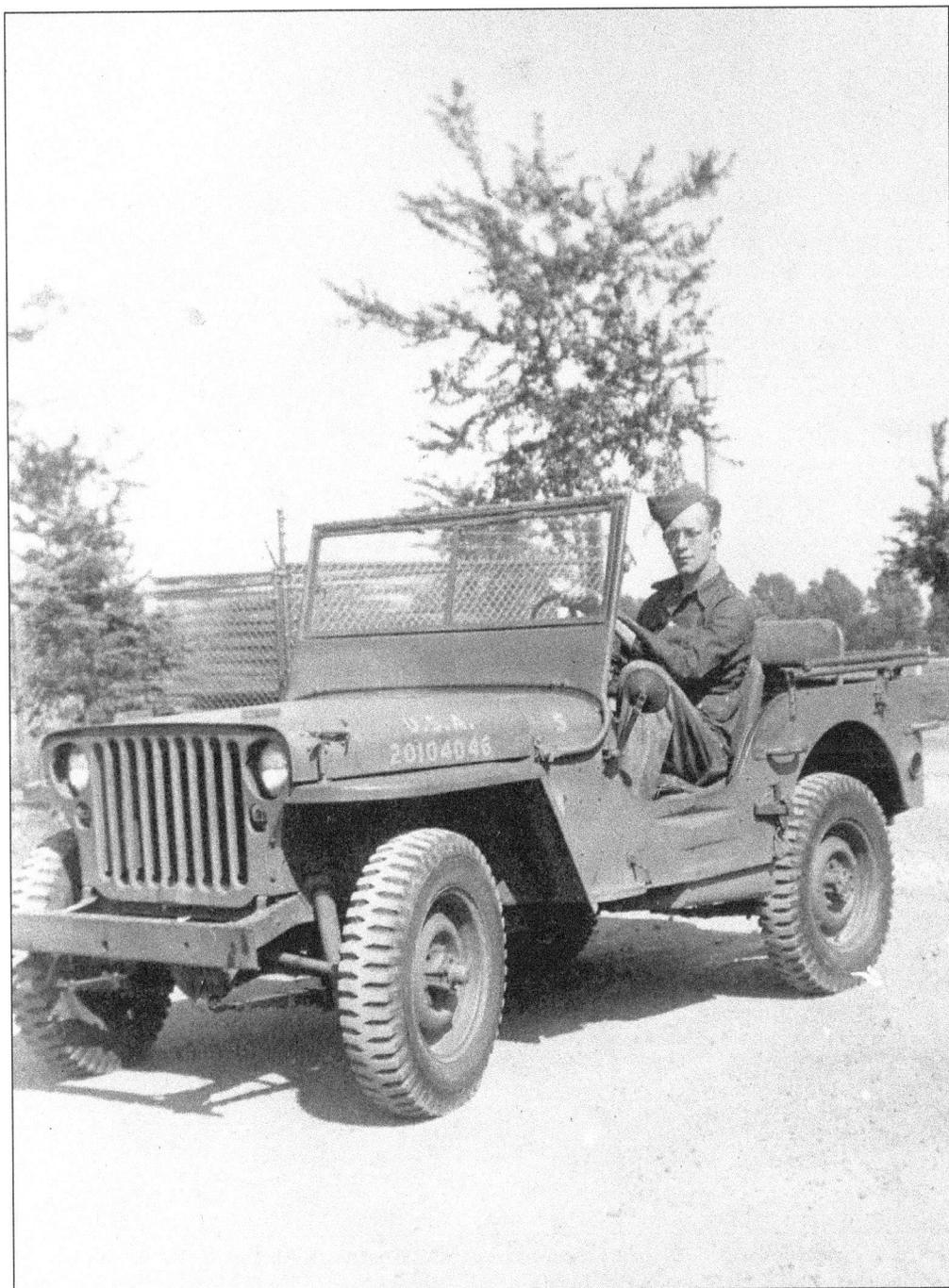

Soldier Irl R. Palmer poses behind the wheel of a well-known piece of World War II equipment during wartime maneuvers through Stanly County. (Stanly County Museum.)

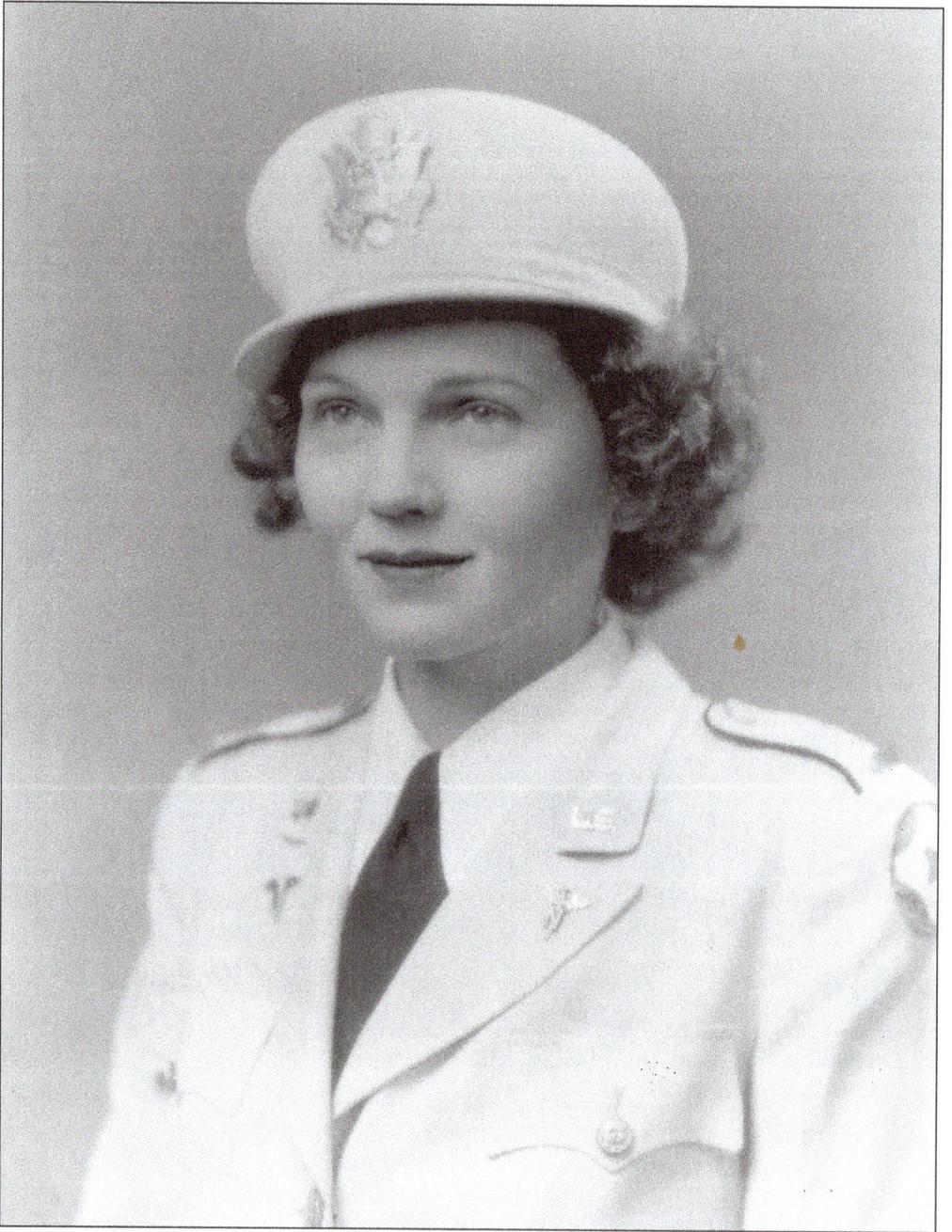

For over a decade, the U.S. Army counted Richfield native Kathleen F. Neely among its distinguished ranks. By the time of her honorable discharge in 1953, Neely had earned the respect of her commanding officers and the rank of captain. Her military records and uniforms were donated to the Stanly County Museum in 1986. (Stanly County Museum.)

Four

FORGING AN INDUSTRIAL REVOLUTION

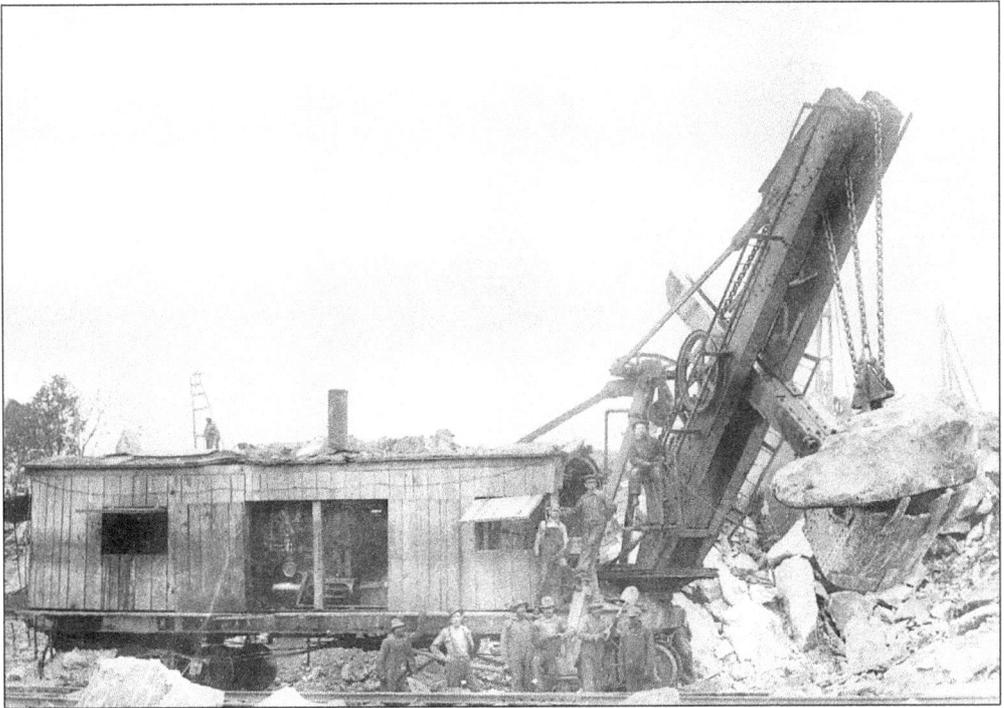

The industrial age shaped new ways of life in early-twentieth-century Stanly County. Men accustomed to the small scale of farm life found themselves dwarfed by mechanical monsters like this 100-ton steam shovel, seen here at work on the Narrows Dam about 1916. (Stanly County Museum.)

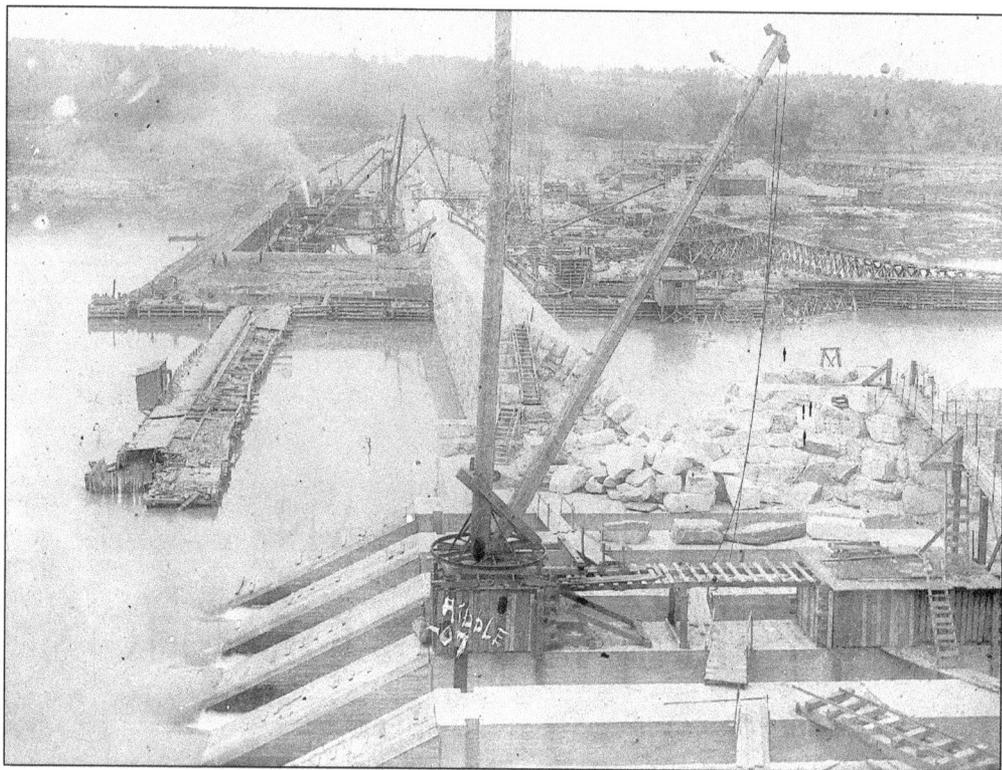

Steam derricks are hard at work on the first attempt to dam the Yadkin River in this turn-of-the-century scene. Wealthy financier George I. Whitney supplied the capital for the abortive works project that bore his name. By 1910, Whitney's company was broke. (Stanly County Museum.)

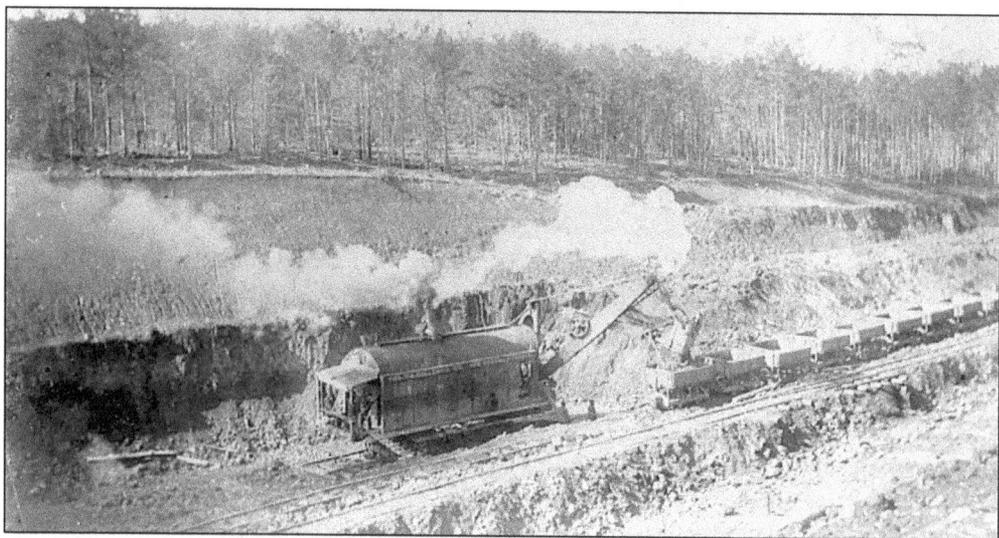

Blowing off clouds of steam, Shovel No. 9 burrows its way through the Stanly County countryside near the Whitney site in this early-twentieth-century image. (Stanly County Museum.)

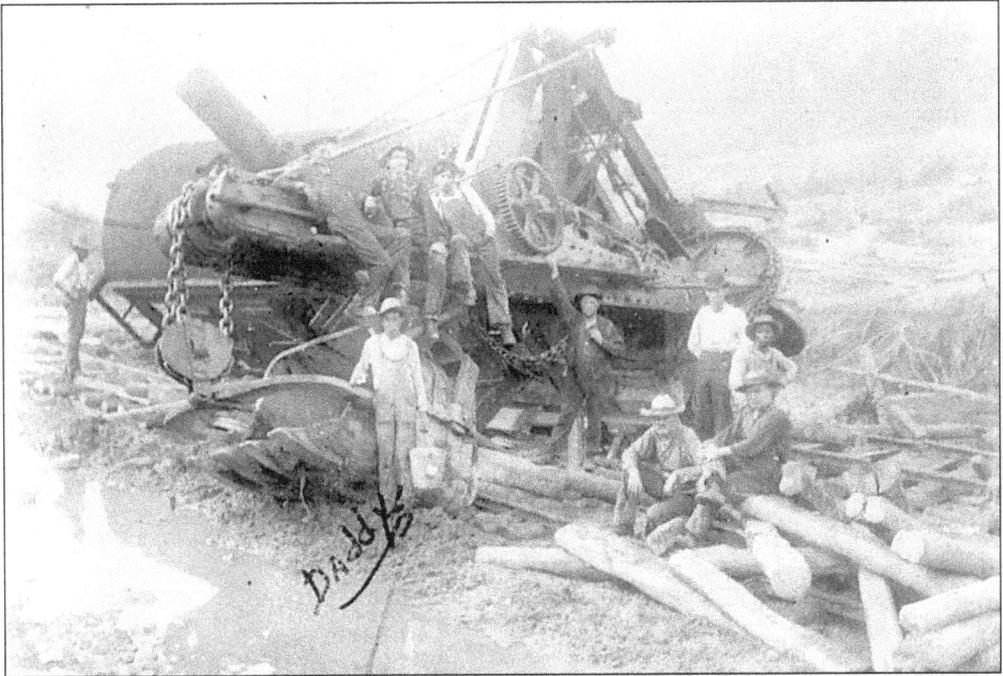

Testament to the hazards of an industrial age, a giant steam shovel lies toppled at the Whitney site following a disastrous flood. (Stanly County Museum.)

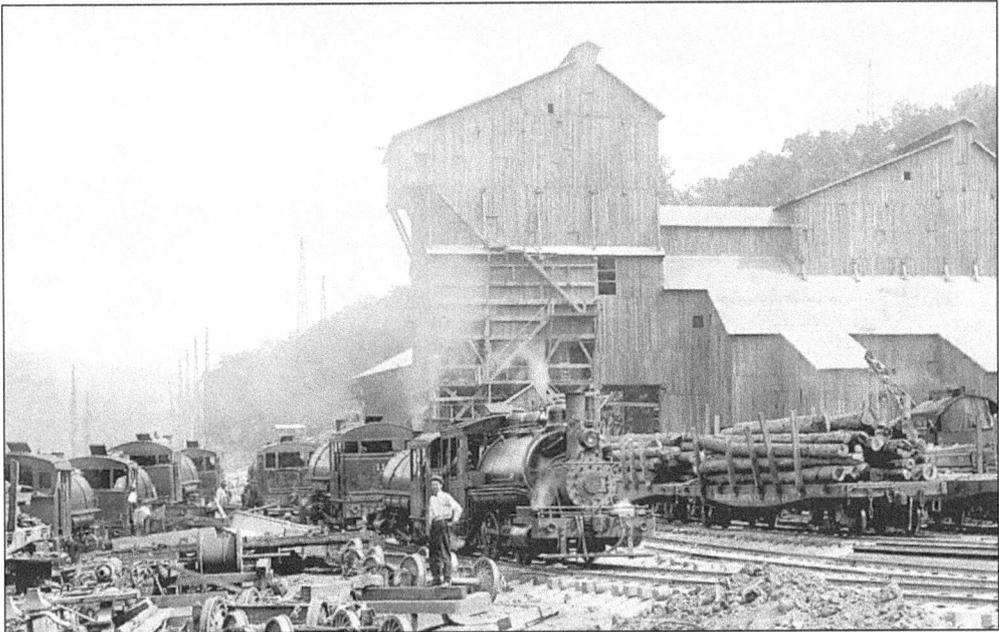

Brute force made subsequent attempts to dam the Yadkin more successful. Here, steam locomotives and rolling stock belonging to the Hardaway Construction Company crowd a massive staging yard near the works. (Stanly County Museum.)

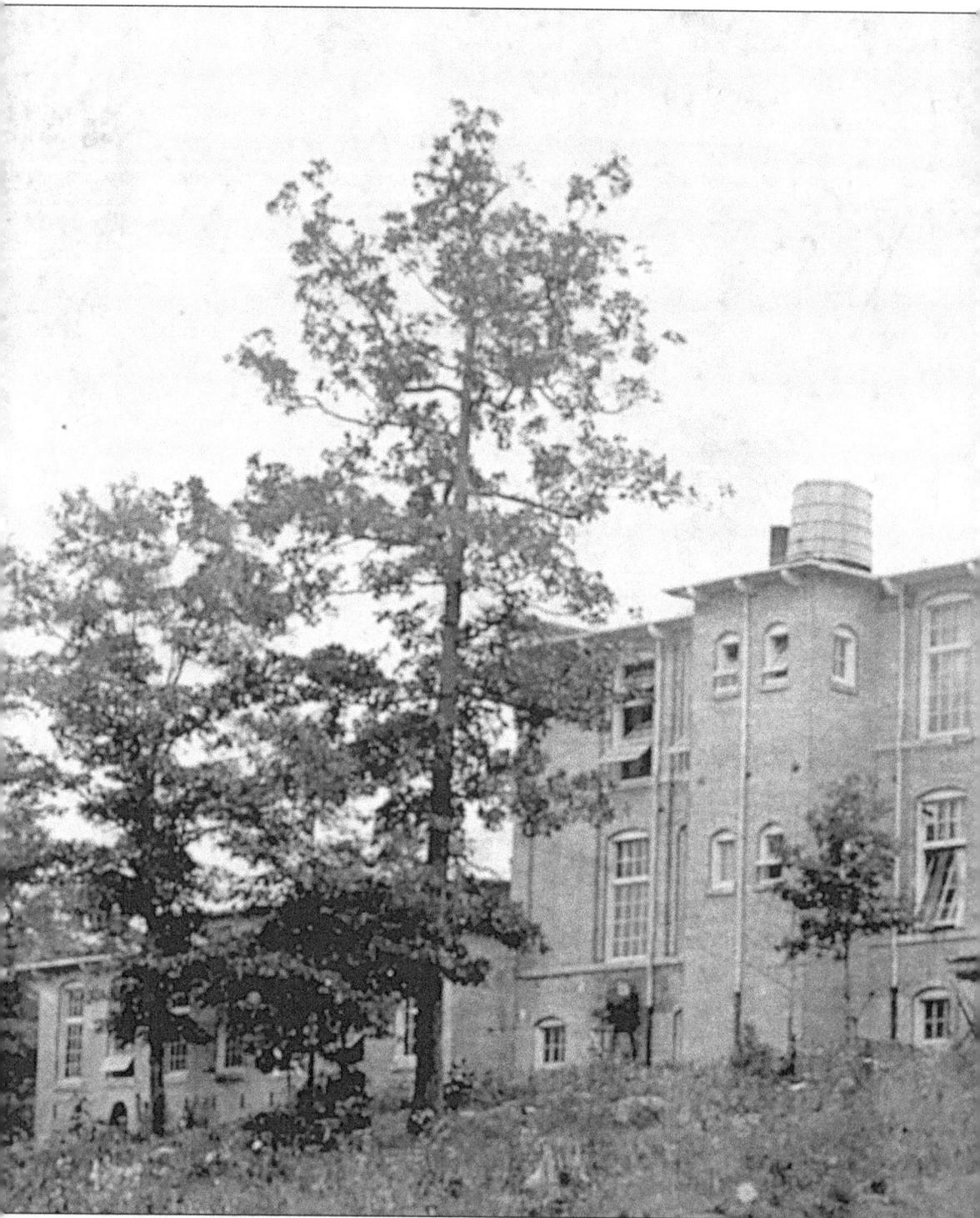

Named for the wife of its founder Arthur Patterson, Albemarle's Lillian Textile Mill rises from a hillside off Main Street in this portrait, c. 1910. As northern labor costs climbed at the turn of the nineteenth century, mill owners turned southwards to find an inexpensive and able

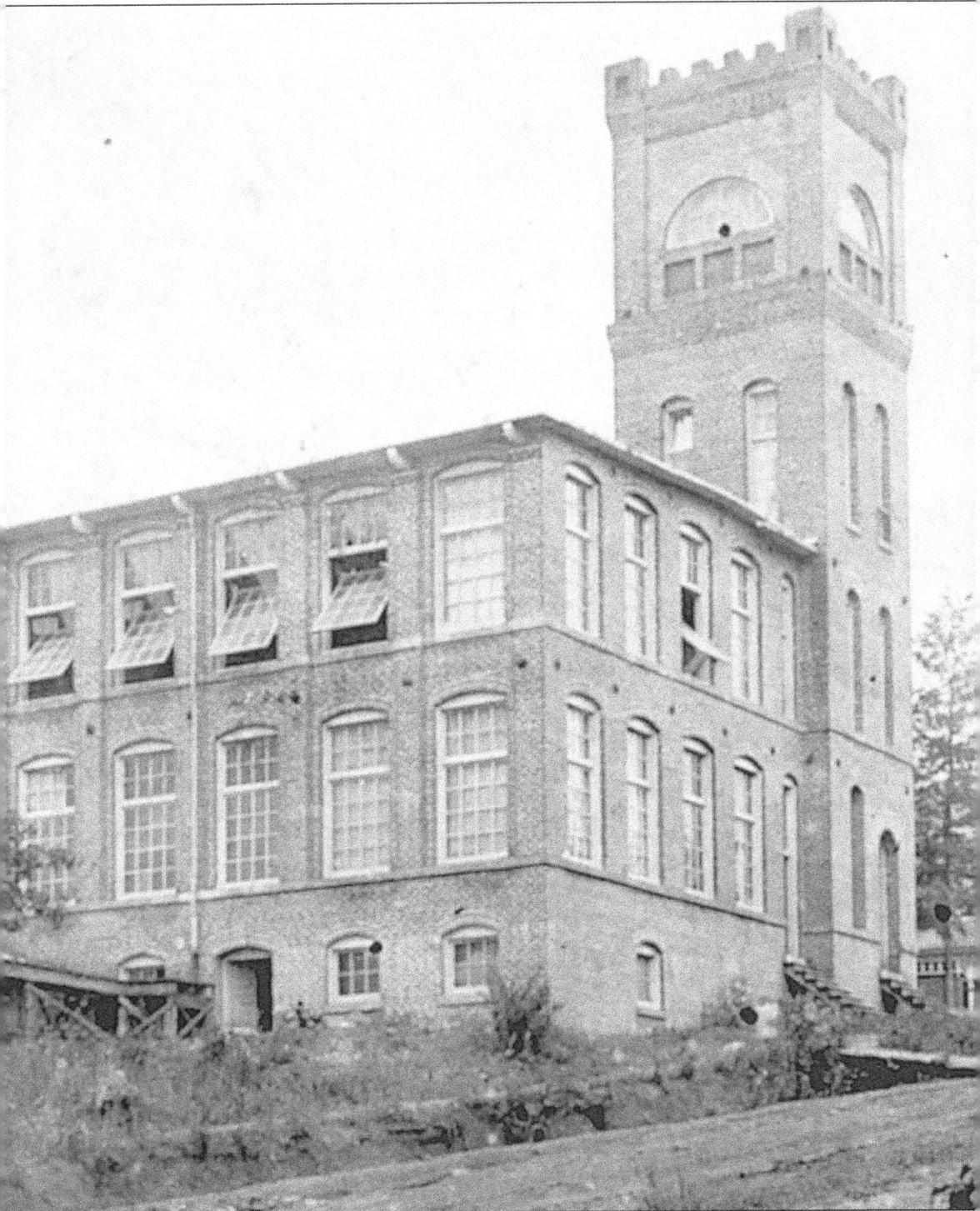

workforce. Men and women across Stanly County responded in earnest, flocking to mill jobs. Though its days as a working mill are over, the Lillian still stands. (Stanly County Museum.)

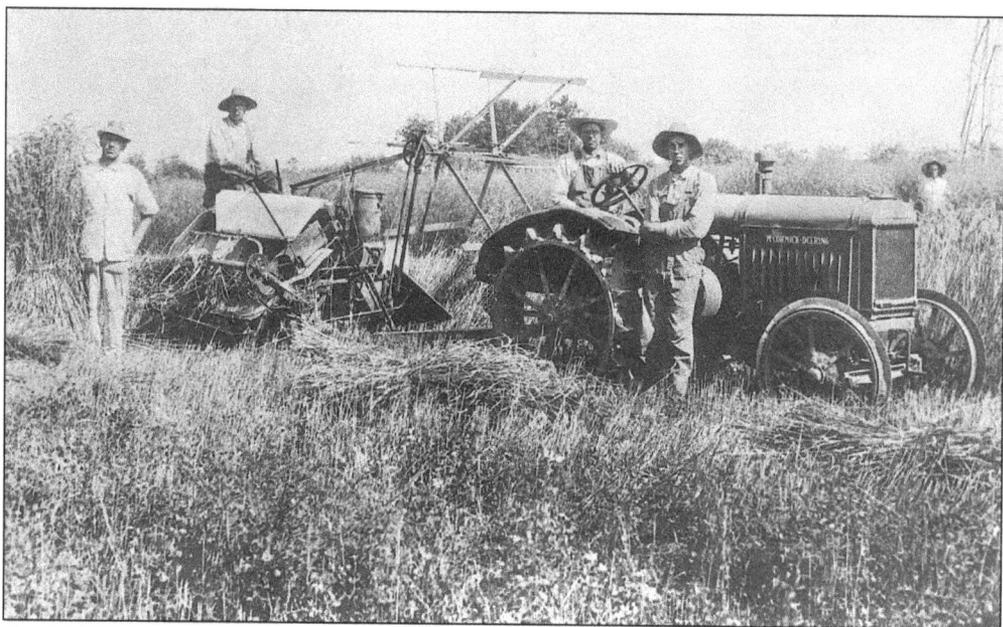

An early McCormick-Deering tractor lends a hand to farmers working off the Badin Road in 1928. Mechanization helped boost the county's agricultural output in the first decades of the twentieth century. (Stanly County Museum.)

On a clear day in 1914, three Stanly County farmers arrive in LaCrosse, Kansas, to take delivery of a giant Case harvester. A Mr. Killis sits on top of the steam tractor at right; Mr. Byrd sits on the running board. Joe Almond stands third from right. (Stanly County Museum.)

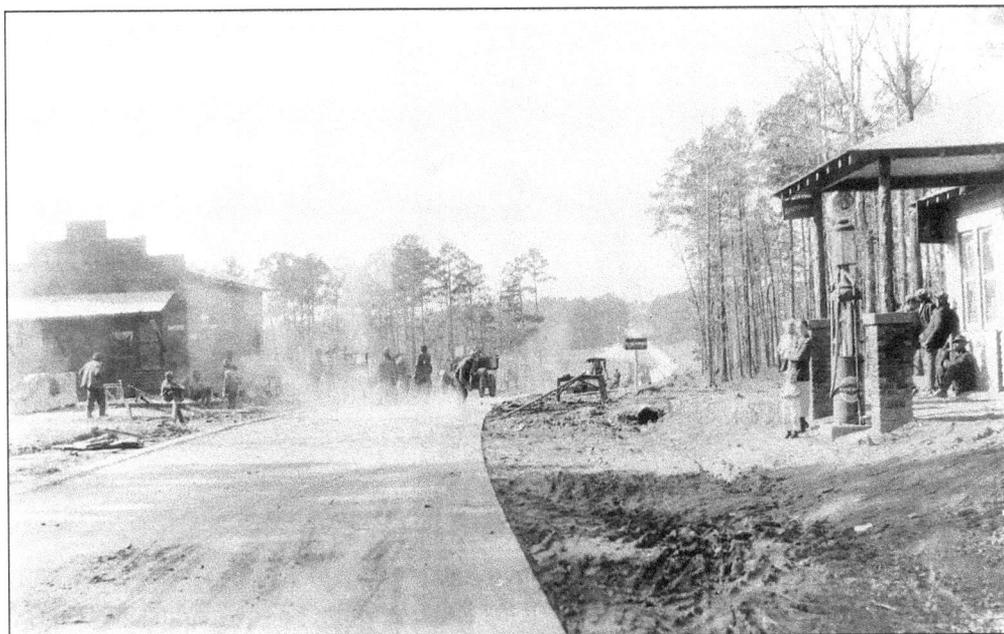

Literally paving the way for the automobile age, a highway crew lays down N.C. 24–27 at Red Cross in this 1925 image. Dan Hinson's filling station stands at right. (Stanly County Museum.)

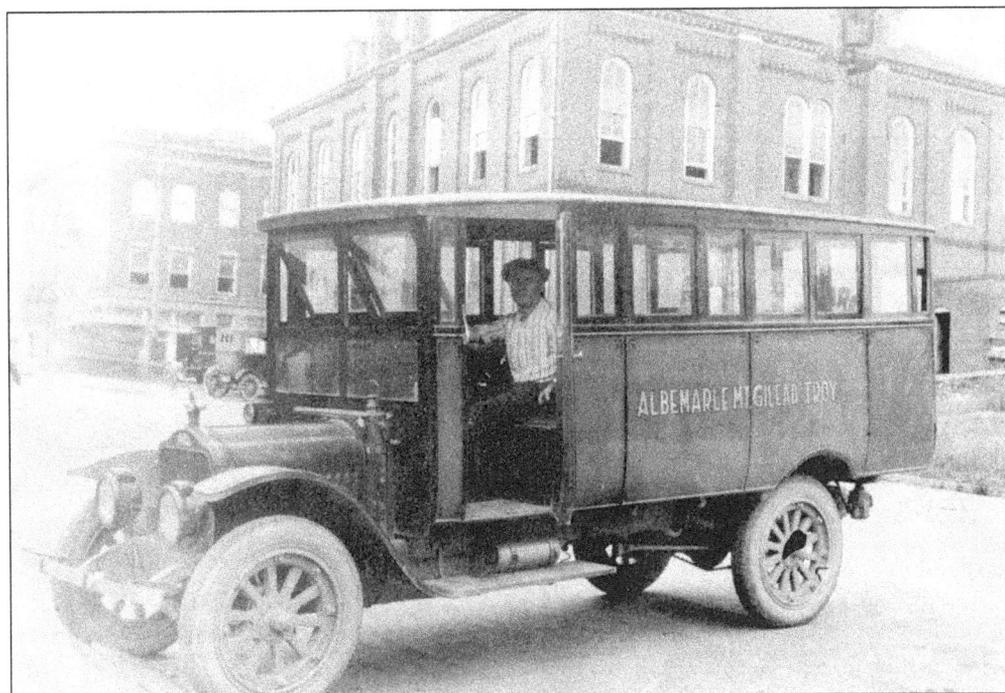

The Albemarle-Mt. Gilead-Troy bus blocks traffic on Albemarle's East Main Street in this scene from the early 1920s. J.E. Redwine's nearby shop built many of the county's earliest trucks and buses, including this example. (Stanly County Museum.)

A wagonload of engineers surveys the future route of the Winston-Salem Southbound Railway (WSS) through Stanly County in this 1910 image. (Stanly County Museum.)

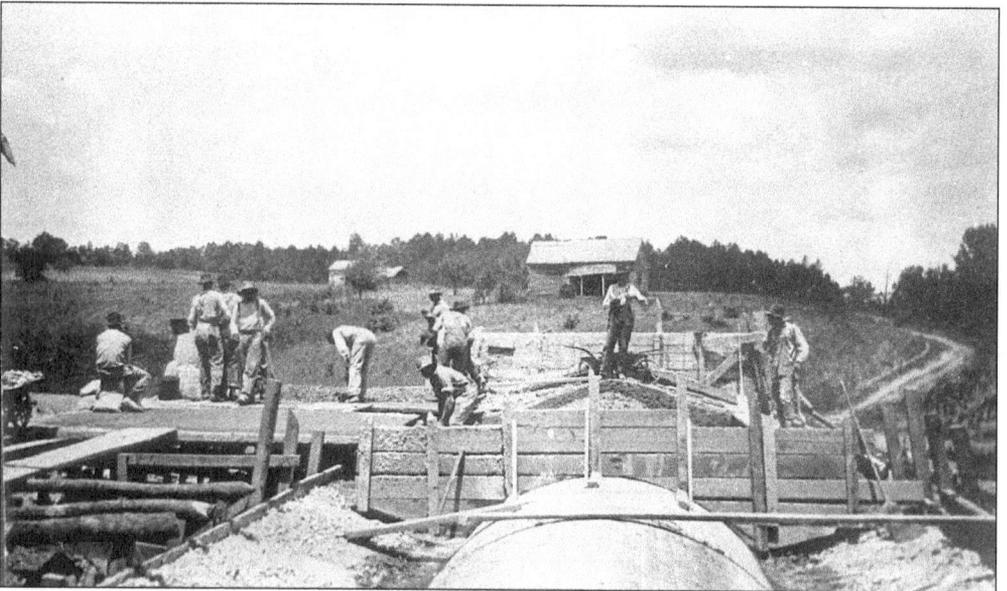

As a lone farmhouse observes from a distance, WSS track gangs blaze a new trail for the iron horse through Stanly County. (Stanly County Museum.)

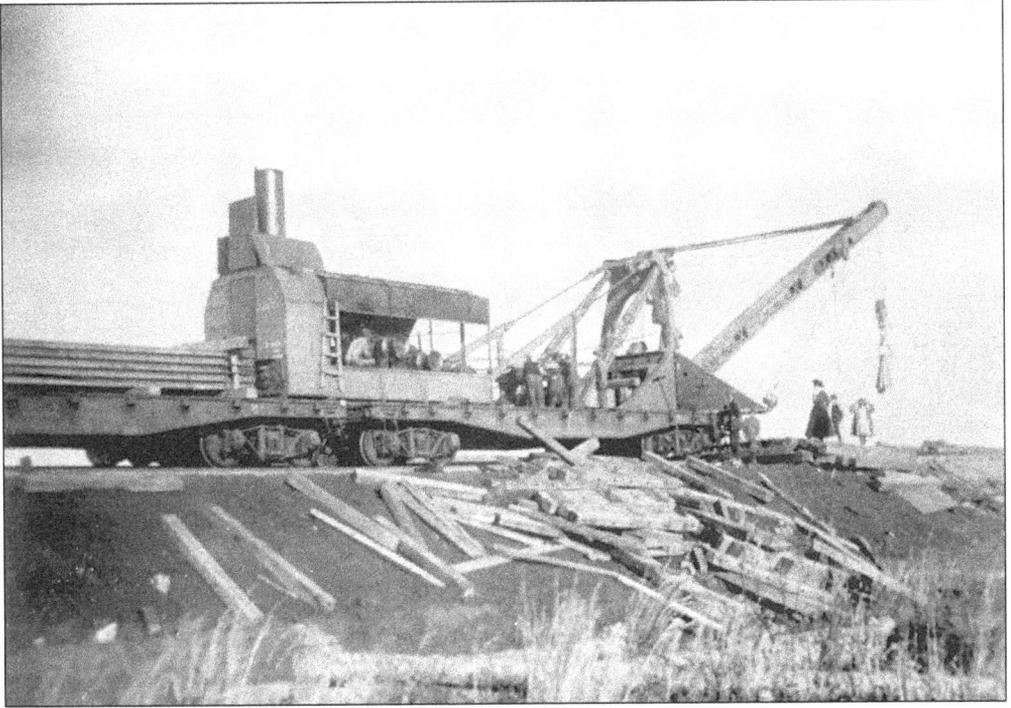

A giant steam derrick works the WSS grade in this 1910 image. At right, sightseers take in the scene. (Stanly County Museum.)

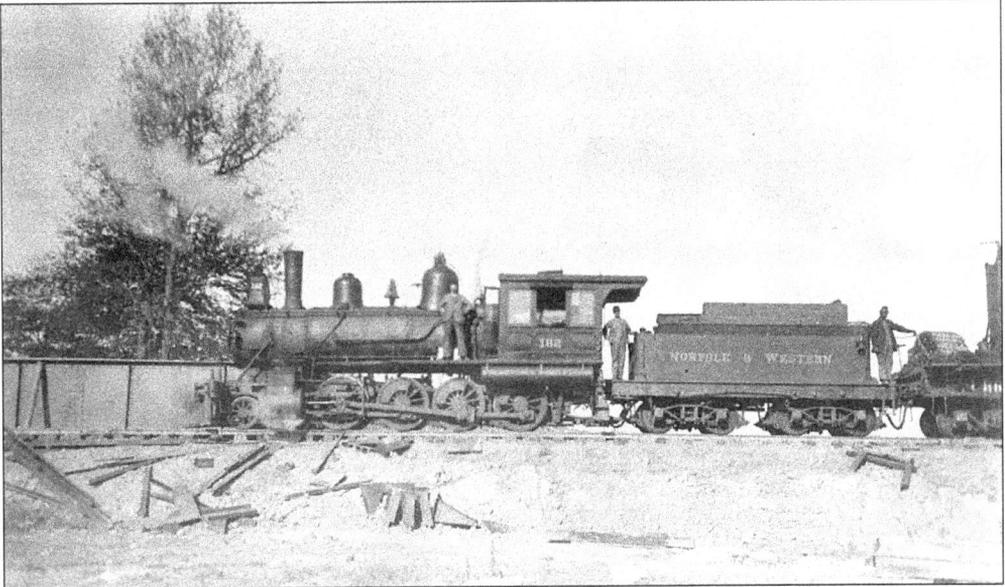

Norfolk & Western No. 162 lends a hand with construction of the WSS line through Stanly County about 1910. Built in 1887, old No. 162 was a veteran even then. (Stanly County Museum.)

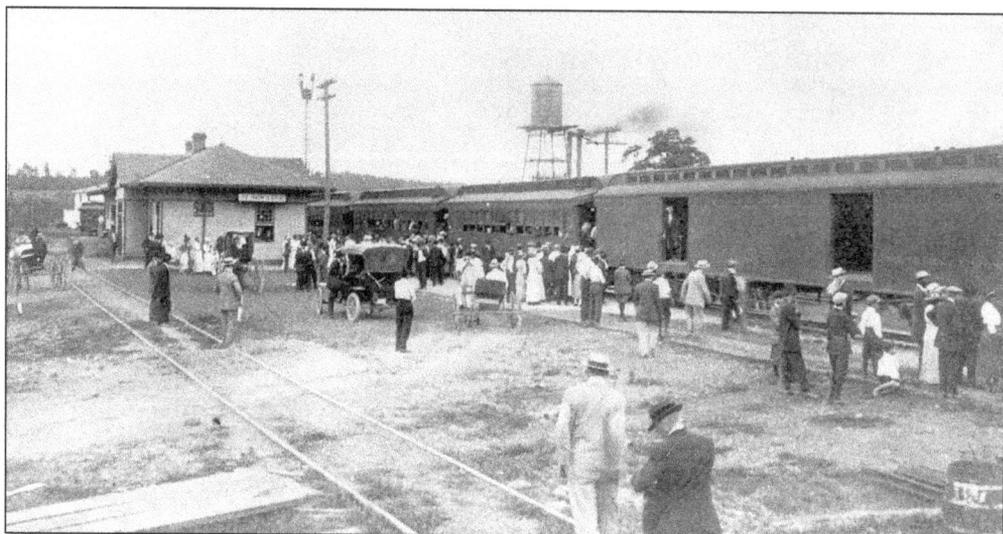

Well-attired crowds gather at Albemarle's WSS depot for a familiar ritual in turn-of-the-century America. A concerted effort by community leaders saved the aging station in the late 1990s. (Stanly County Museum.)

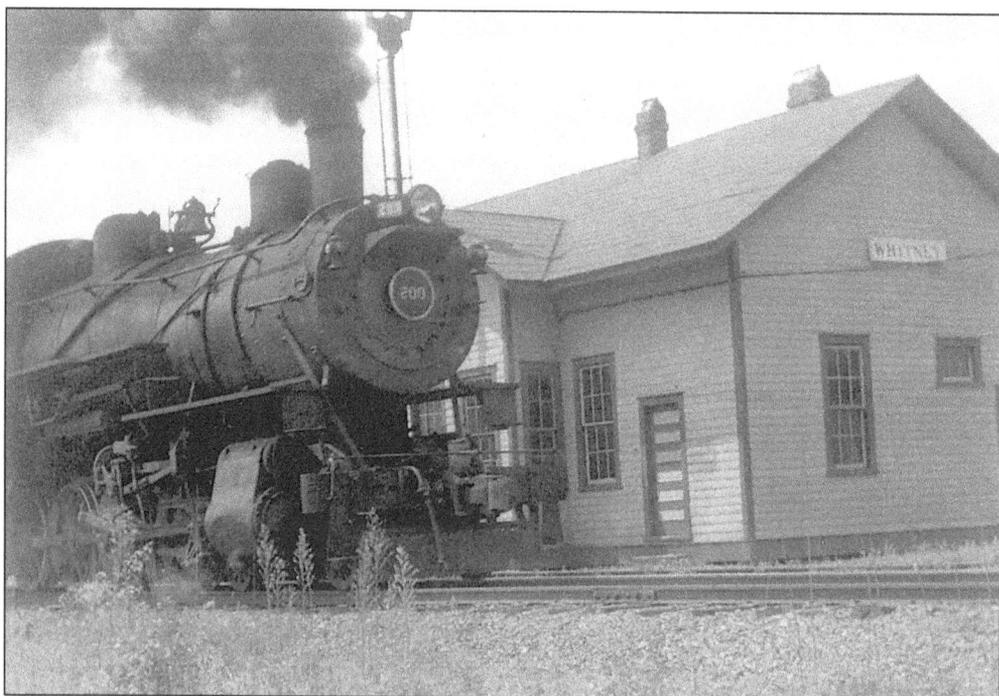

In the twilight of its career, WSS No. 200 chuffs past Whitney station in 1950. Built in 1910, No. 200 ended its days in a Winston-Salem scrapyard. (Stanly County Museum.)

Five

MAKING A LIVING

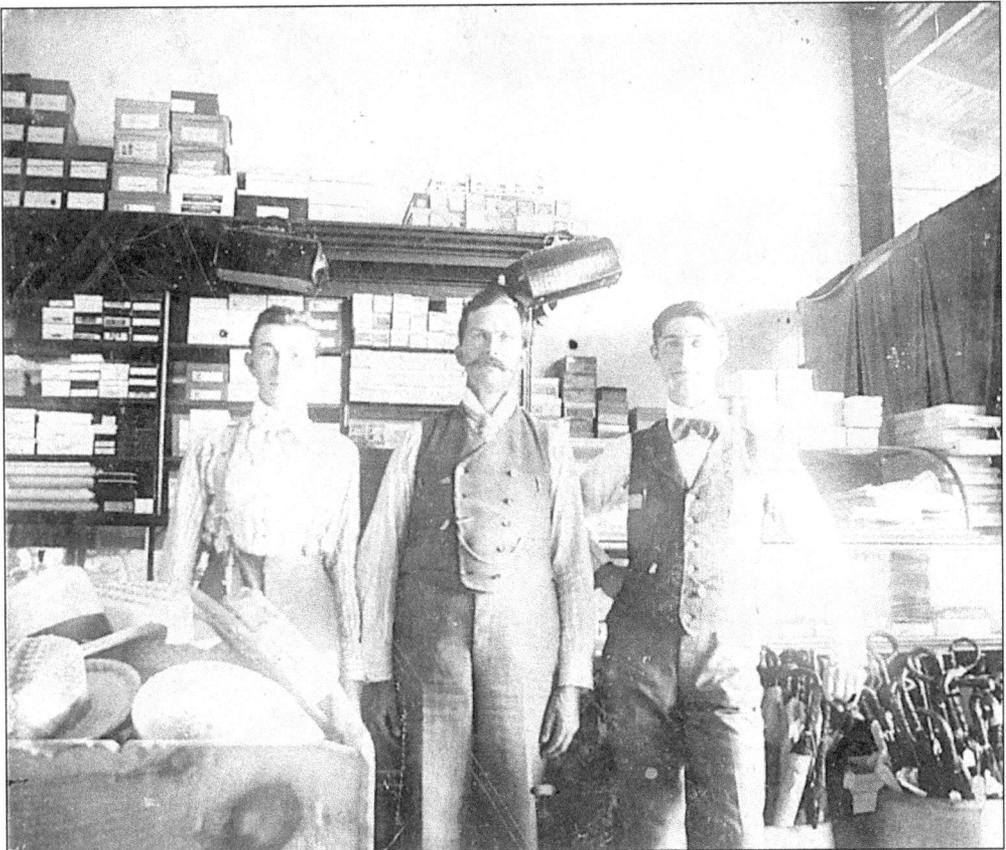

Staff at M.F. Little's haberdashery on Second Street in Albemarle stand ready to do business in this 1906 portrait. From left to right are Frank Rose, former sheriff Tom Forrest, and Frank Snuggs. (Stanly County Museum.)

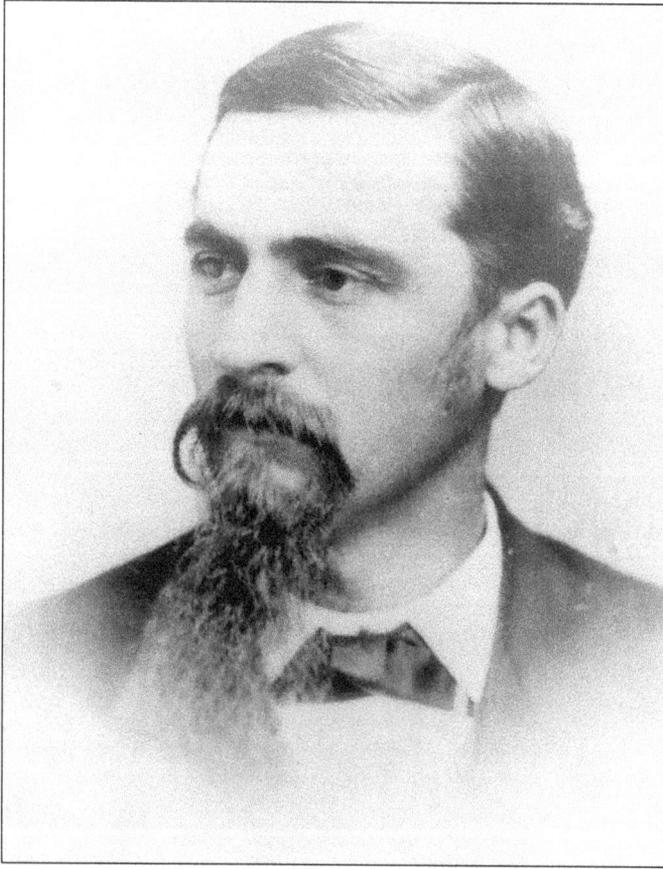

Attorney Samuel J. Pemberton established his law offices in Albemarle's Marks House in 1871. Pemberton's celebrated court victories made him one of the county's wealthiest men. (Stanly County Museum.)

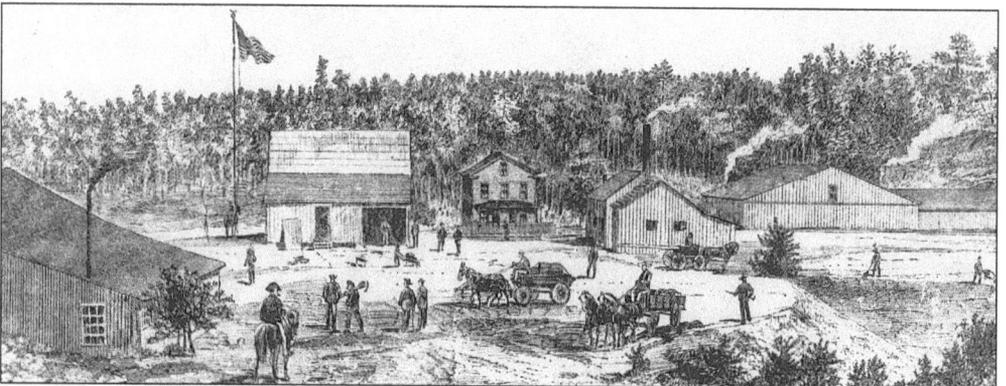

Operations at the Crowell Gold Mine near New London are in full swing in this nineteenth-century engraving. Lured by the promise of instant wealth, many county men traded in their plows for picks and shovels during the county's famous gold rush. (Stanly County Museum.)

With Albemarle's Wiscassett Mill as a backdrop, surveyors for the Winston-Salem Southbound Railway pause with their equipment in this 1906 image. Gaines Whitley stands second from left. (Stanly County Museum.)

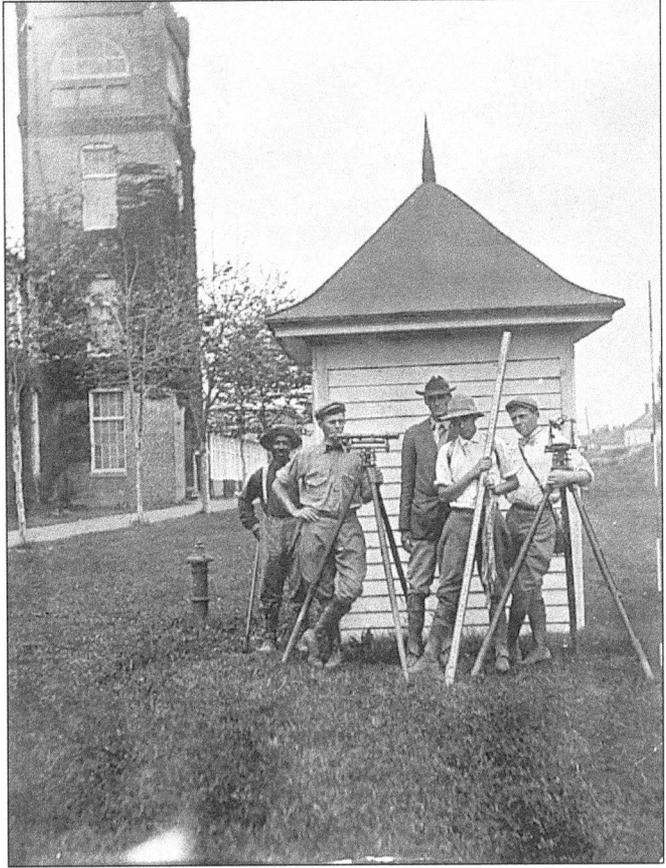

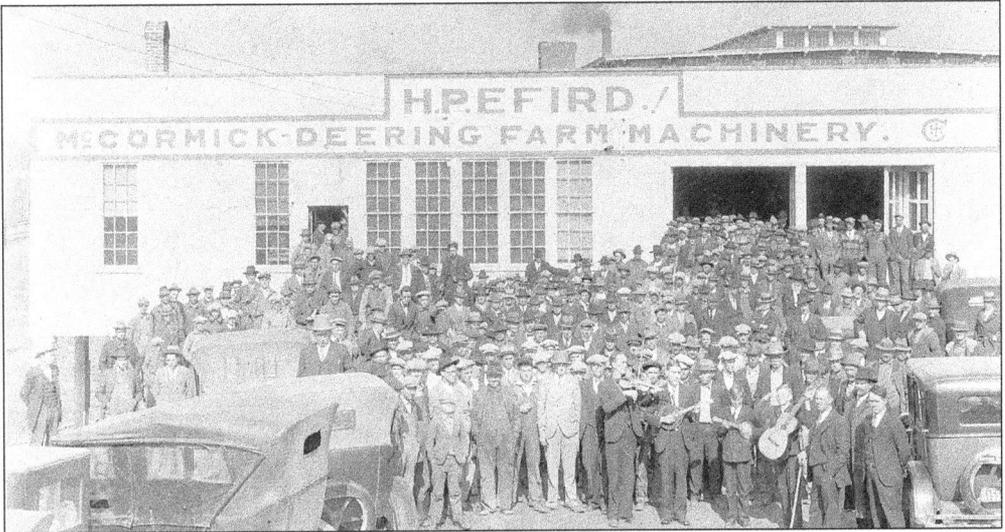

Farmer's Day at H.P. Efird's plant in Albemarle draws a big crowd in this 1920s scene. The Hatley Band has come up from Oakboro to play a few Carolina favorites. (Stanly County Museum.)

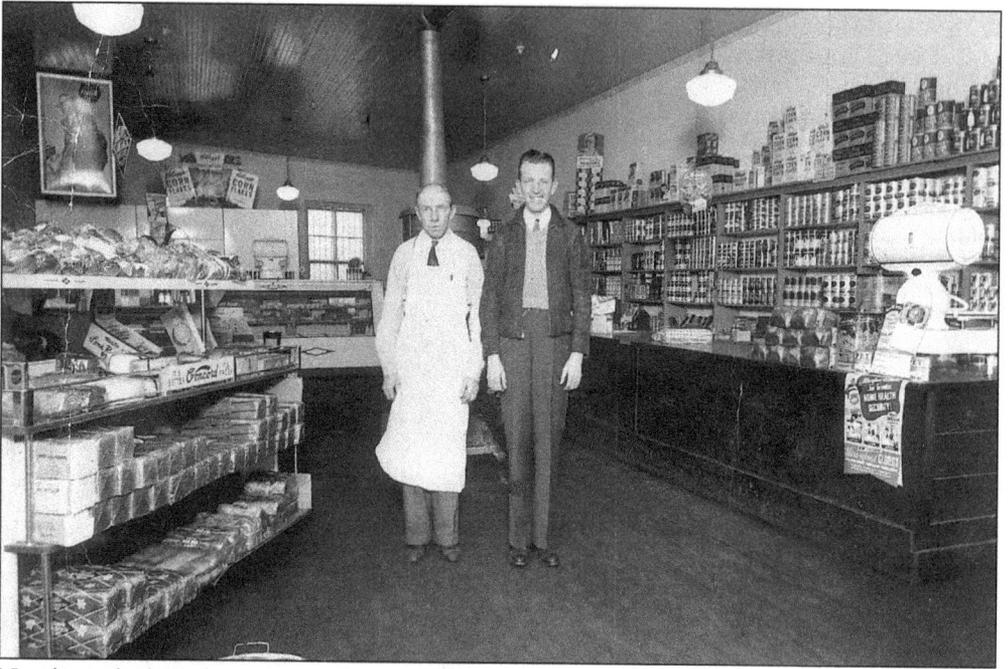

Neatly stacked goods await customers at Townsend's store on Oakwood Street in Albemarle in this undated image. (Stanly County Museum.)

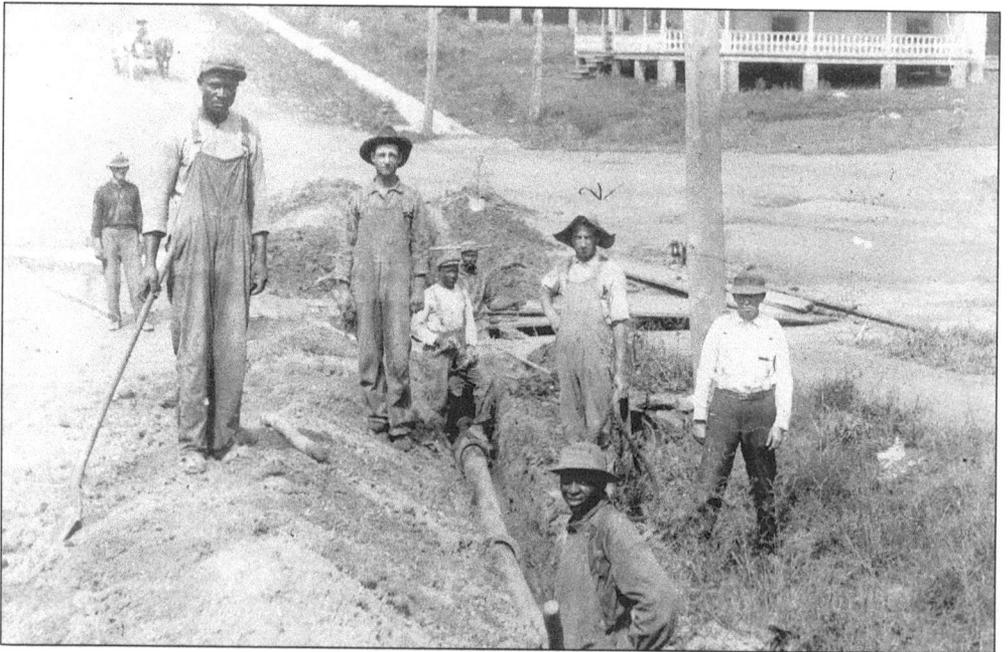

A water main on East Main Street in 1920s Albemarle goes in the old-fashioned way: by hand. (Stanly County Museum.)

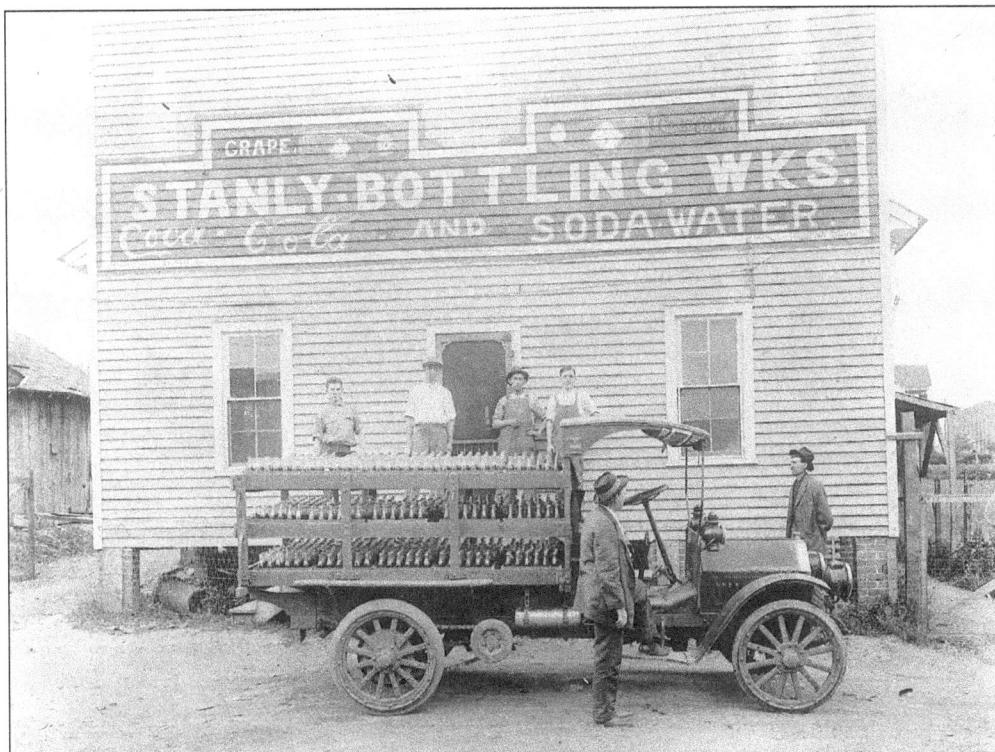

Employees of the Stanly Bottling Works pose with their chain-driven delivery truck, c. 1905. (Stanly County Museum.)

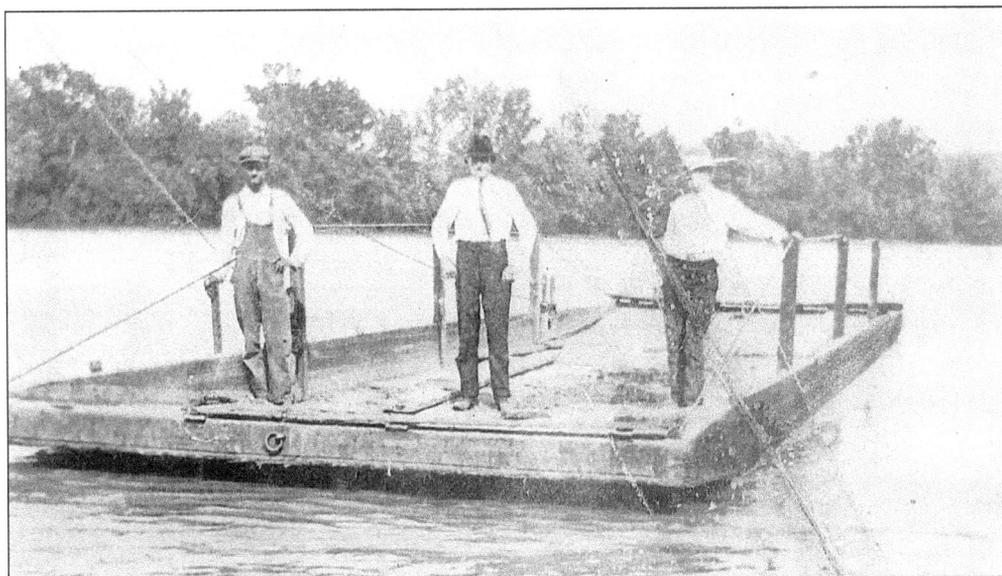

Before 1923, folks needing to cross the Yadkin River into Montgomery County could count on Lowder's ferry. Pictured left to right are Lacy, Carl, and Will Lowder. (Stanly County Museum.)

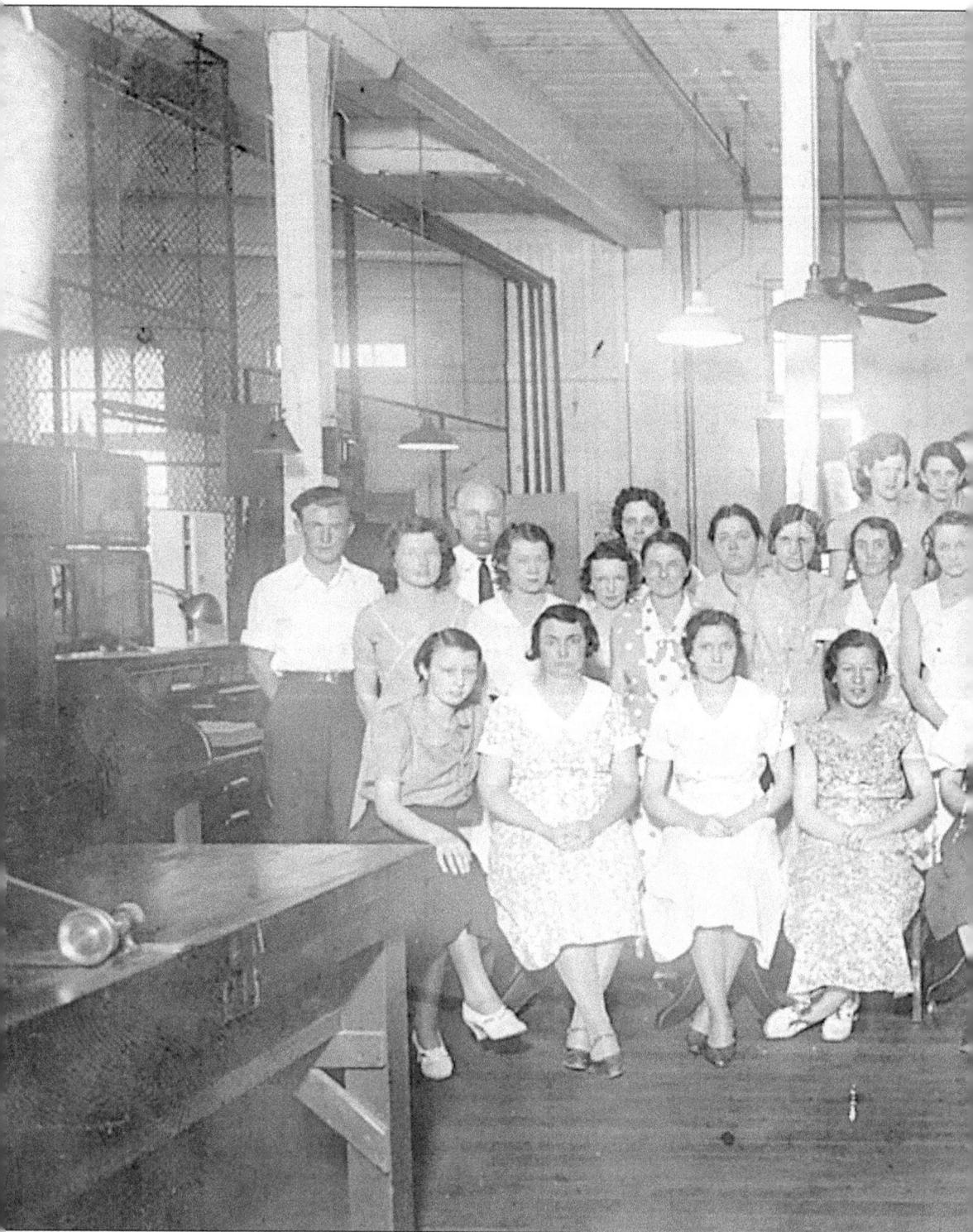

Employees at Albemarle's Lillian Mill (see pages 62–63) gather for a company photograph, *c.* 1920. Despite the long hours and dangerous working conditions, mill jobs were highly

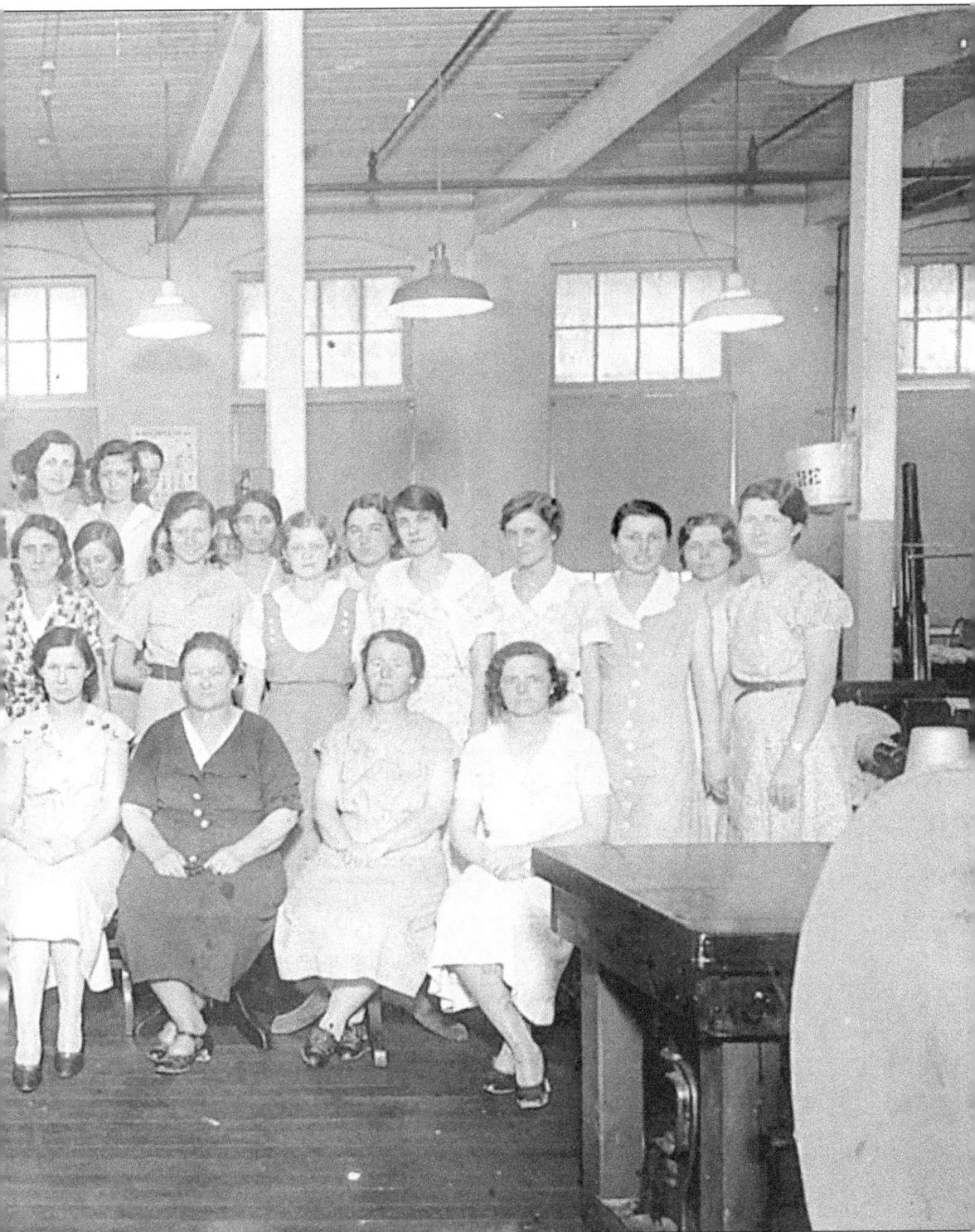

coveted. North Carolina's textile output was the highest in the nation by 1923. (Stanly County Museum.)

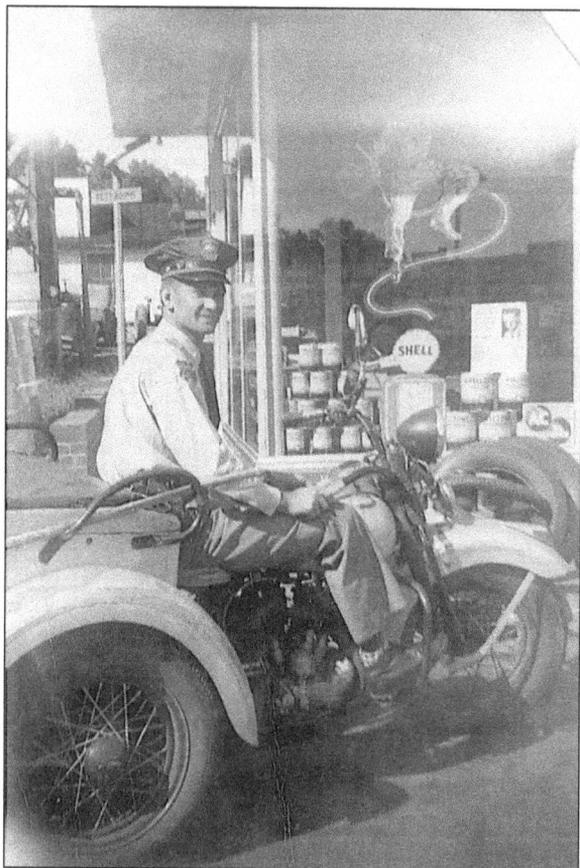

Officer Bill Calloway pulls his three-wheeled Harley-Davidson into Herlocker's Service Station in Albemarle about 1950. (Stanly County Museum.)

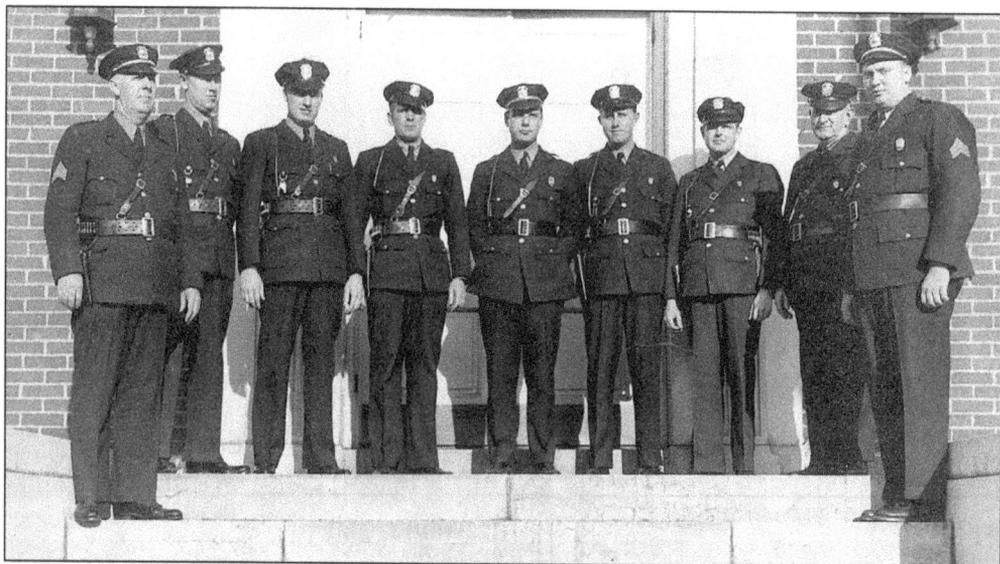

Nine police officers were sufficient to keep the peace in 1930s Albemarle. Pictured left to right are Lewis Mason, Paul Helms, Homer Furr, Archie McQueen, Chief L.D. Cain, Shelby Burleson, R.B. Coe, G.D. Biddix, and Charlie Drye. (Stanly County Museum.)

A rising generation of nurses poses on the steps of Albemarle's Graded School building in this portrait, *c.* 1917. (Stanly County Museum.)

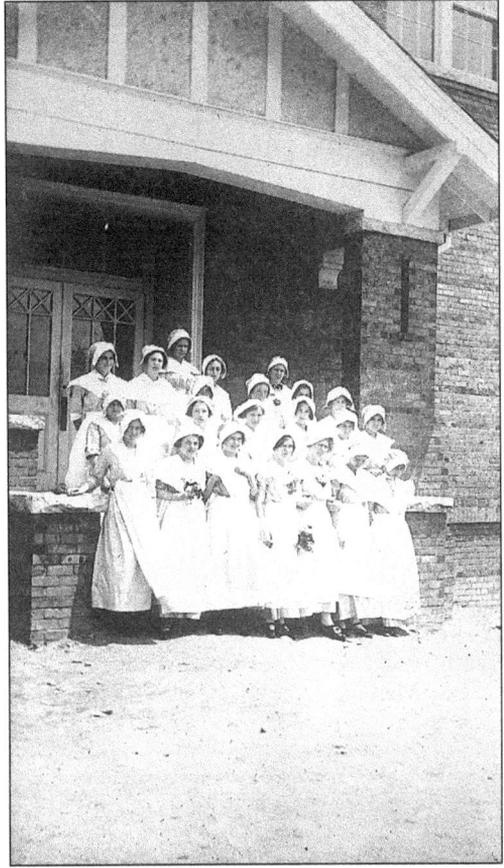

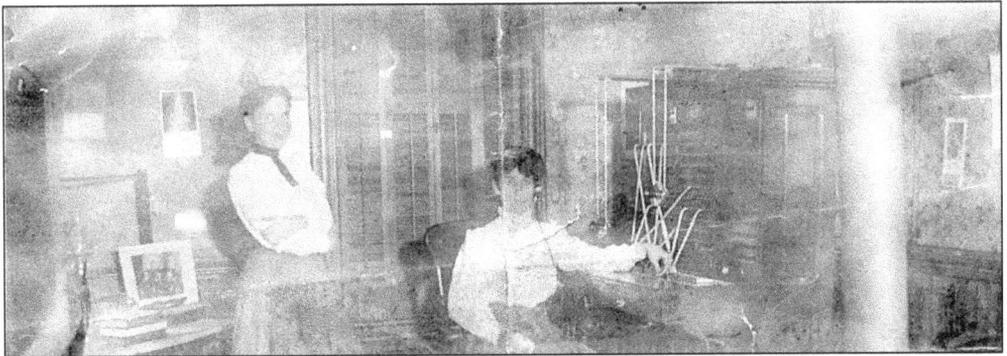

Shadowed by a photographer's flash, Sallie Marks (left) and Fanny Harris route calls through Albemarle's first telephone switchboard, *c.* 1910. Sallie Marks later moved to Chapel Hill to become the University of North Carolina's first female professor. (Stanly County Museum.)

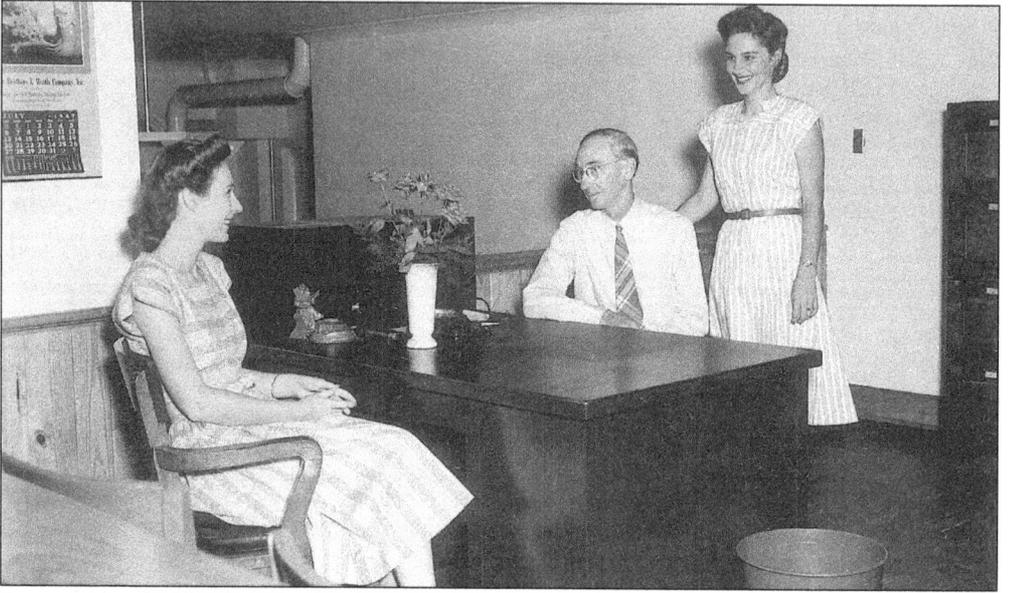

Businessman J. Heath Morrow chats with his daughter Martha Morrow Clements—seated at left—in this 1947 snapshot. Martha's father kept Albemarle's famed Morrow Brothers & Heath hardware store prospering into the 1960s. The woman at right is unidentified. (Stanly County Museum.)

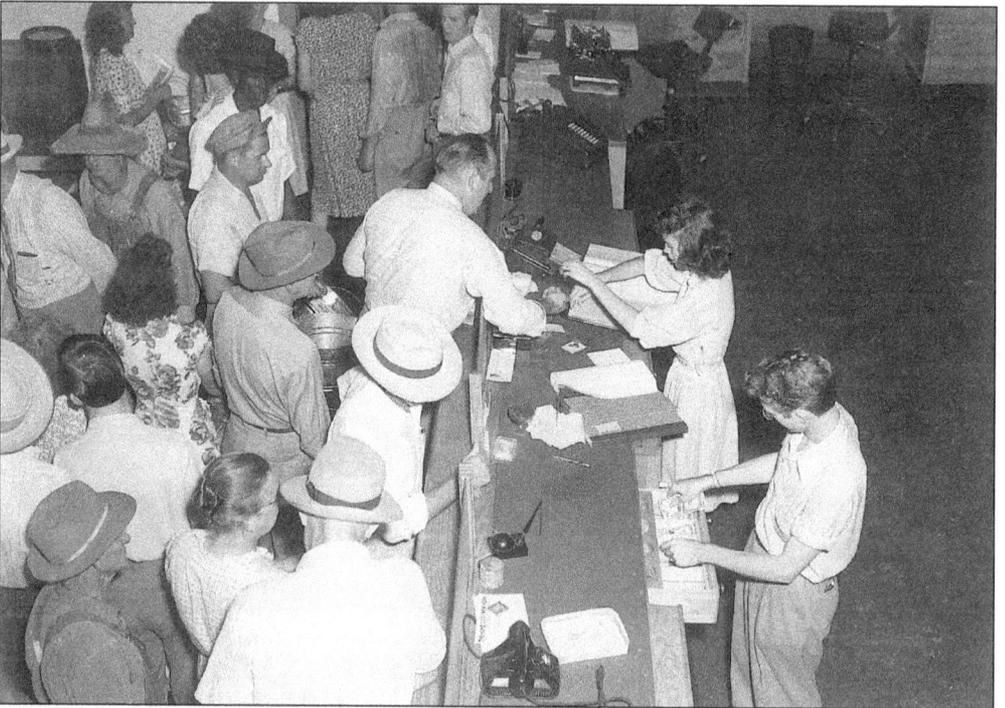

Customers crowd the payment counter at Albemarle's new Morrow Brothers & Heath hardware store on a busy day in 1947. (Stanly County Museum.)

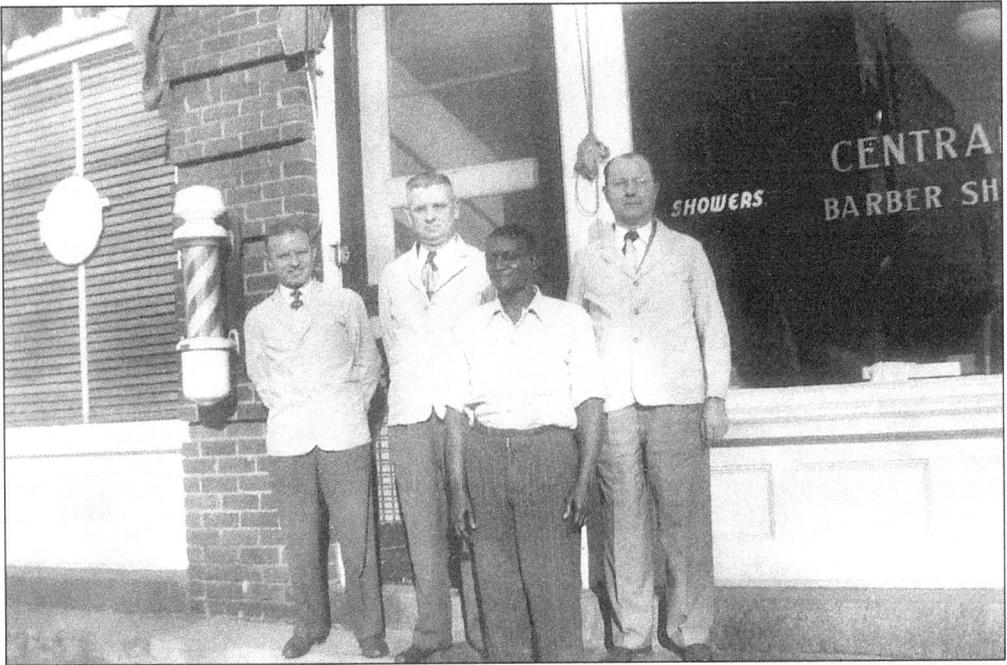

Albemarle's Central Barber Shop offered showers as well as haircuts, shaves, and shoeshines. Standing left to right in this 1951 scene are Elworth Plyler, Prevo Harwood, James Harris, and owner Fred Harwood. (Stanly County Museum.)

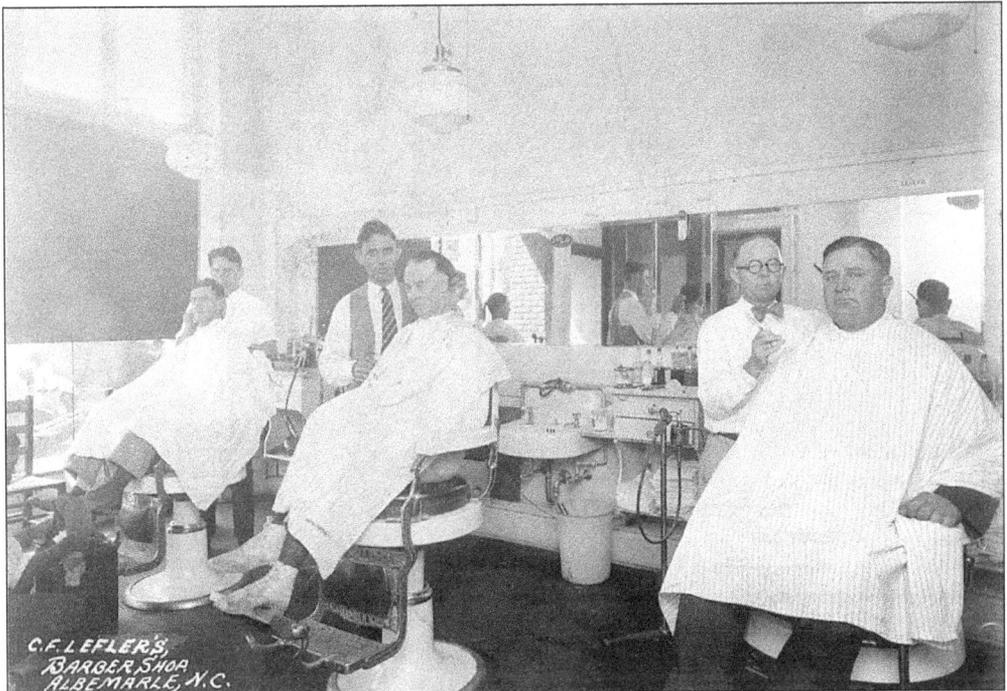

Barbers tend to their clients at C.F. Lefler's shop in the 1930s-era Albemarle Hotel. Mr. Lefler himself stands at right. The old hotel remains in business today. (Stanly County Museum.)

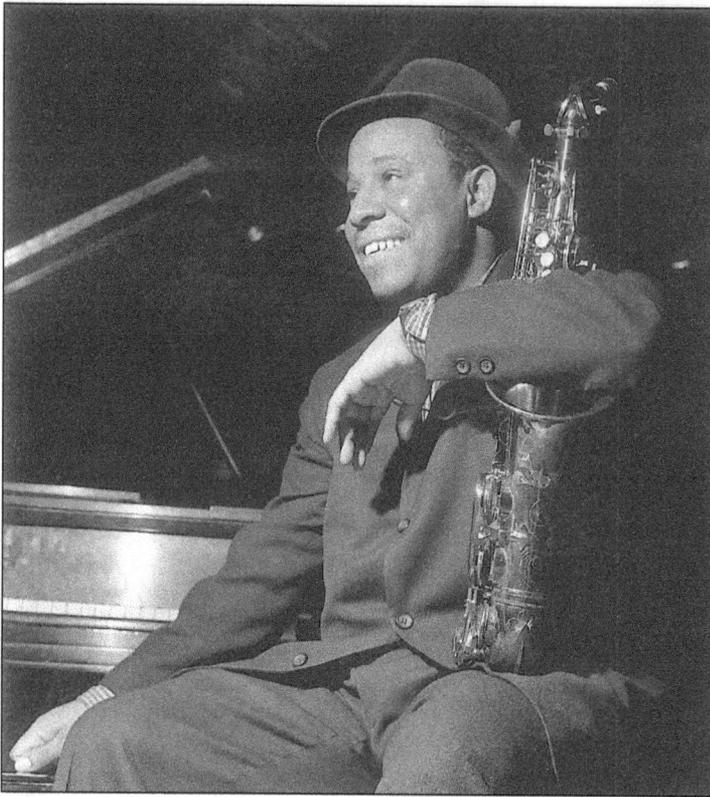

Badin native Lou Donaldson cradles his saxophone in this 1959 portrait. The renowned jazz artist has recorded more than 80 albums. He now lives in New York City. (Photograph by Francis Wolff; copyright Mosaic Images.)

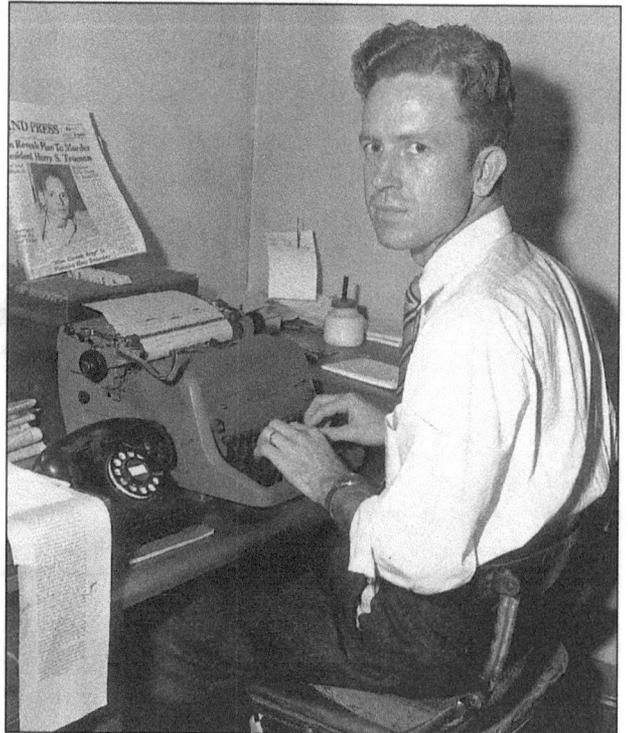

Look up the term "journalist" in an encyclopedia and you may find this classic image of Fred T. Morgan at work. In his many decades at the *Stanly News & Press*, Morgan achieved the reporter's ultimate goal of developing a clear, consistent, and unmistakable writing style. This image dates from the 1950s. (Stanly County Museum.)

Six

SCHOOL DAYS

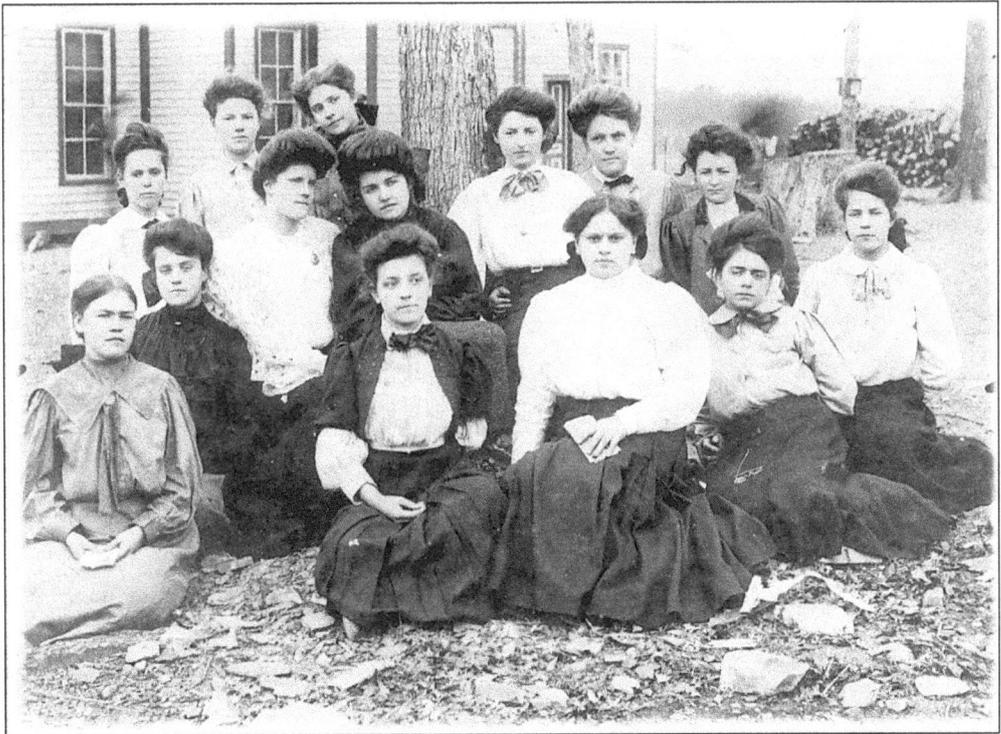

Outfitted in high Edwardian fashion, a group at the Palmerville Academy sits for a turn-of-the-century portrait. By 1900, students in Stanly County attended classes in no fewer than 74 schools. (Stanly County Museum.)

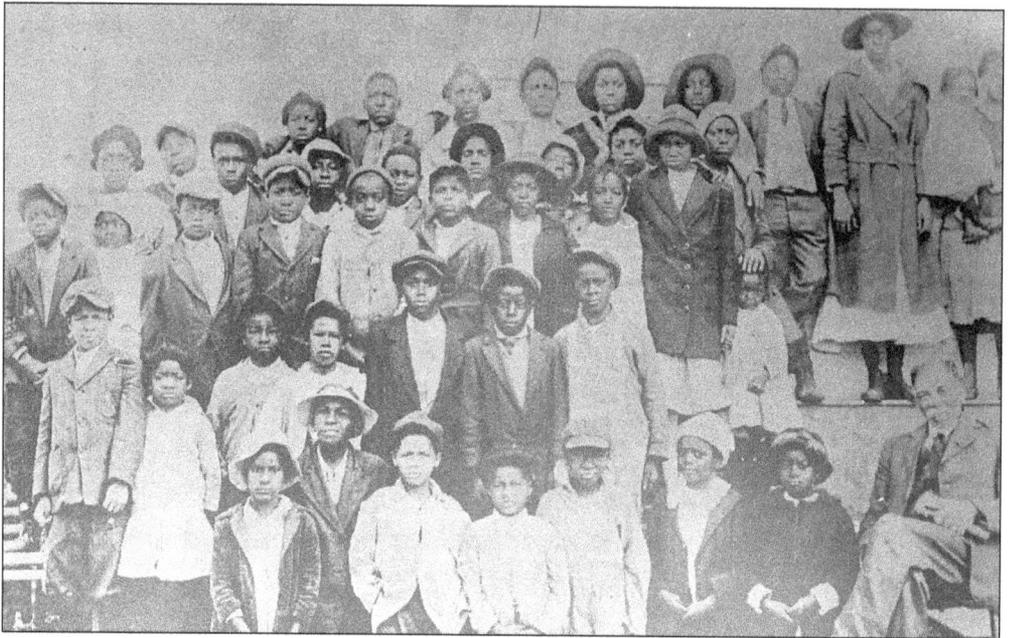

Principal H.S. Sellers—seated at far right—poses proudly with his students at Norwood's school for African Americans in this 1917 image. The racial integration of the county's schools lay 48 years in the future. (Stanly County Museum.)

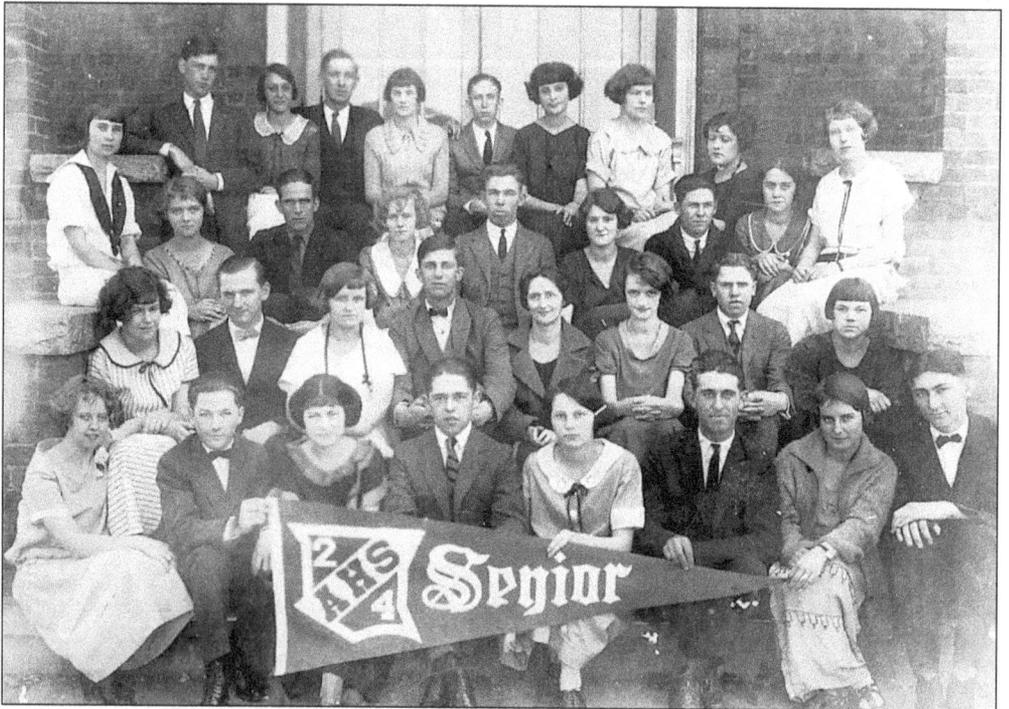

Albemarle High School's graduating Class of 1924 gathers for a senior portrait before moving out into the world. (Stanly County Museum.)

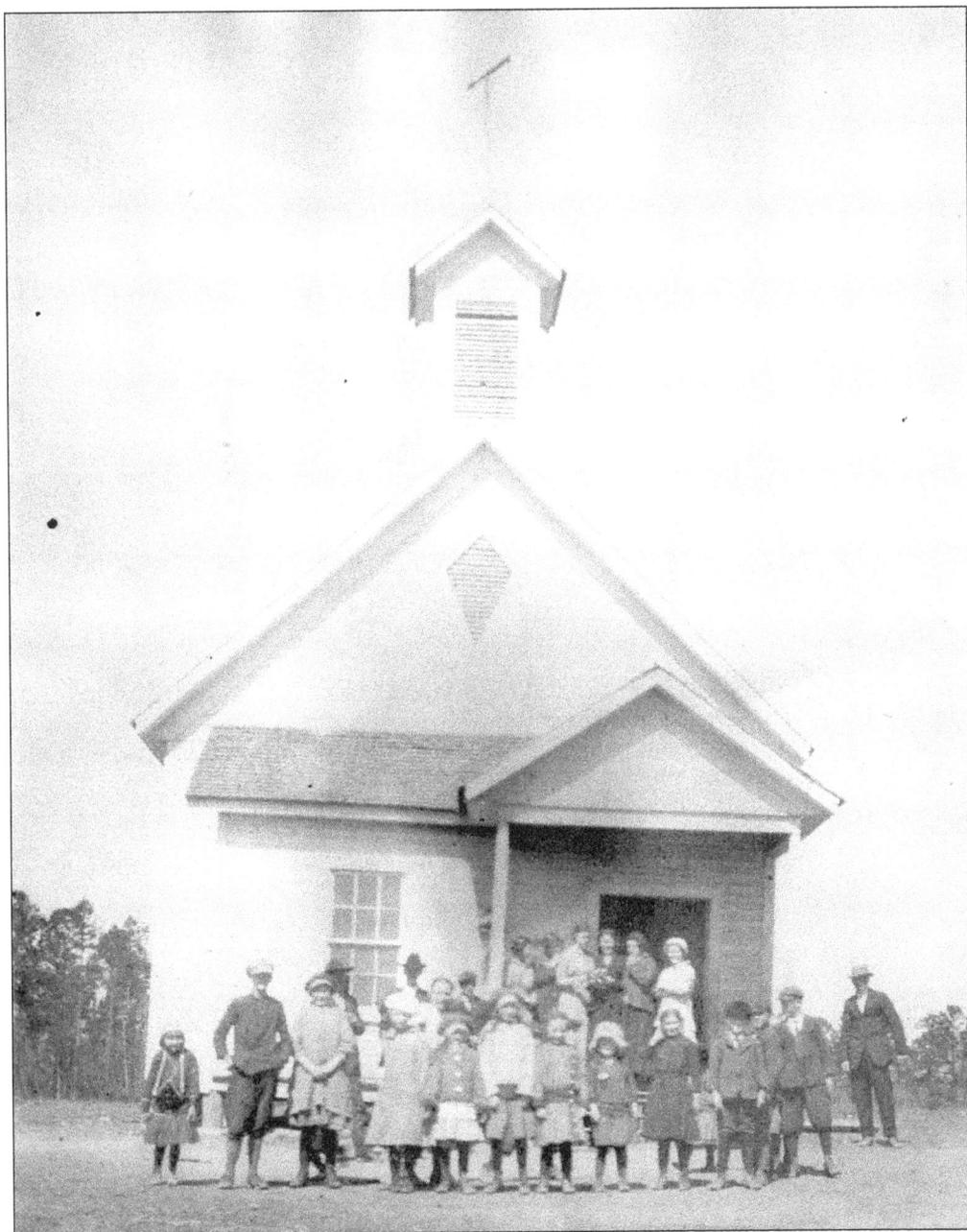

One-room schoolhouses were still a common sight in rural America when students at the Hatley School gathered in the sunshine for this early photograph. (Stanly County Museum.)

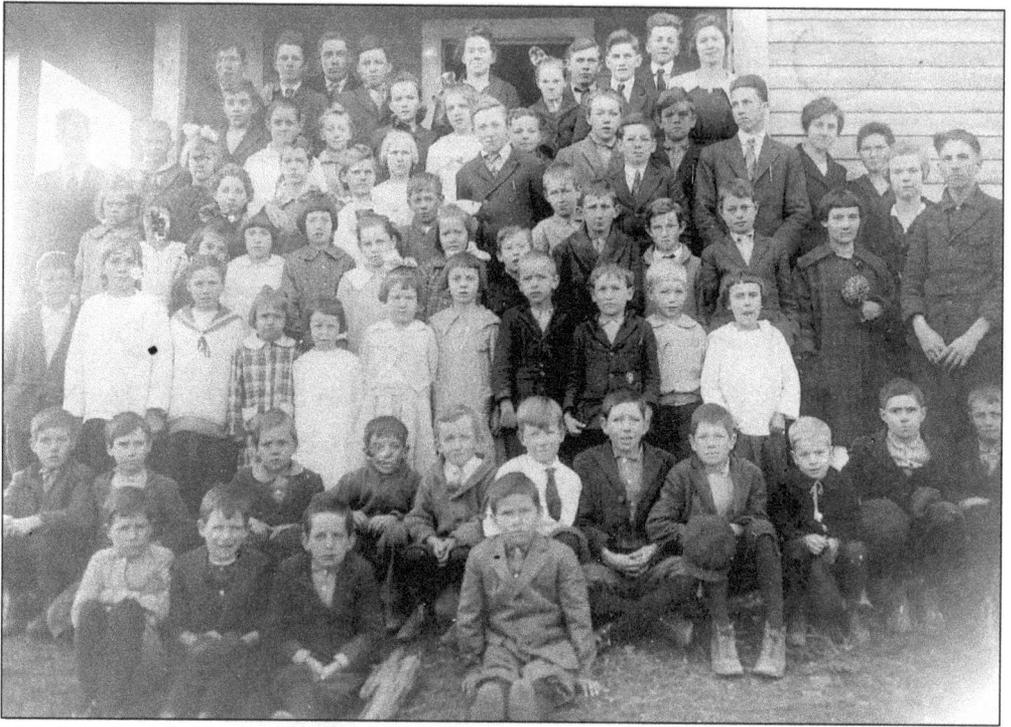

Kirk School students assemble on their schoolhouse porch for a class portrait, c. 1917. Born in an era of Model Ts and gaslight, most of these young people would live to see television and moonshots. (Stanly County Museum.)

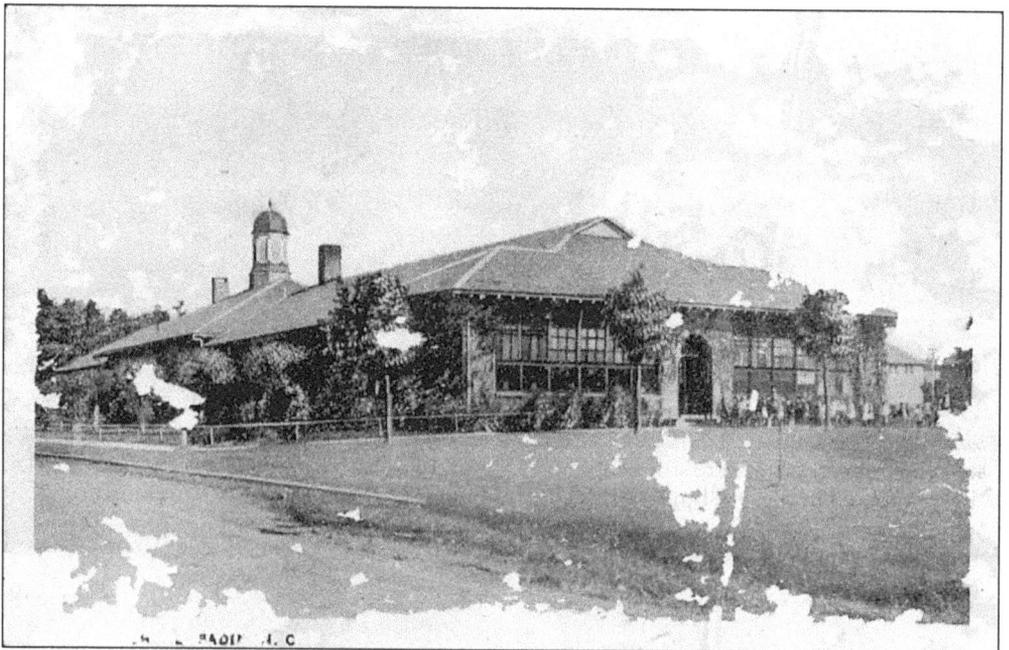

Badin's Elementary School is featured on this water-damaged image from the early twentieth century. The handsome school remains in use. (Stanly County Museum.)

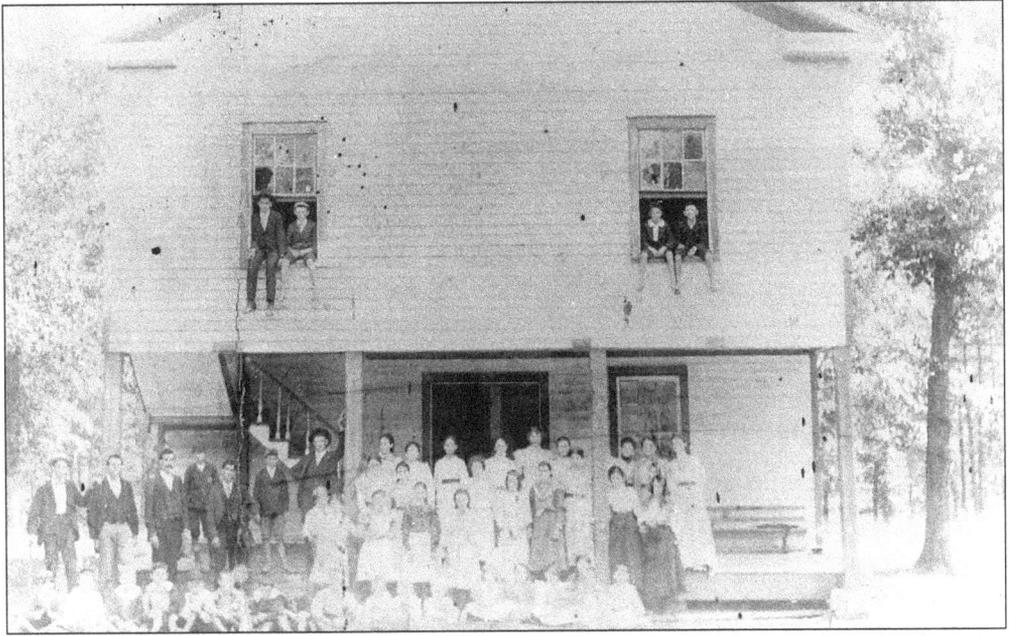

Students eager to get into the picture hang from the windows of the Spinks School in this turn-of-the-century image. The building later became part of Albemarle's Central Elementary campus. (Stanly County Museum.)

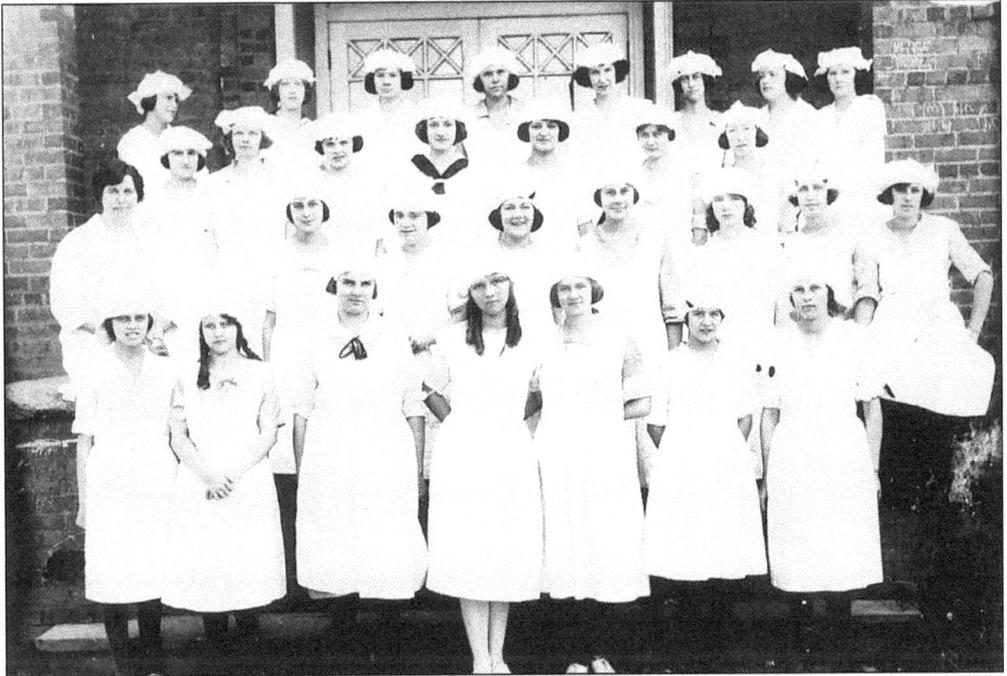

Nurse's attire is the order of the day for these home economics students at Albemarle's Graded School. The date is 1922. (Stanly County Museum.)

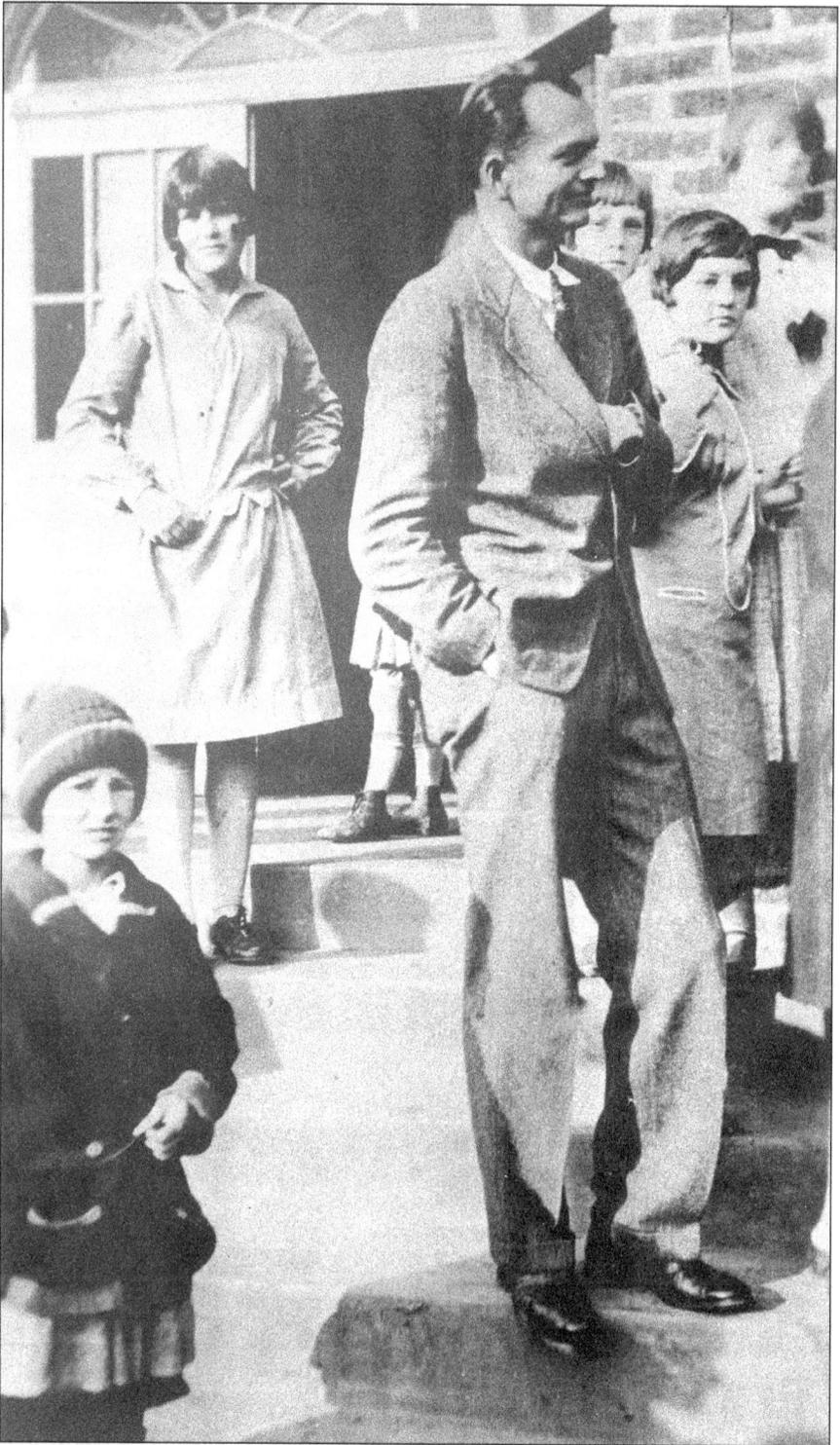

New London School principal Malcolm Palmer relaxes with his students in this 1927 snapshot. (Stanly County Museum.)

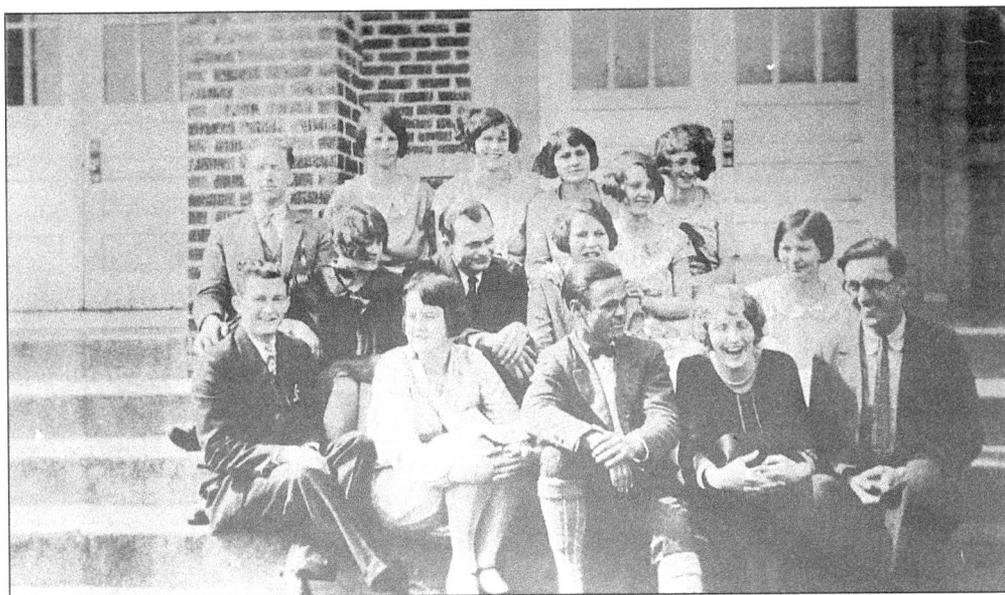

A quick photographer captures a light moment while New London High School's Class of 1927 sits for their portrait. (Stanly County Museum.)

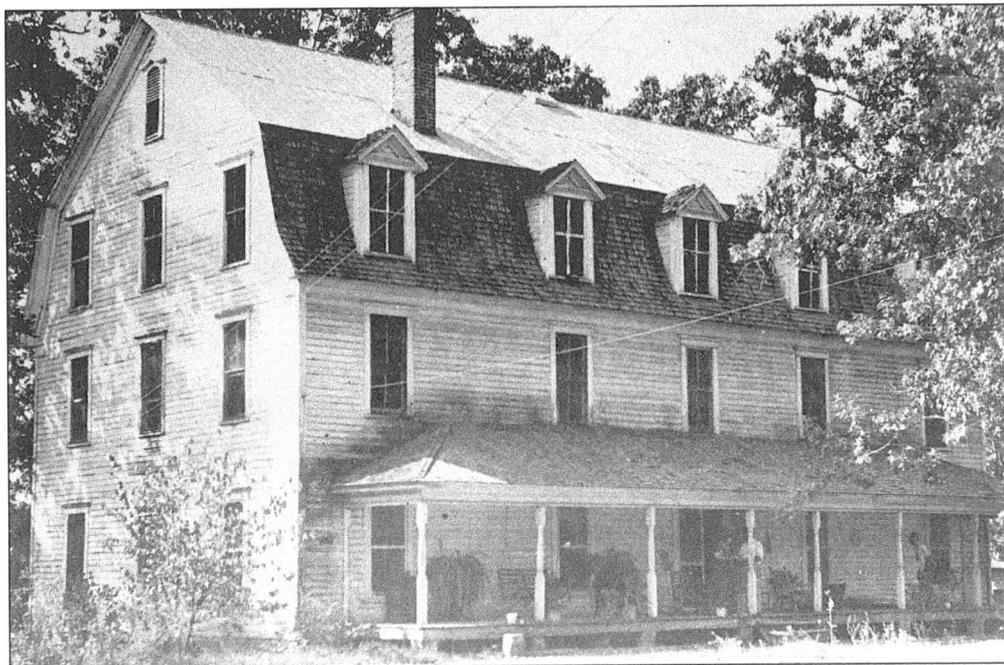

New London's Teacherage began life as a boarding school dormitory. The building came down in the late 1930s. (Stanly County Museum.)

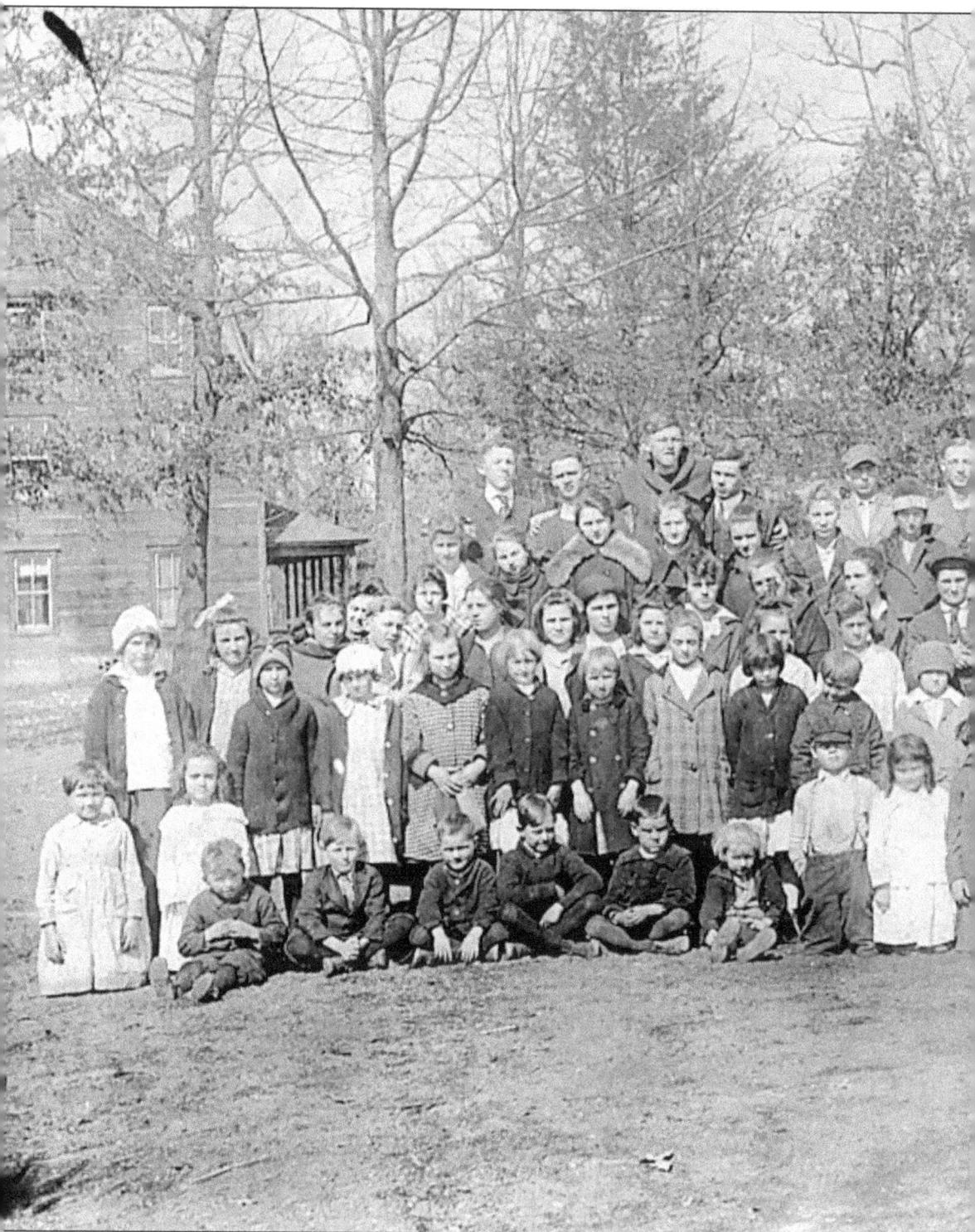

With a handmade basketball goal as a backdrop, students at the New London School assemble for an undated portrait. By 1928, Stanly County boasted 12 brick schoolhouses and 150 classrooms.

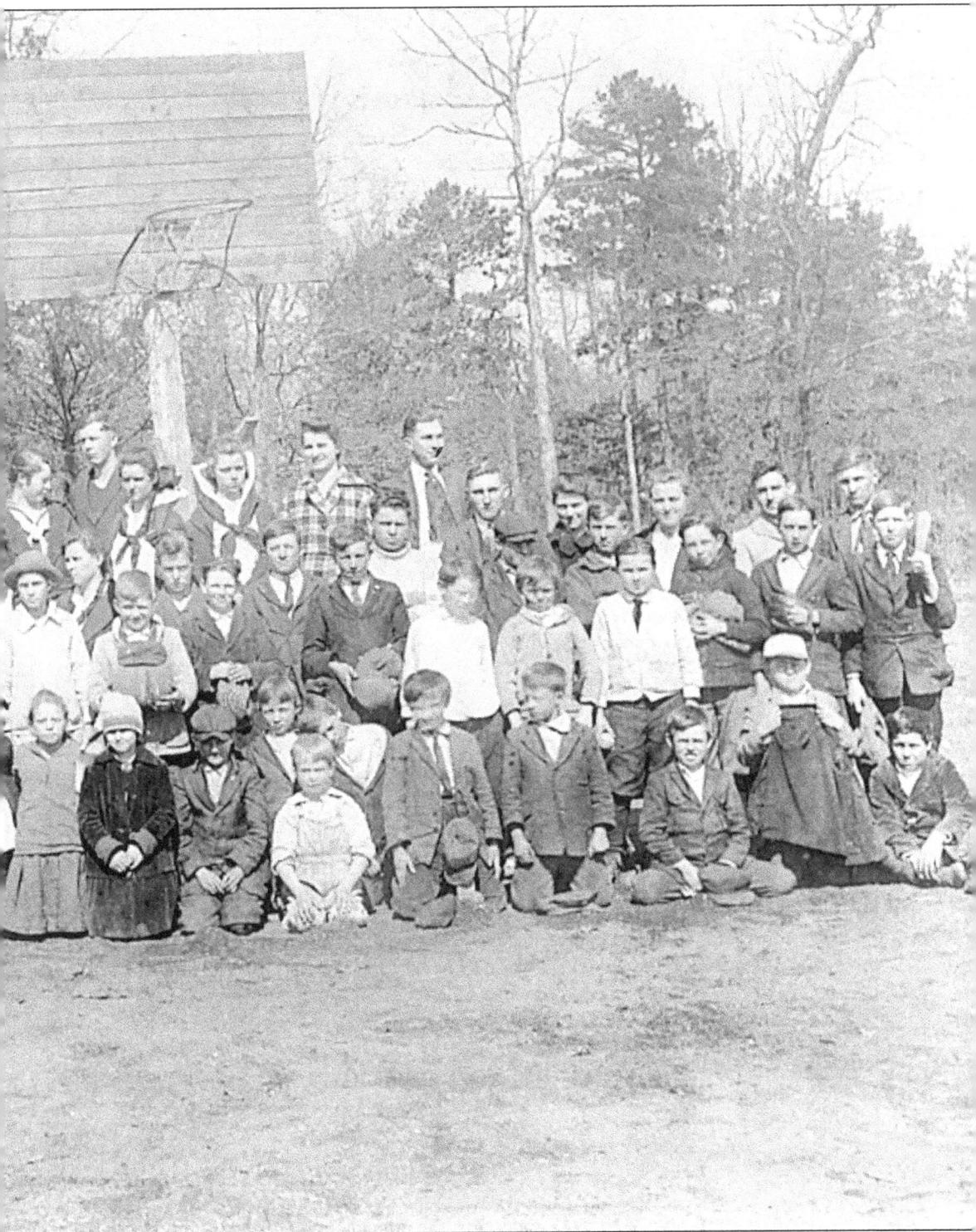

A fleet of 40 buses gave every student in the county access to a high school education. (Stanly County Museum.)

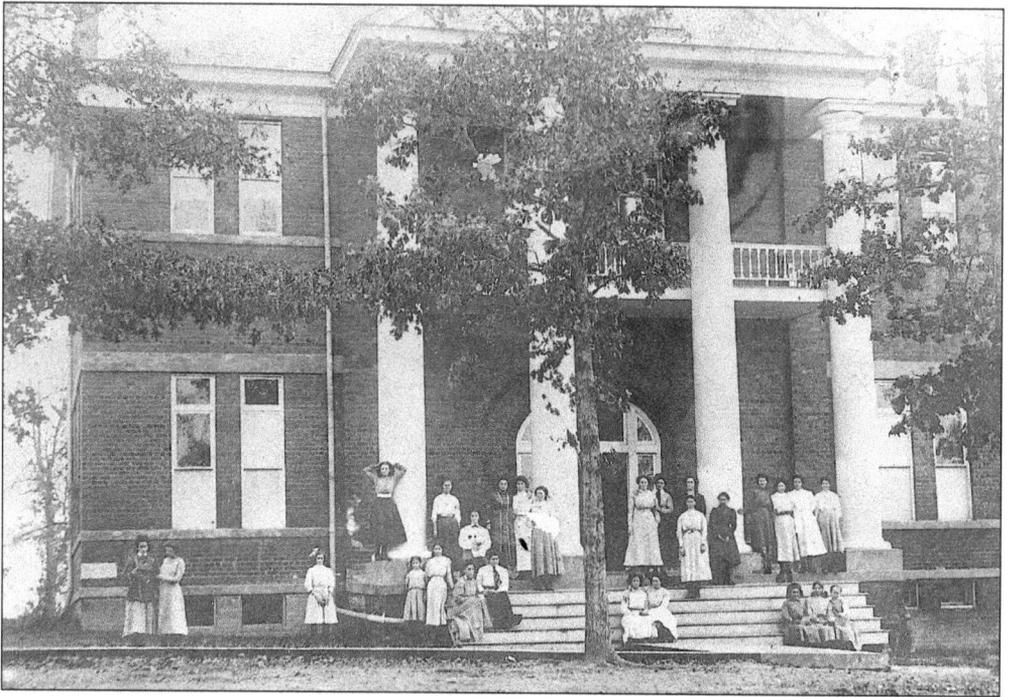

Students relax on the spacious porch of the Albemarle Normal & Industrial Institute (A.N.I.I.), founded by Frances E. Ufford in 1896. The dedicated Ufford worked in Albemarle for ten years without salary. (Stanly County Museum.)

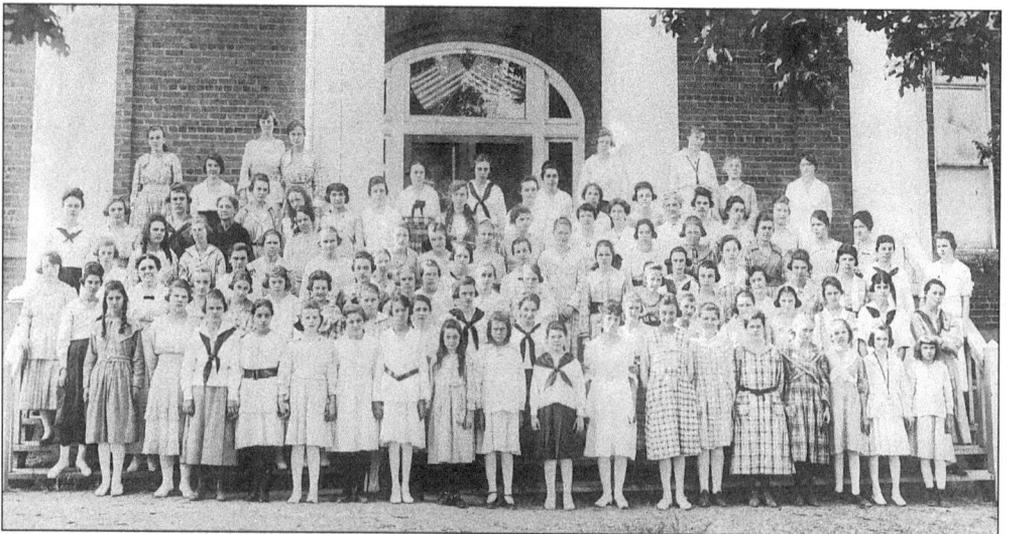

In this later image, faculty, staff, and students at the Albemarle Normal & Industrial Institute assemble for a summertime portrait. The institute closed its doors in the late 1920s; the handsome building survived until 1975. (Stanly County Museum.)

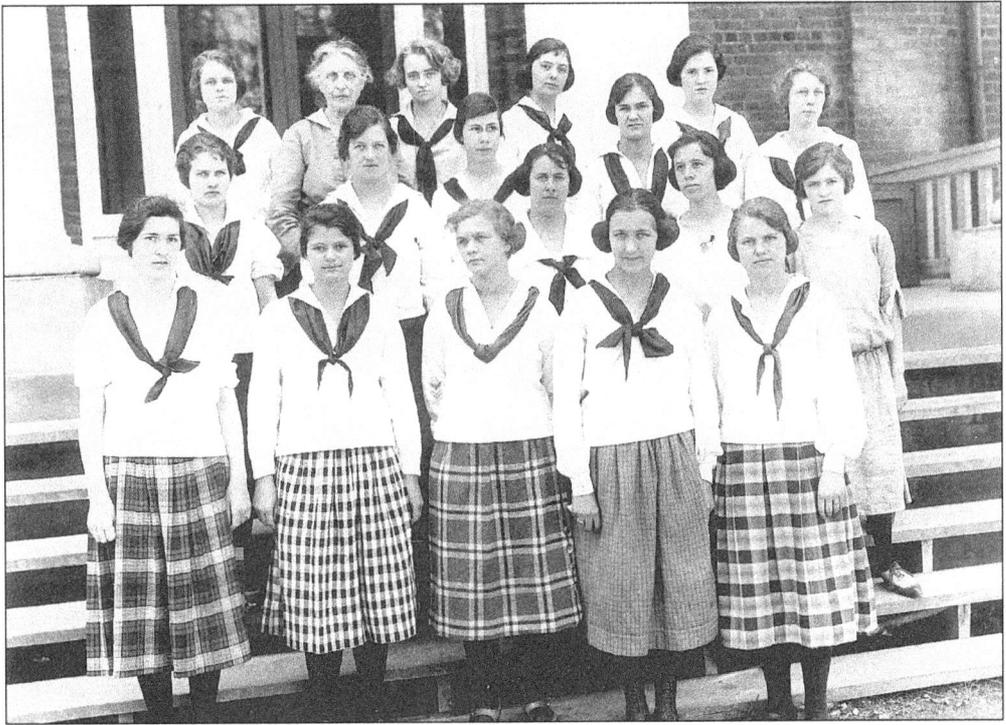

Albemarle Normal & Industrial Institute students appear ready for an outing in this undated snapshot. A.N.I.I. founder Frances Ufford also established a similar institute for both male and female students—Stanly Hall—in Locust. (Stanly County Museum.)

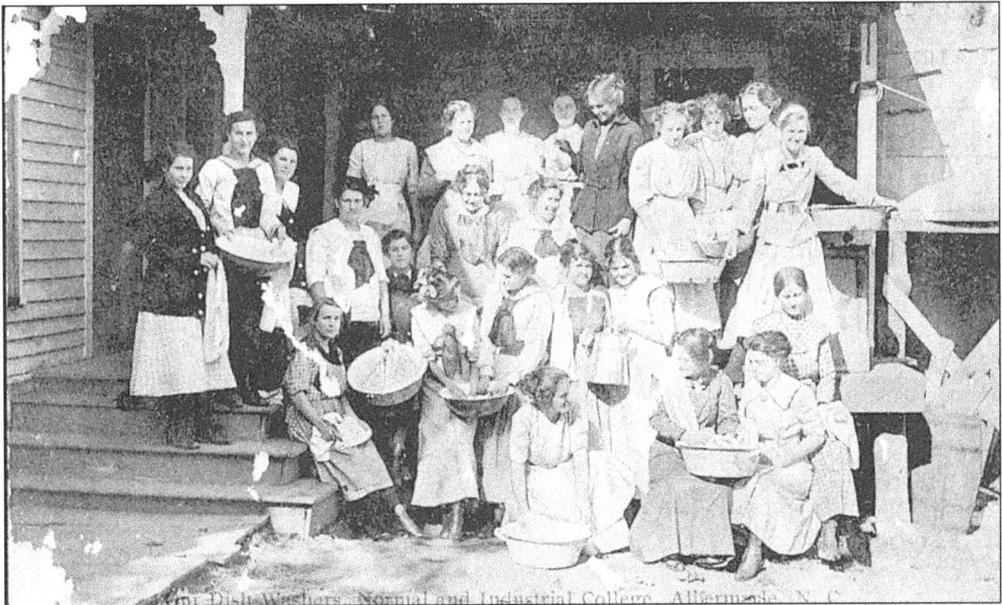

"Our dish washers—Normal and Industrial College, Albemarle, N.C.," reads the caption on this turn-of-the-century postcard. Though the A.N.I.I. did not survive, another well-known county school—the Mitchell School—prospered. The school is now Pfeiffer University. (Stanly County Museum.)

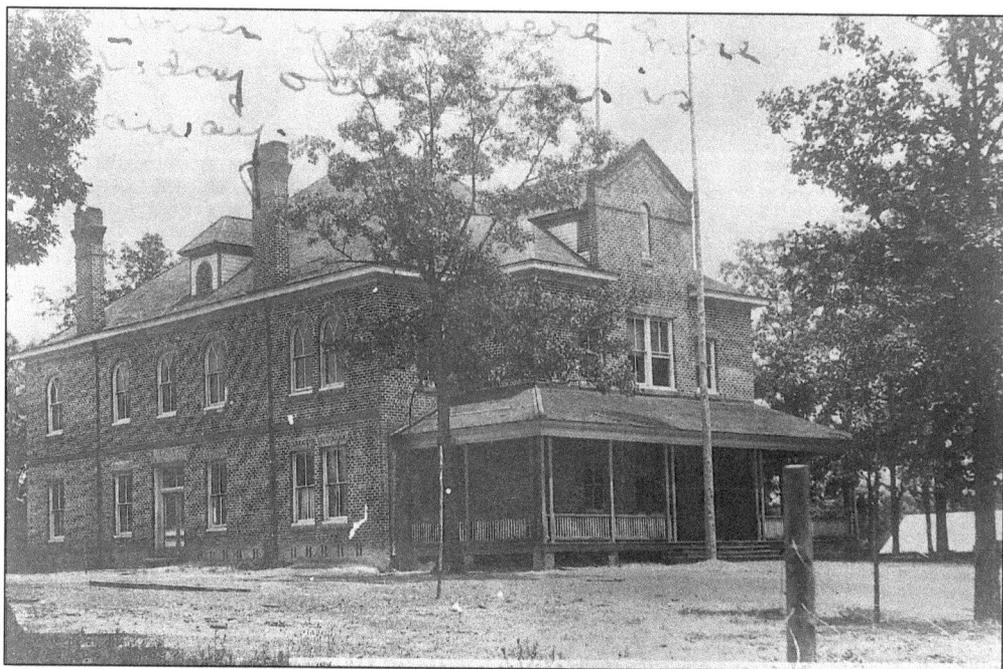

Albemarle Graded School presents its handsome brick facade in this early-twentieth-century portrait. (Stanly County Museum.)

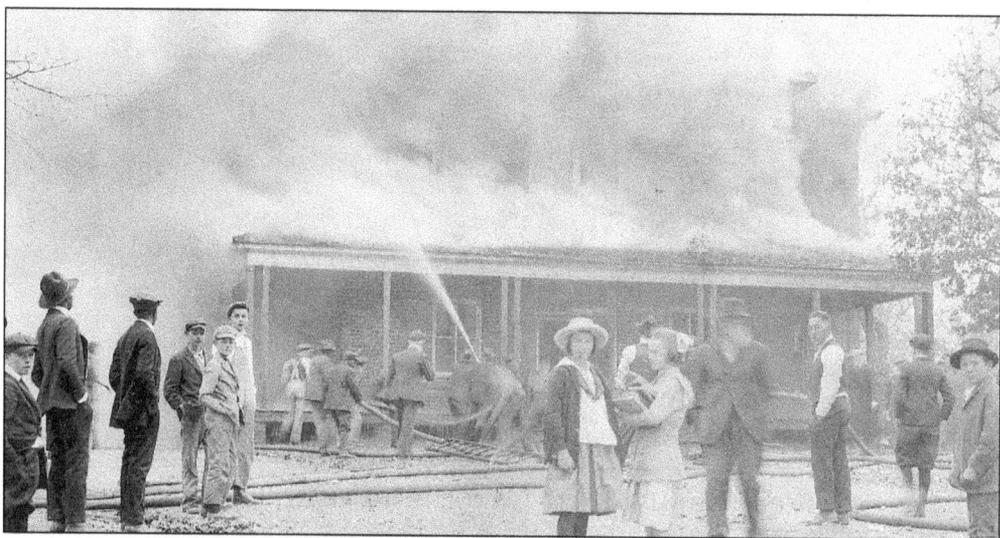

Students wait anxiously as smoke billows from the Graded School during a 1920 fire. Despite heavy damage, the venerable building was later refurbished. (Stanly County Museum.)

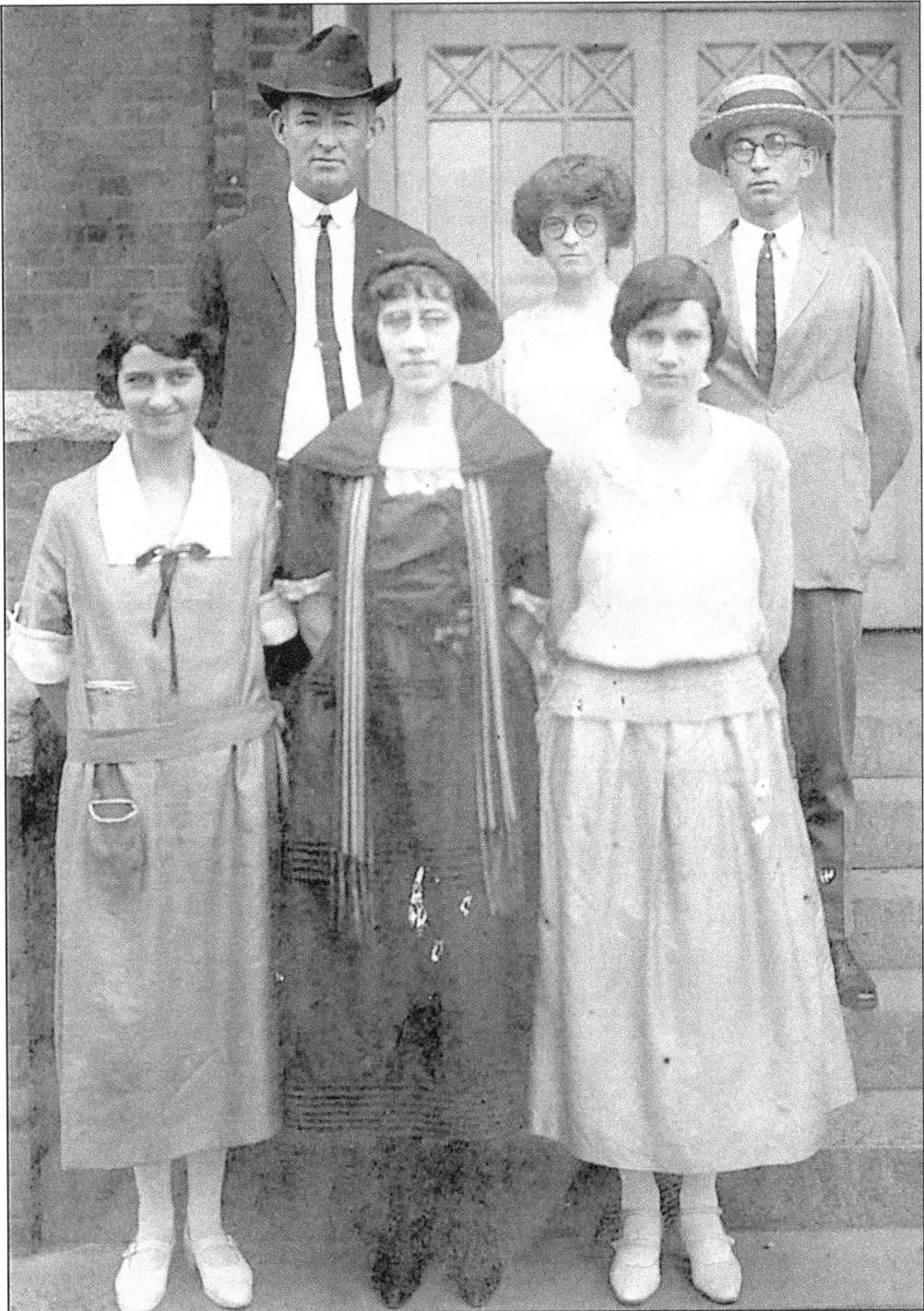

Faculty members of the Albemarle Graded School gathered for this photograph the year after their school's devastating fire. They are, from left to right, as follows: (front row) Mary Liles and two unidentified women; (back row) Principal McKeever, Kate Pridgen, and Rex Stephens. (Stanly County Museum.)

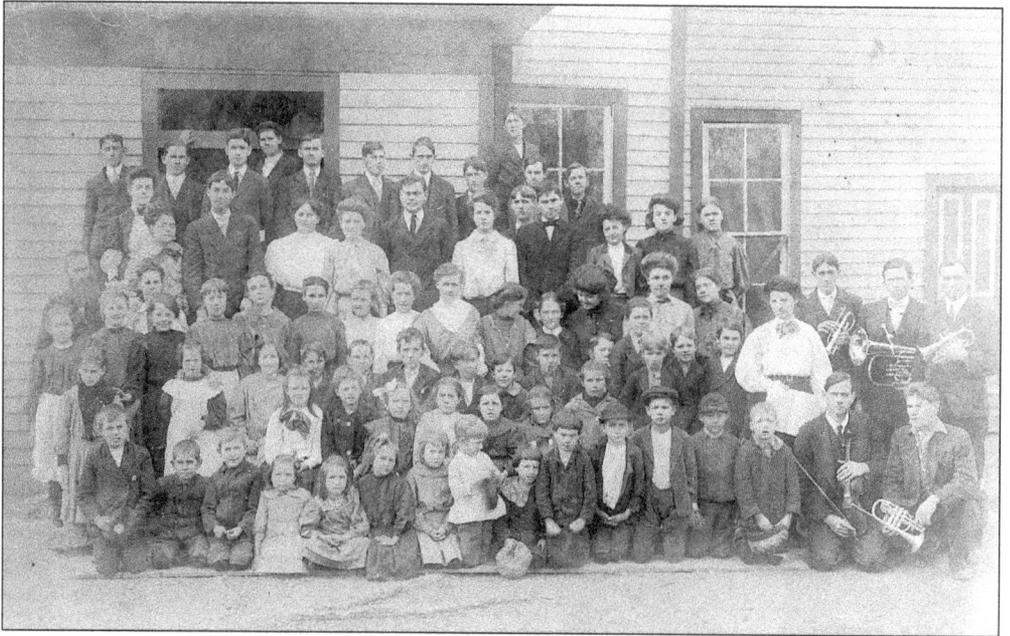

Palmerville Academy students face a new century in this detailed image from the early 1900s. The school's orchestra stands with their instruments at right. (Stanly County Museum.)

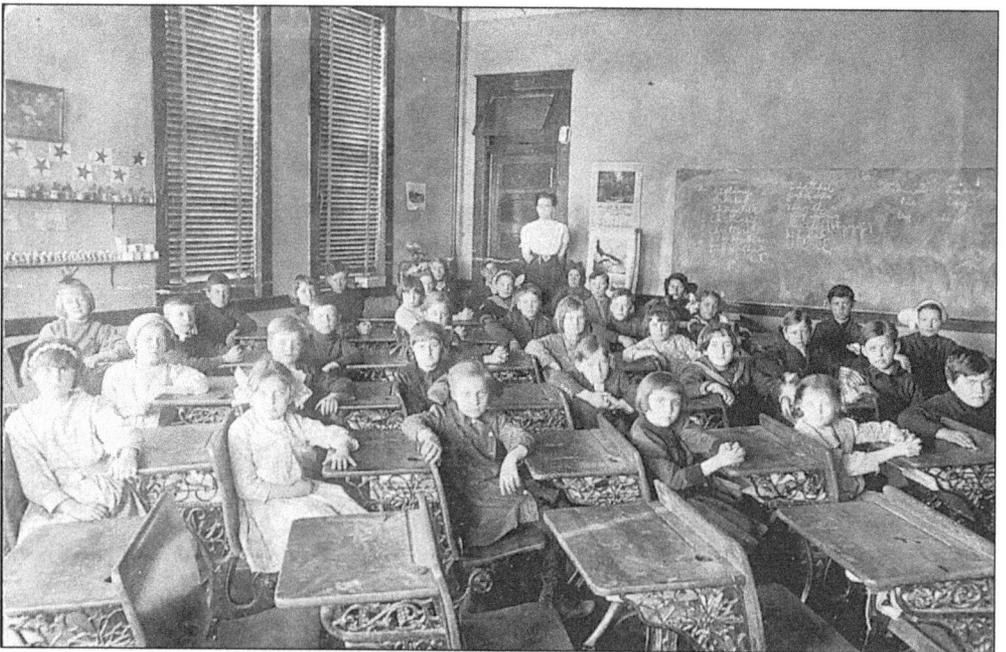

With the day's lesson already on the board, students in Patty Marks's classroom have their work cut out for them. The image dates from about 1910. (Stanly County Museum.)

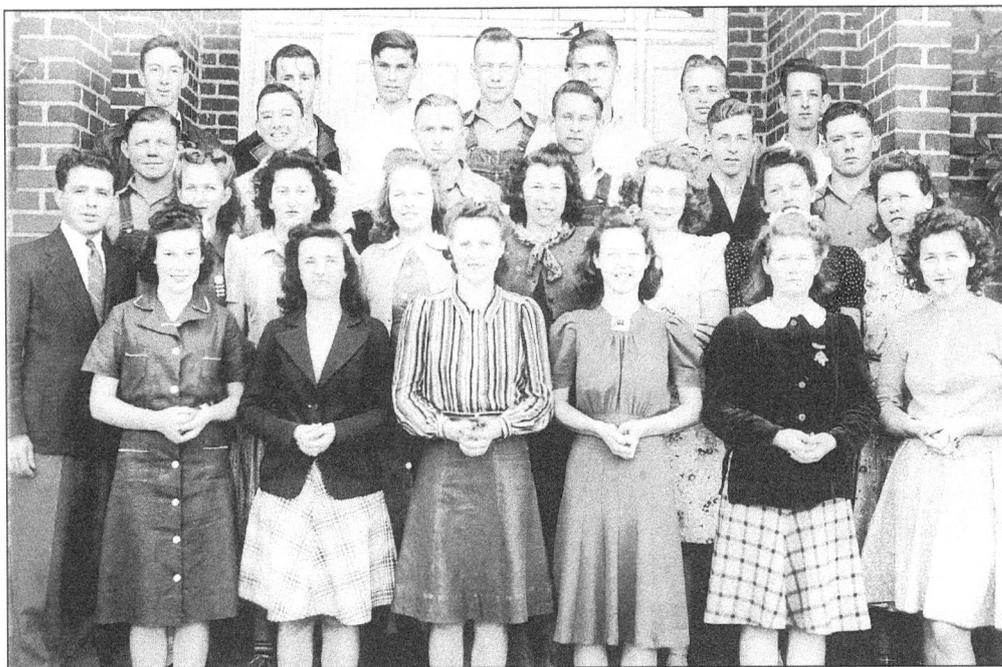

Though World War II rages overseas, Millingport High School's Class of 1942 is nearly all smiles in this group portrait. (Stanly County Museum.)

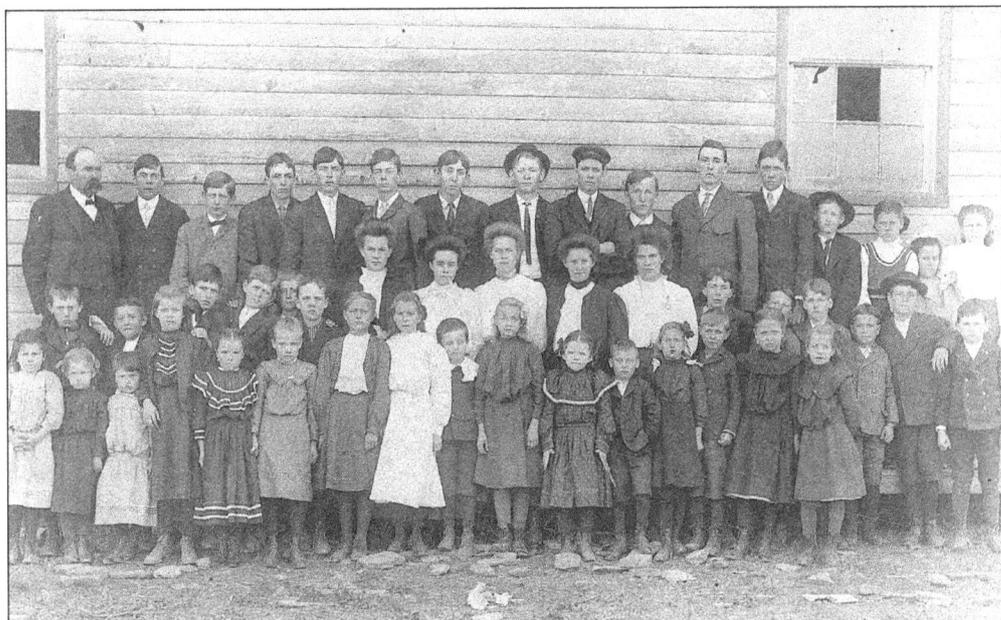

Students at the Palestine School assemble with a member of the faculty (far left) in this image, c. 1905. (Stanly County Museum.)

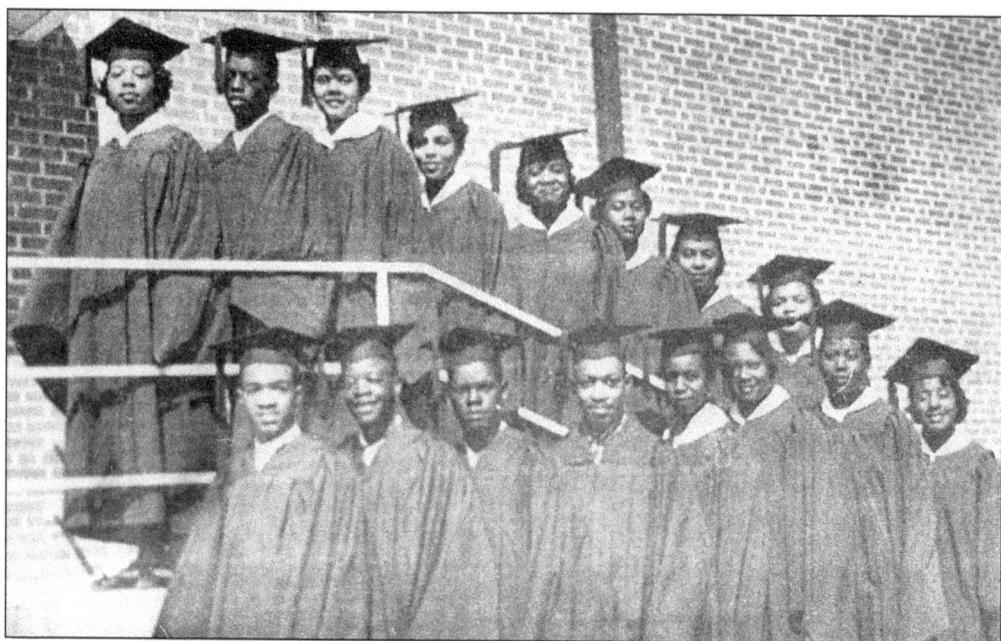

Members of Kingville High School's Honor Society strike dignified poses on the steps of their Albemarle school. Despite the harsh inequities of a racially-divided school system, Kingville High remained a focal point for African-American pride throughout its operation. (Stanly County Museum.)

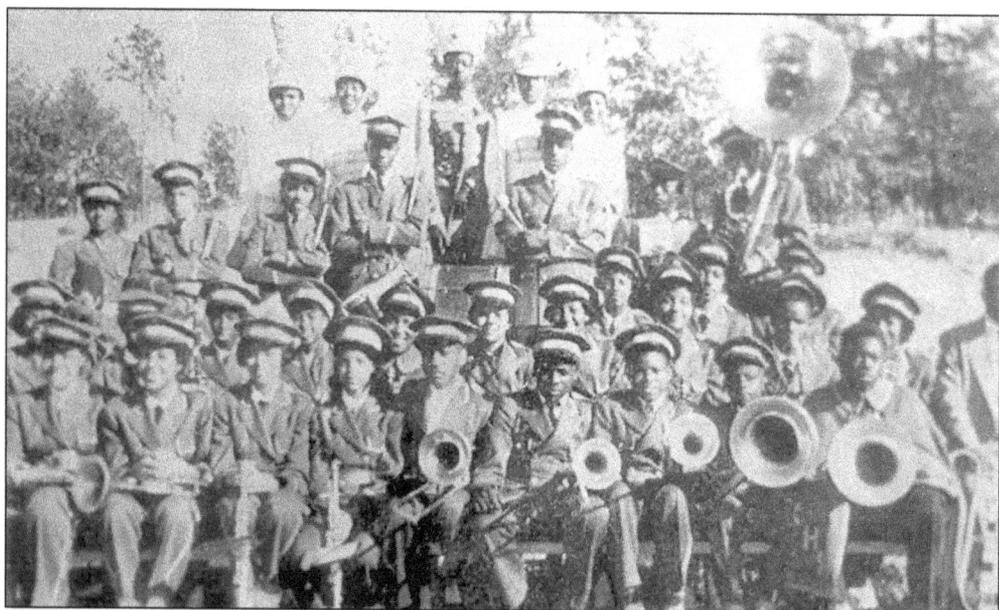

Instruments in hand, Kingville High School's famed marching band gets ready to make some noise in this undated snapshot. The school closed its doors shortly after the desegregation of the county's schools in 1965. (Stanly County Museum.)

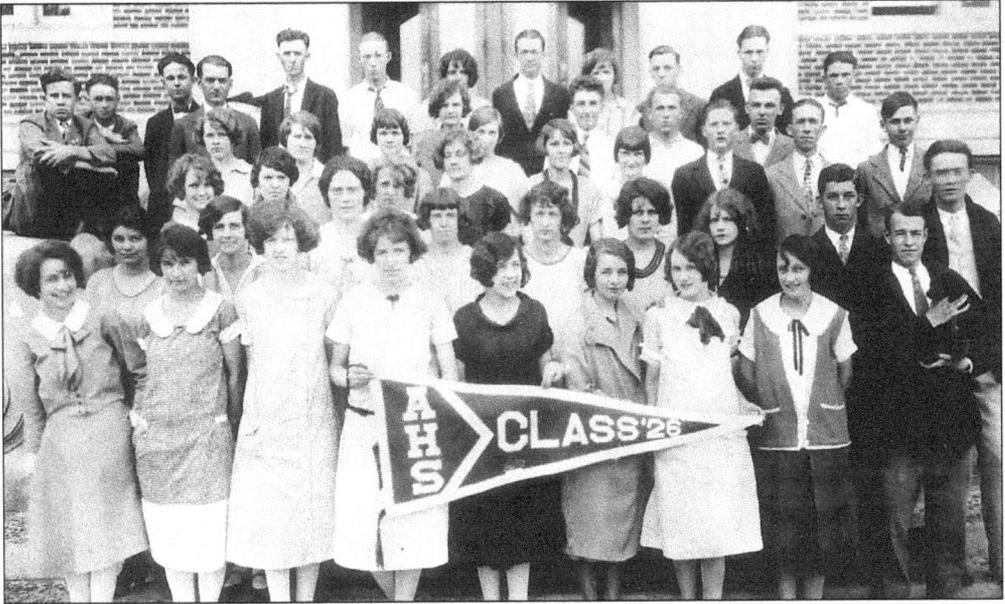

Proudly displaying their class pennant, Albemarle High School's 1926 graduates pose for a group portrait. (Stanly County Museum.)

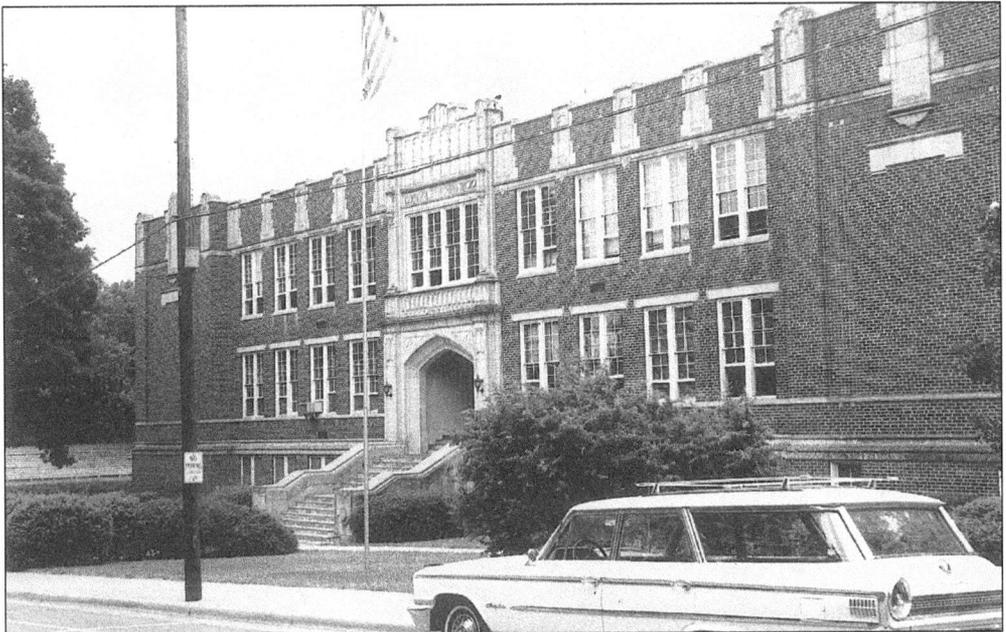

Built in 1924, Albemarle's original high school for white students has since been converted for use as a middle school. The building—seen here in 1965—stands on the town's North Third Street. (Stanly County Museum.)

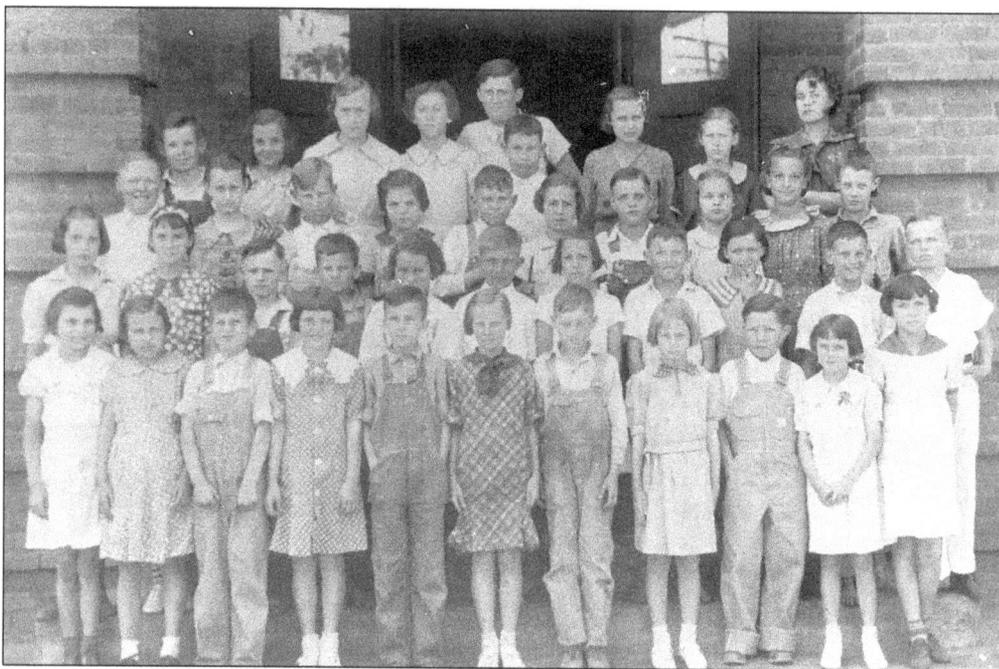

Many of the county's largest textile mills formed their own schools for the children of employees. Students at the Wiscassett Mill School in Albemarle pose with their teacher in this 1932 image. (Stanly County Museum.)

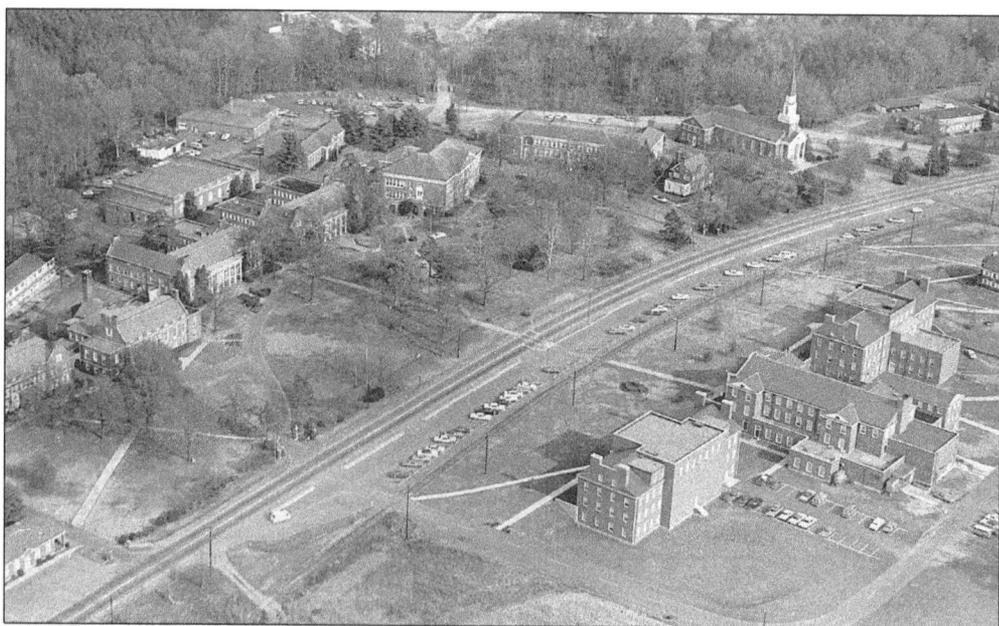

Pfeiffer University in Misenheimer flanks both sides of U.S. 52 in this aerial view from the early 1970s. Once confined to just 10 acres, the school's growing campus had spread across 365 acres by 1992. (Stanly County Museum.)

Seven

HOMES, HEARTHS, FRIENDS, AND FAMILIES

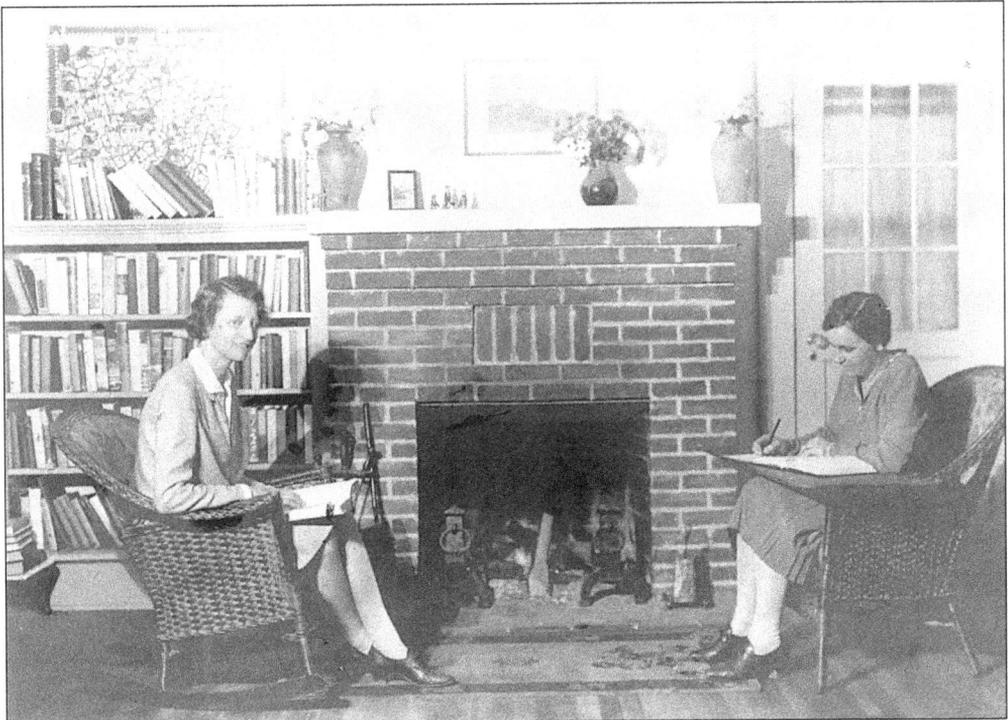

Stanly County native Patty Marks—seated here at right—and longtime friend Nora Beust of Chapel Hill relax around the hearth in this undated image. Both women were lifelong educators. (Stanly County Museum.)

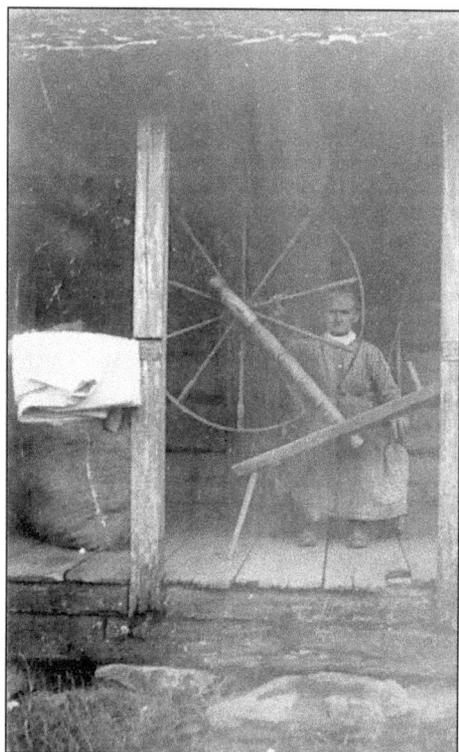

A log home's front porch shelters an unidentified woman and her spinning wheel in this early photograph. In addition to cooking, cleaning, and childrearing, rural women were also expected to make and mend a family's clothing. (Stanly County Museum.)

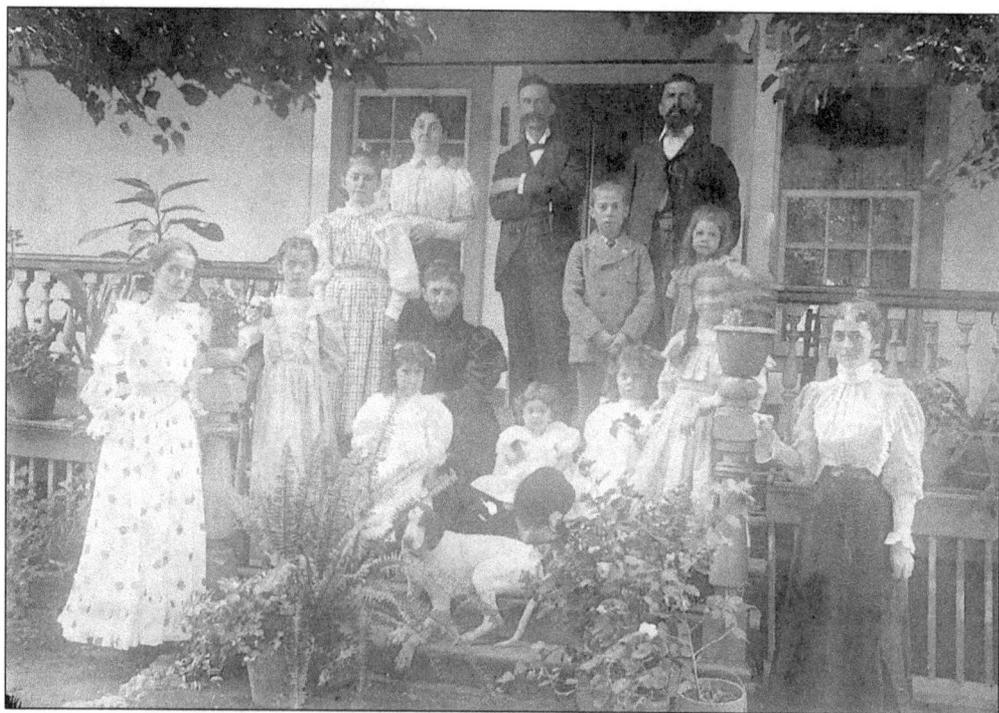

Sidney Hannibal Hearne's family gathers together at his home on Albemarle's South First Street for an 1896 portrait. (Stanly County Museum.)

100

Lena Spinks and a friend share a conversation over a picket fence. (Stanly County Museum.)

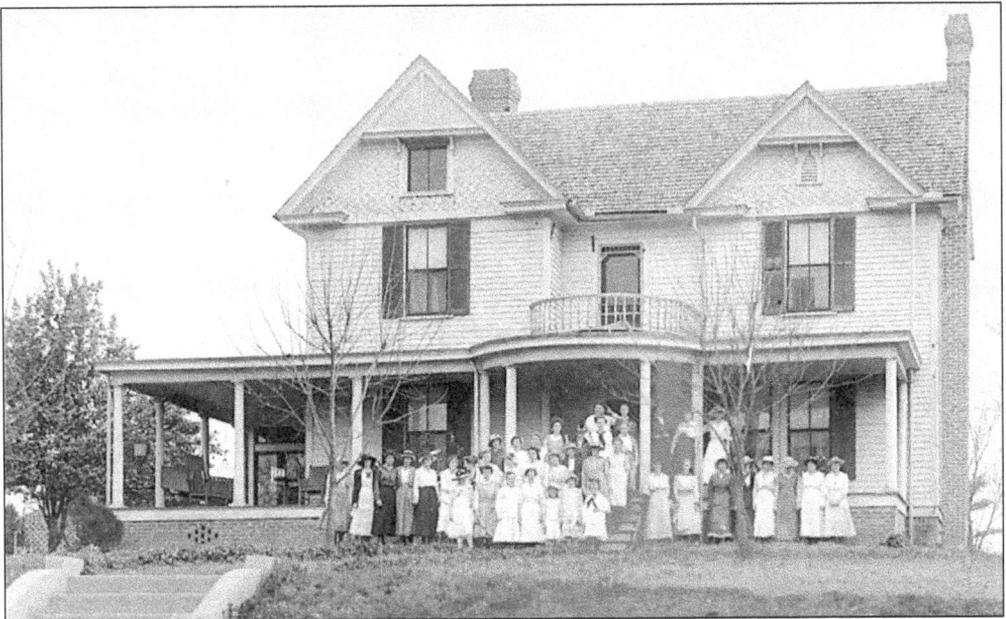

Friends and family gather on the lawn and steps of the Reynolds House on Albemarle's East Main Street. Built between 1910 and 1915, the handsome home survives. (Stanly County Museum.)

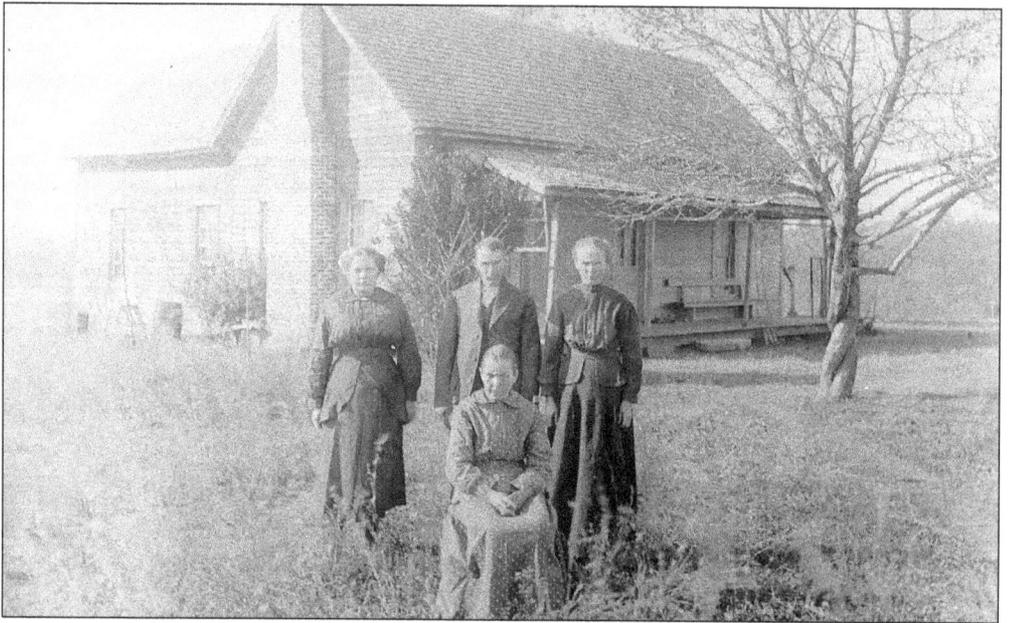

Nancy Lambert Furr sits in her front yard near Bear Creek with 3 of her 12 children. Standing from left to right are Flora Belva Furr, Eldridge Walton Furr, and Mally Alie-Ann Furr. Nancy Lambert and her husband, Ransom, built the house themselves. (Stanly County Museum.)

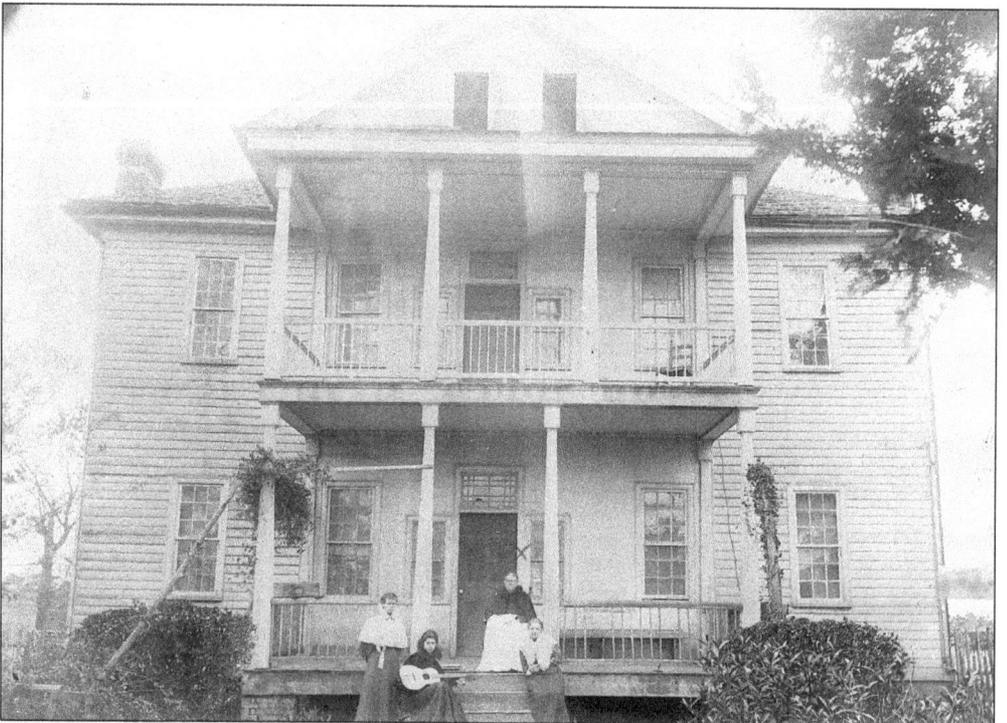

Members of the Shankle family pose on the steps of their antebellum plantation home near Norwood, *c.* 1870. A devastating 1998 fire reduced the house to ashes. (Stanly County Museum.)

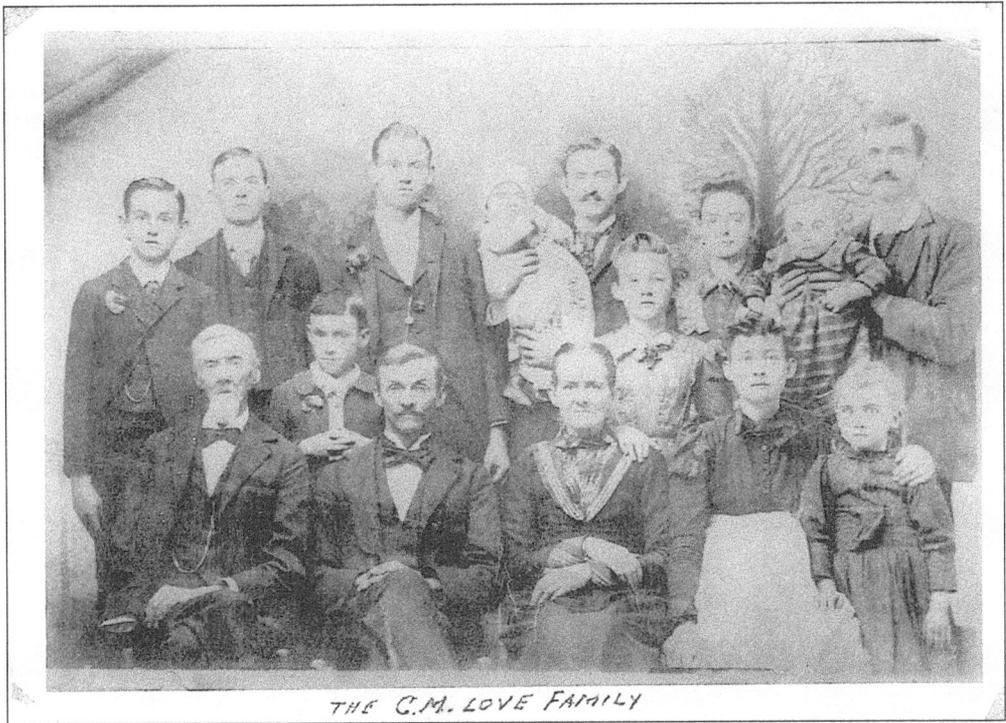

The C.M. Love family poses together for a nineteenth-century studio portrait. (Stanly County Museum.)

Patty Marks told the county's historic preservationists they could have her family's old cottage, seen here on the left, but only after her garden was done for the year. The Marks House—also pictured opposite the title page—turned out to be the oldest home in Albemarle. (Stanly County Museum.)

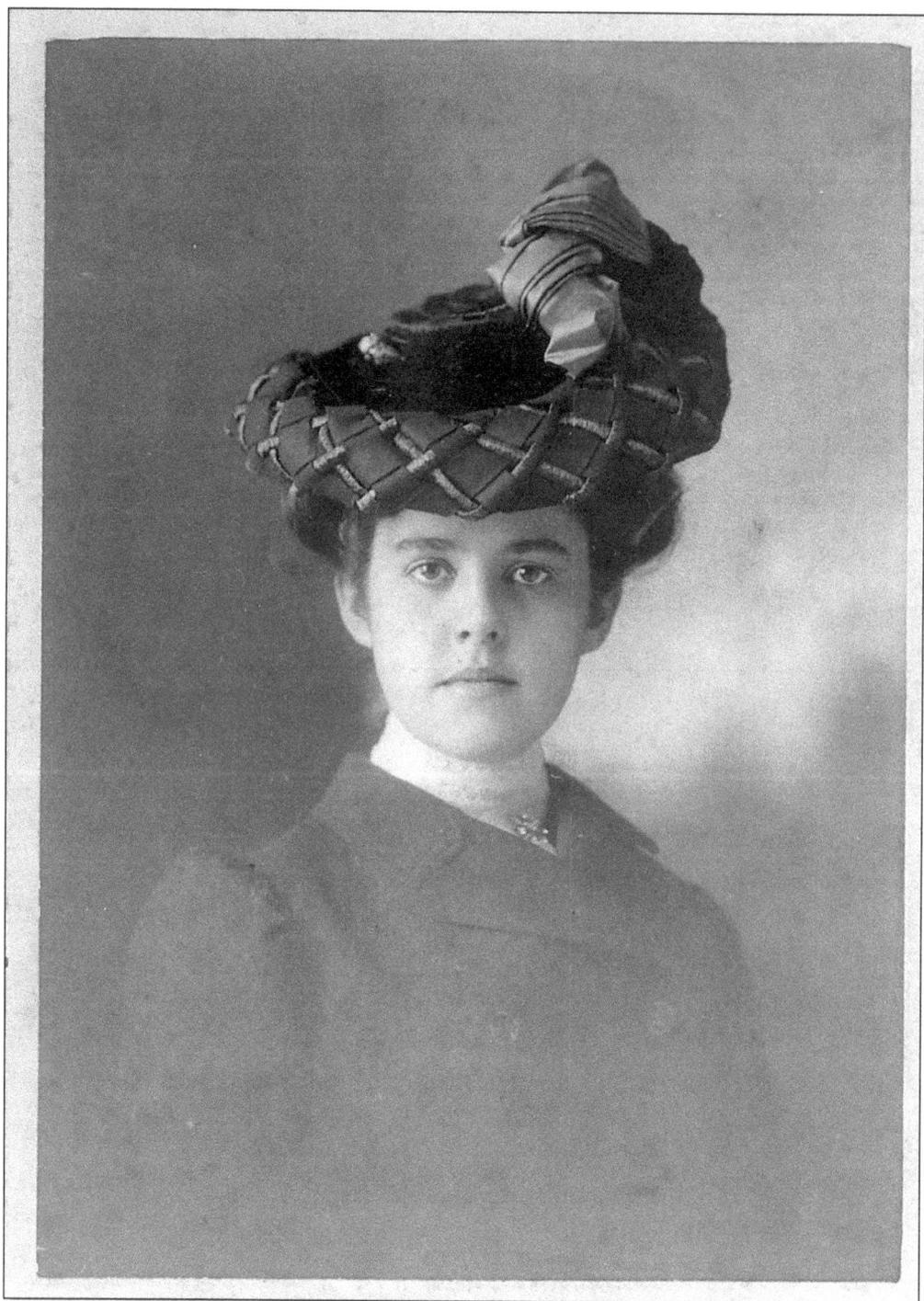

Edwardian fashions frame Mary H.K. Townsend in this undated studio portrait. (Stanly County Museum.)

Margaret Ellen (with bow) and Pat Patterson take a ride up Albemarle's East North Street on a fine day in 1913. Note the town's old plank sidewalk in the foreground. (Stanly County Museum.)

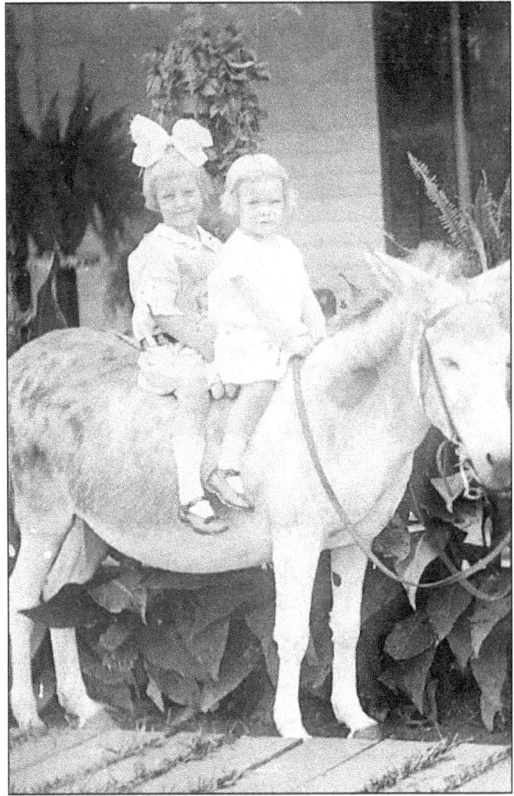

Sidney Hannibal Hearne, age 84, pauses on the grounds of the Albemarle Normal & Industrial Institute. (Stanly County Museum.)

Elmina Hearne takes her new baby sister Ellen out into the fresh air for a 1924 snapshot. (Stanly County Museum.)

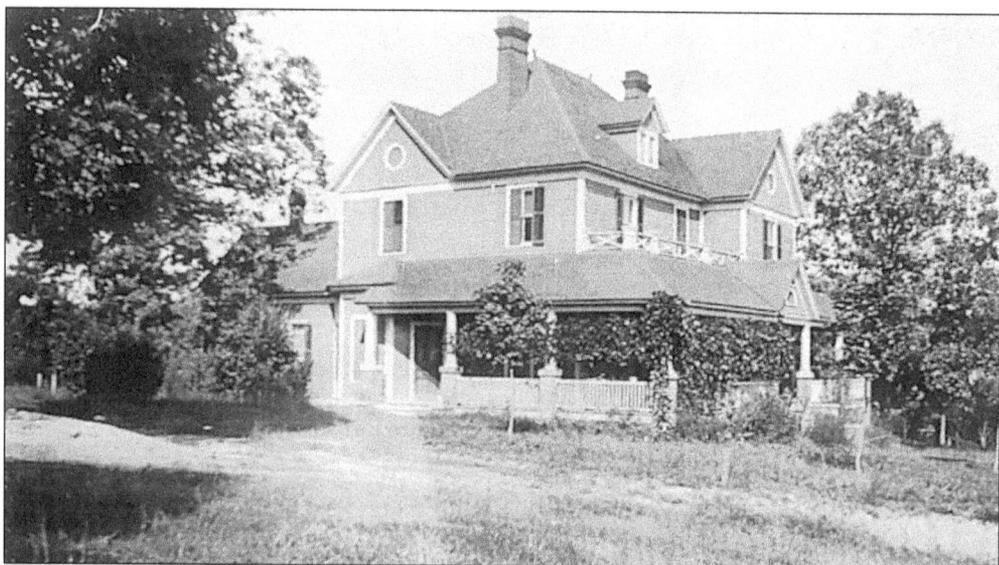

Dr. V.A. Whitley's homeplace once stood on Albemarle's East North Street. (Stanly County Museum.)

Laura Hearne Henning sits for a 1922 studio portrait with son Dick and daughter Frances. (Stanly County Museum.)

Two unidentified boys pose in a photographer's studio, *c.* 1920. (Stanly County Museum.)

Seated at her piano, Margie Mauney strikes a thoughtful pose. For years, worshippers at Albemarle's Central Methodist Church enjoyed Mauney's talents as an organist. (Stanly County Museum.)

Mabel Pennington poses with a utilitarian structure common to county backyards in the days before plumbing. (Stanly County Museum.)

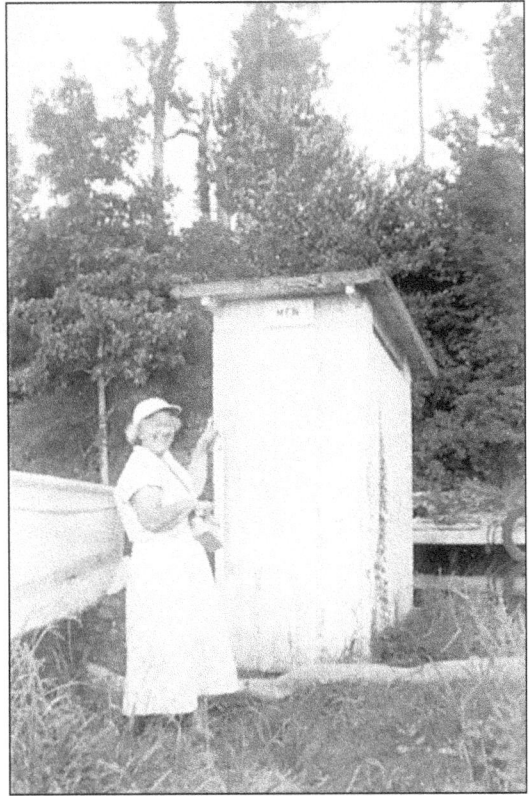

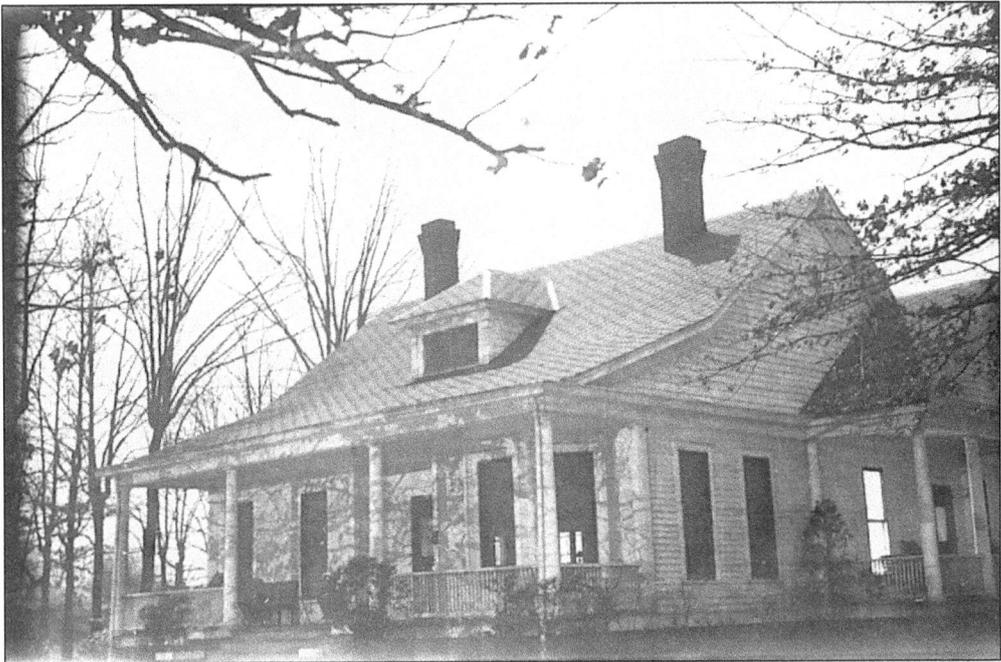

Moonlight shadows streak across the Morrow family home in this unusual nighttime image. The house once stood on Albemarle's Pee Dee Avenue. (Stanly County Museum.)

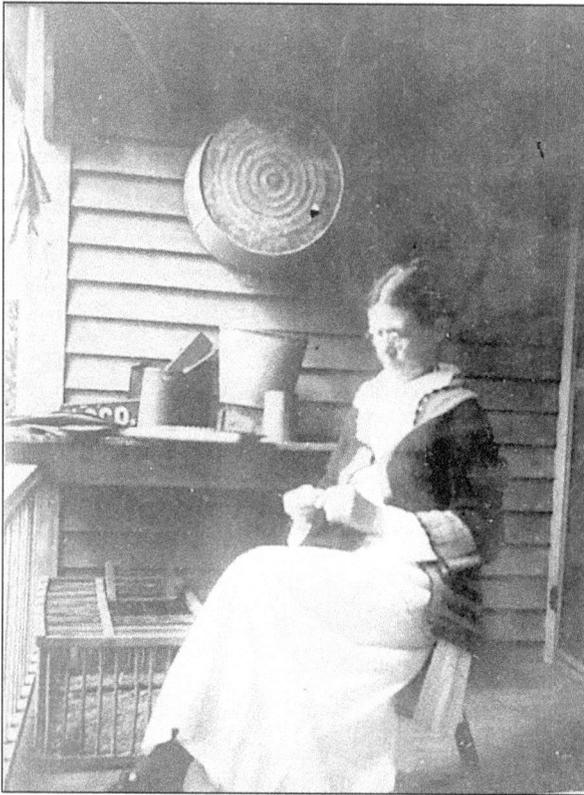

Geraldine Watkins knits on the porch of her Albemarle home. A washpan hangs on the wall behind her. (Stanly County Museum.)

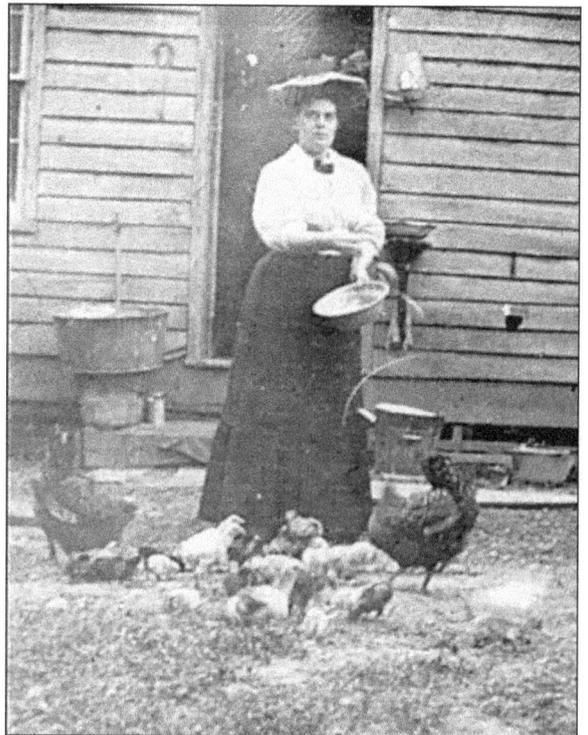

Hungry chickens gather around an unidentified woman in this turn-of-the-century image. The house is thought to have once stood on Albemarle's Second Street. (Stanly County Museum.)

Eight

LAZY DAYS

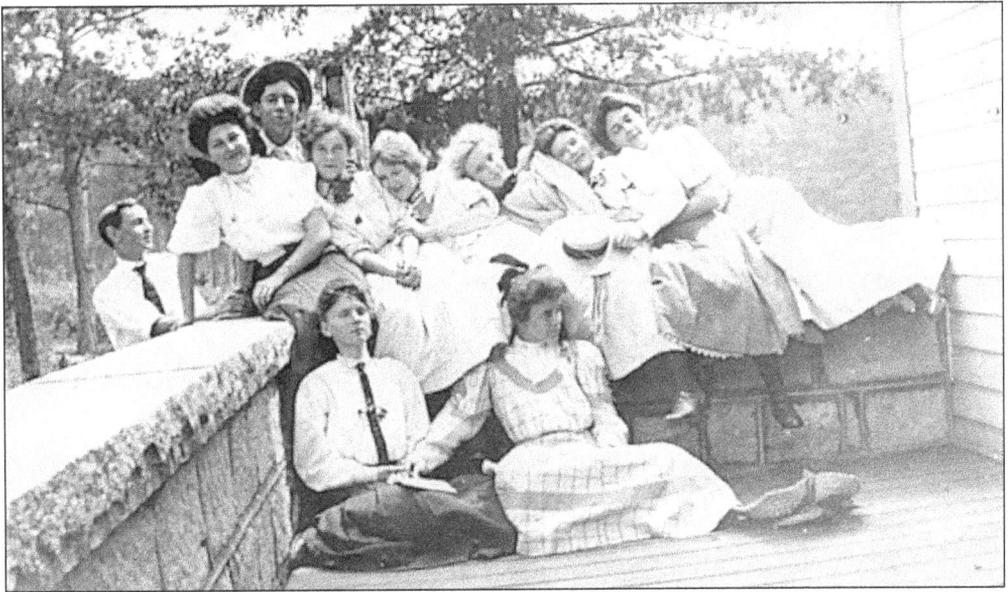

In June 1907, even picnics at the old Whitney Clubhouse called for dressing up. Though not all are pictured here, the outing included Kathleen Whitfield, Etta Belle Stevens, Pauline Whitley, Isabelle Grier, Ellen Harris, Maggie Ewing, Lanny Bostian, Velma Morrow, Lu Morrow, Willie Pemberton, Frank Rose, Will Whitley, and Gregory Mabry. (Stanly County Museum.)

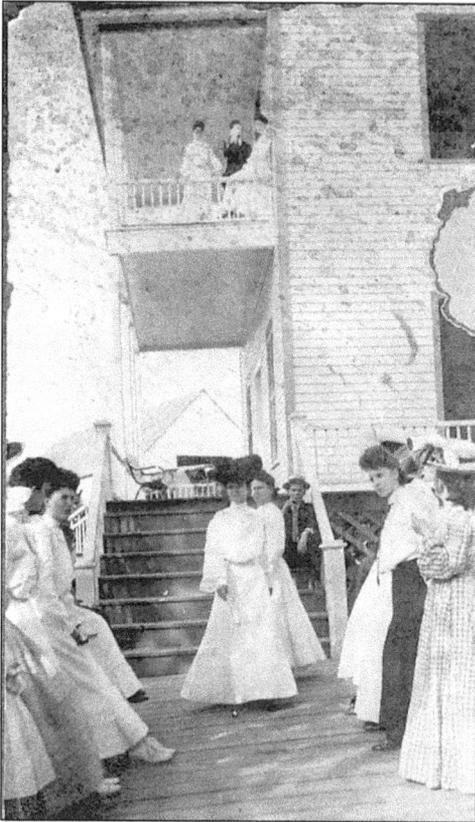

Fashionable guests at the Rocky River Springs Hotel near Aquadale take in the late afternoon air in this undated image. The building has long since vanished. (Stanly County Museum.)

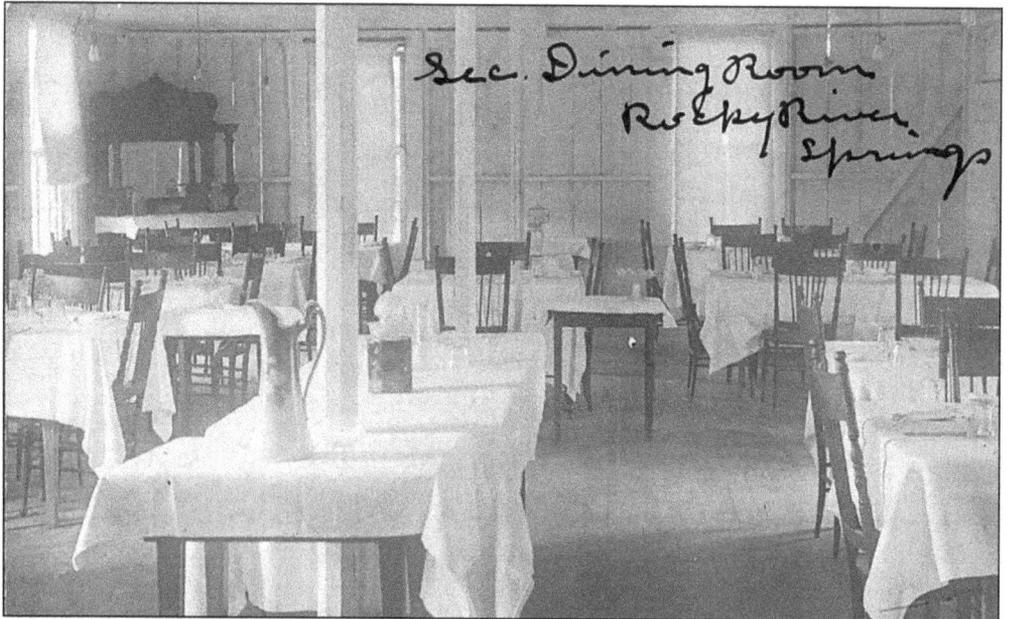

Sec. Dining Room Rocky River Springs

Freshly-set tables await diners in this 1910 postcard view of the Rocky River Springs Hotel dining room. Newfangled electric bulbs dangle from the ceiling. (Stanly County Museum.)

Well-dressed picnickers explore the falls of the Yadkin River in this early-twentieth-century scene. The site now lies submerged under Badin Lake. (Stanly County Museum.)

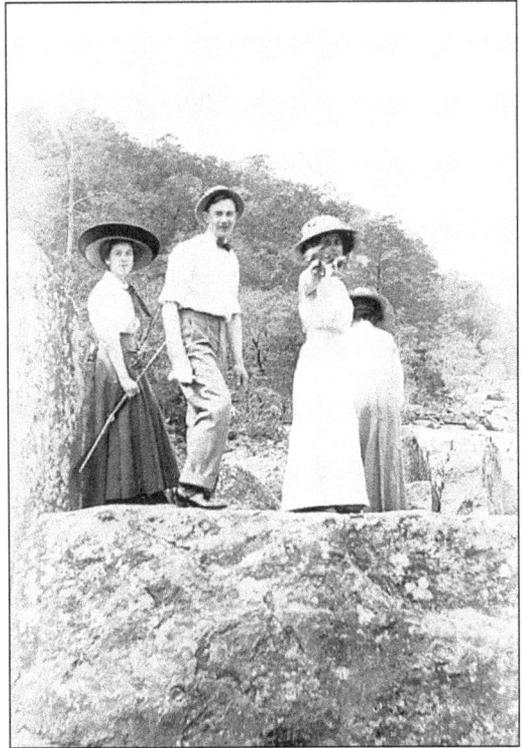

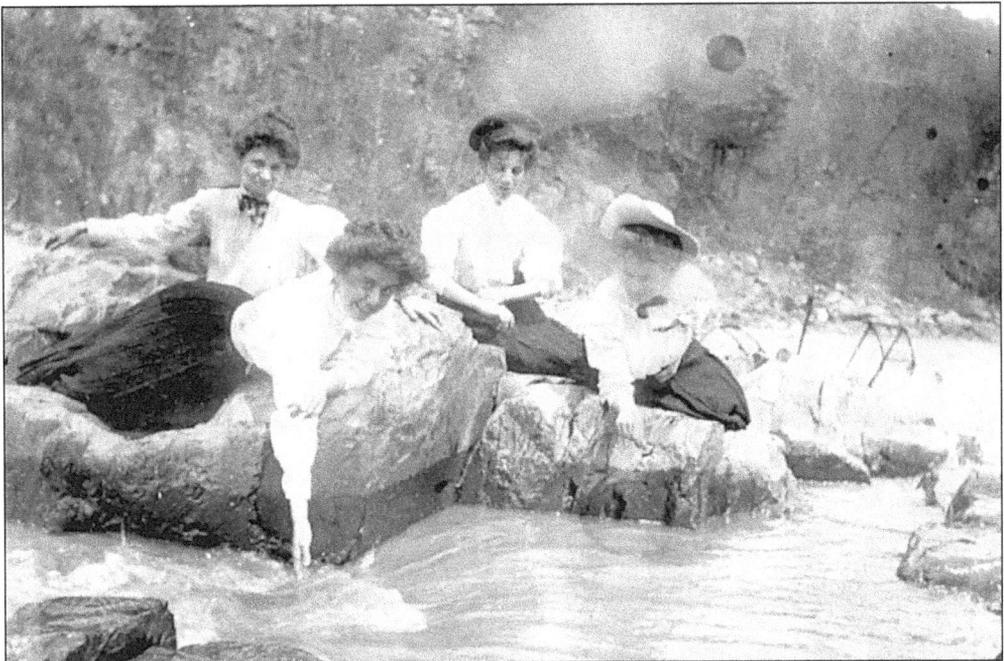

Waters of the Yadkin River swirl around four friends on a country outing. Though the county's roads were seldom up to the task, the automobile made day trips into the countryside relatively easy. (Stanly County Museum.)

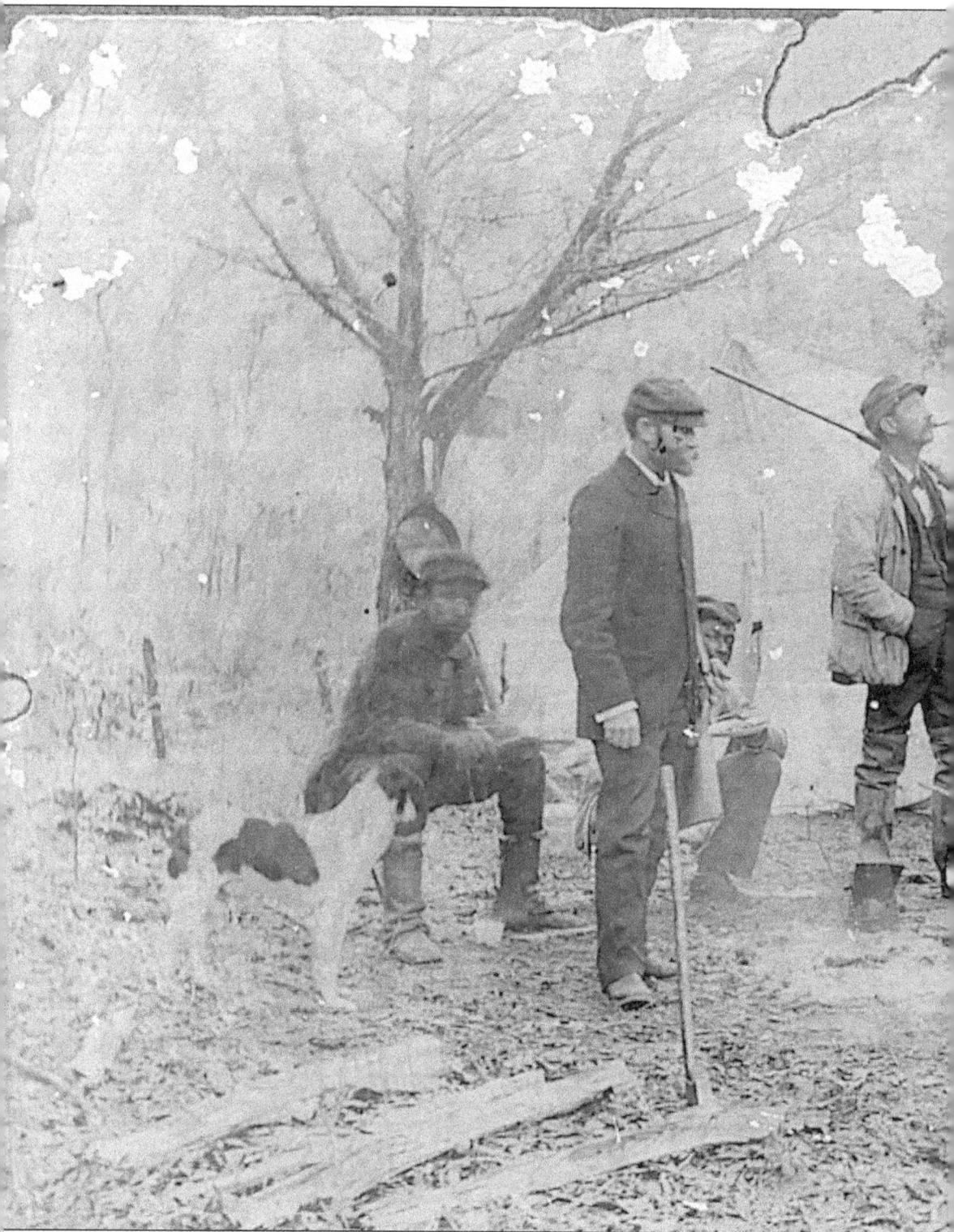

As a member of their party scans the skies, a group of hunters and their dogs prepare for the

day's outing. The scene is undated. (Stanly County Museum.)

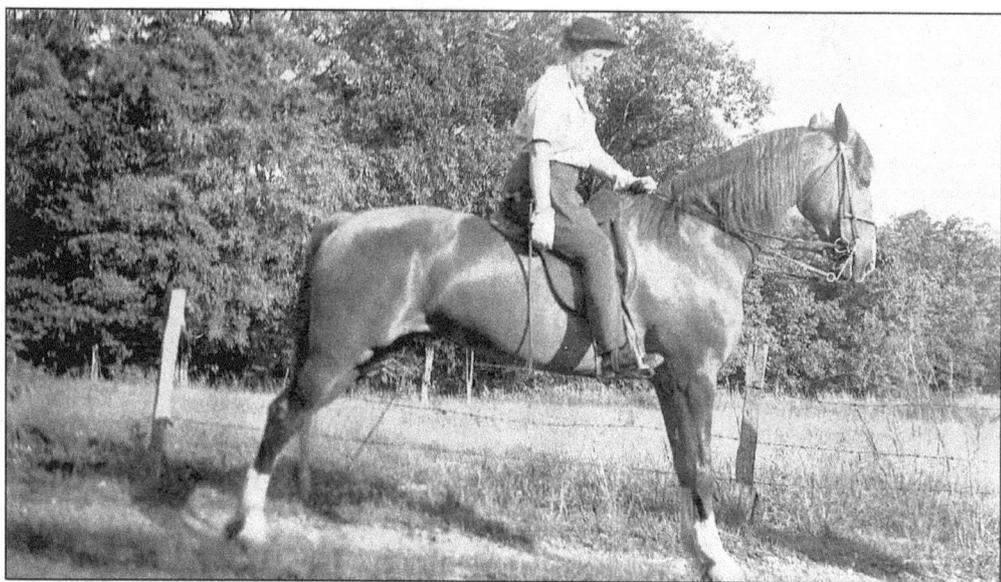

Nelle Groves and her horse strike a fine pose during a leisurely ride. (Stanly County Museum.)

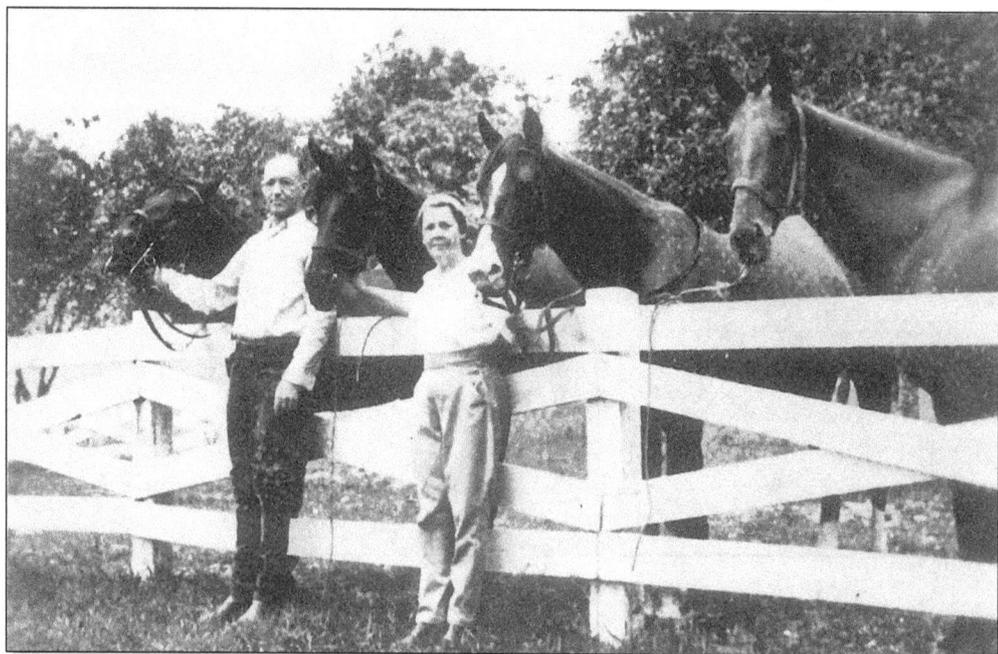

Nelle and J.A. "Governor" Groves stand with friends Bill, Tuck, Sunshine, and Dan. (Stanly County Museum.)

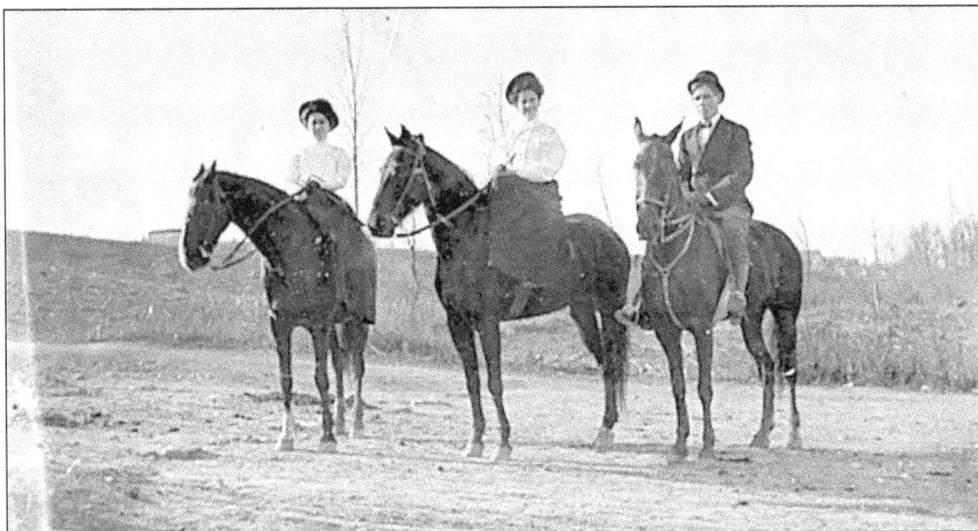

A bright day finds members of the Hearne family out for a country ride. (Stanly County Museum.)

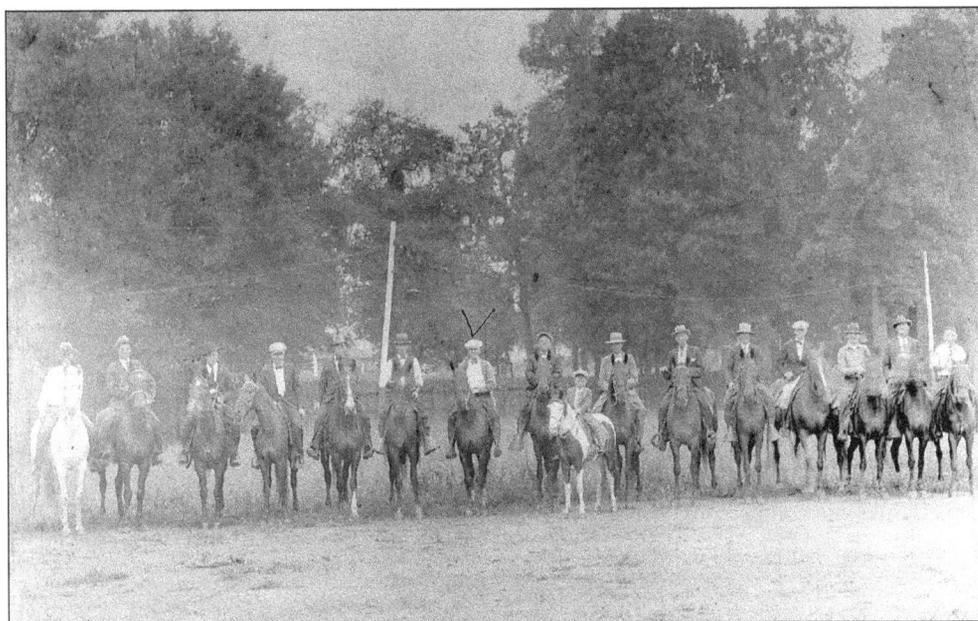

A young rider and his pony stand before horses and riders of the Albemarle Riding Club, c. 1918. The arrow at center marks James A. Harward; other riders are unidentified. (Stanly County Museum.)

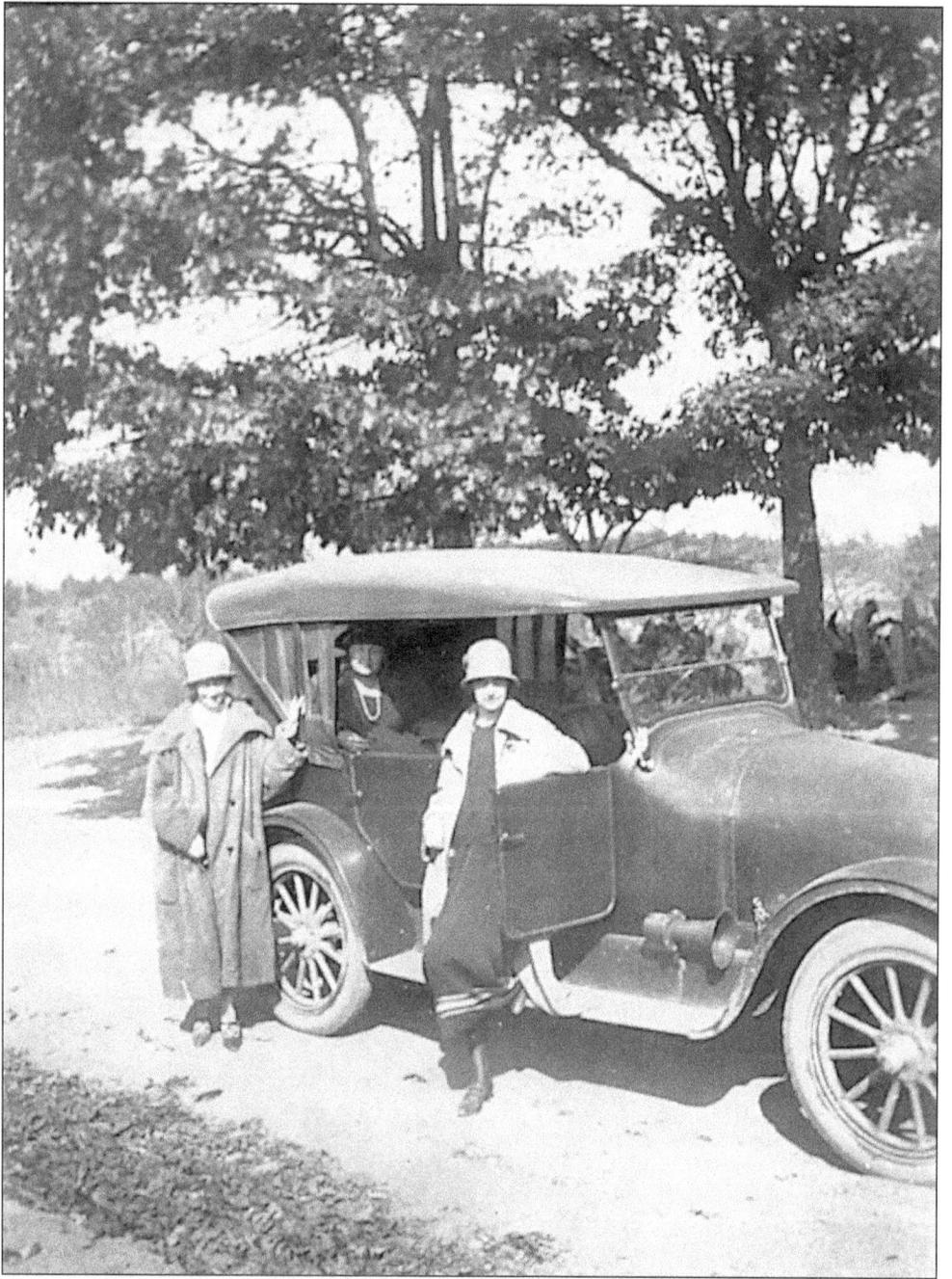

Lena Spinks and companions pose with a vintage sedan. (Stanly County Museum.)

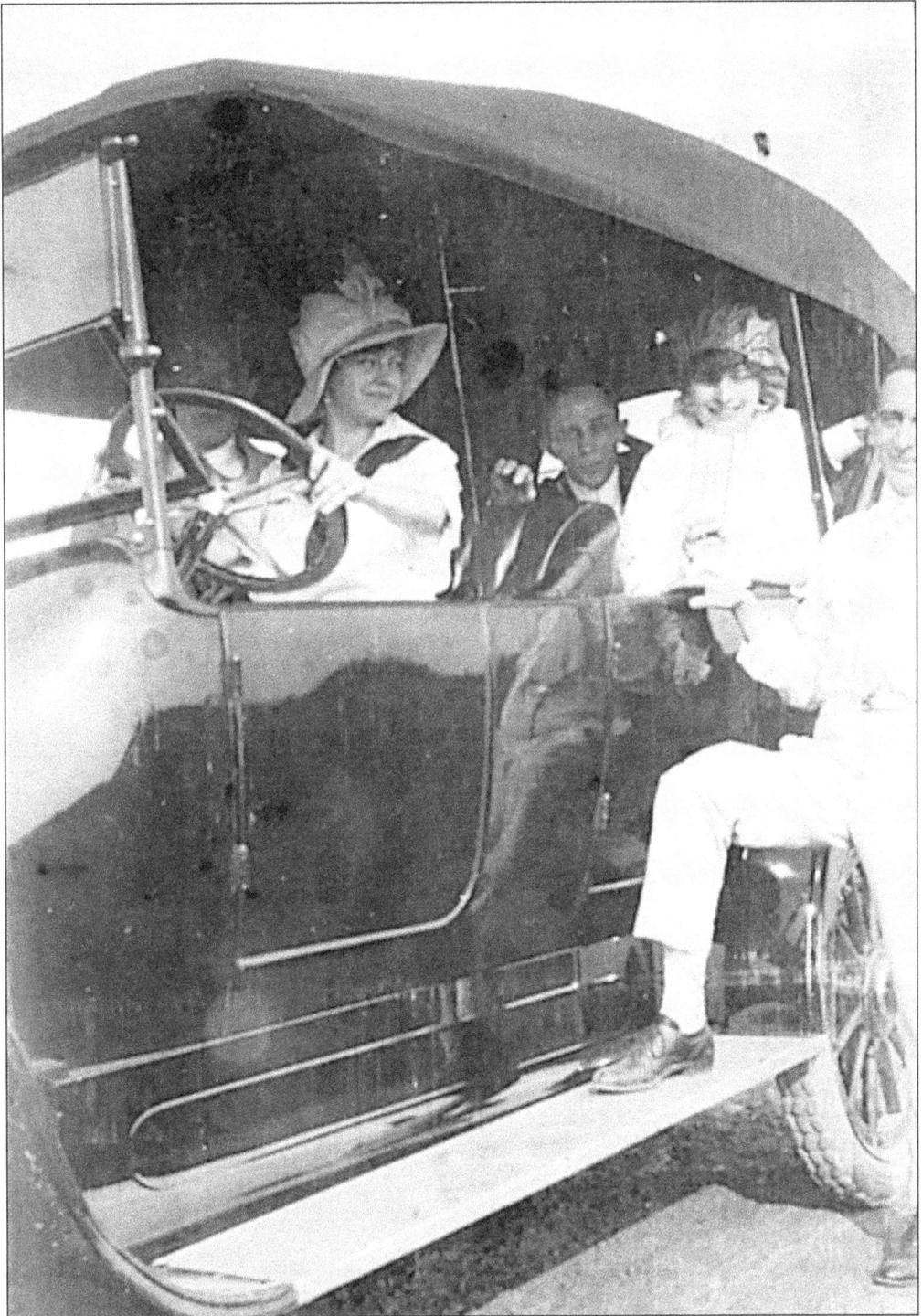

Mary Biles Nunally—second from left—and friends seem ready to hit the road in this undated snapshot. (Stanly County Museum.)

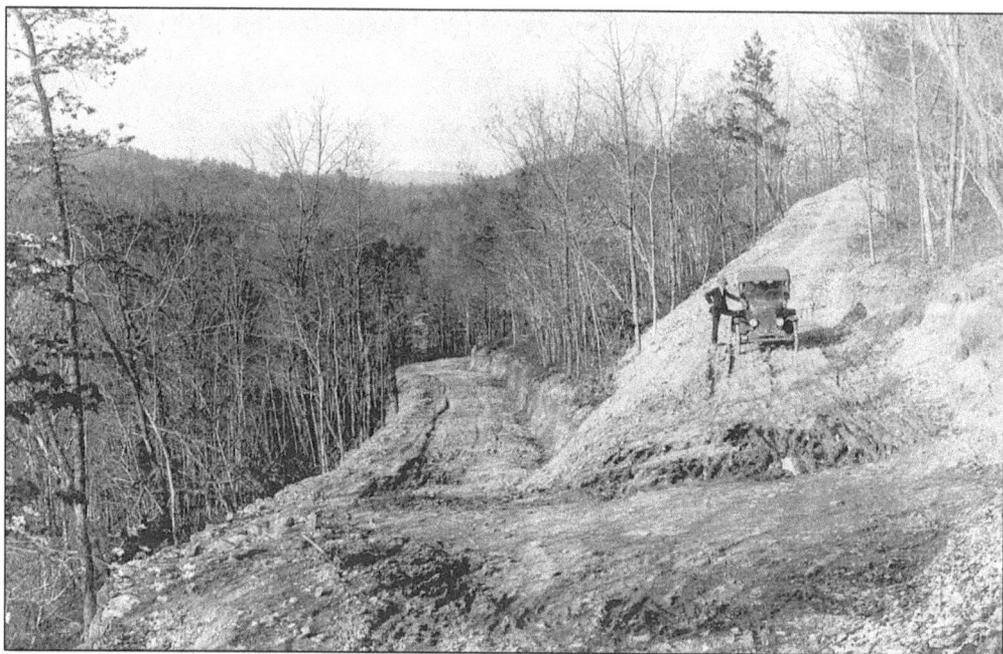

With its bicycle tires, this vintage auto has done well to make it this far up Morrow Mountain. County residents had long recognized the area's natural beauty when plans were formulated in the 1930s to designate the mountain as public parkland. Standing next to the car is park founder J.M. Morrow. (Stanly County Museum.)

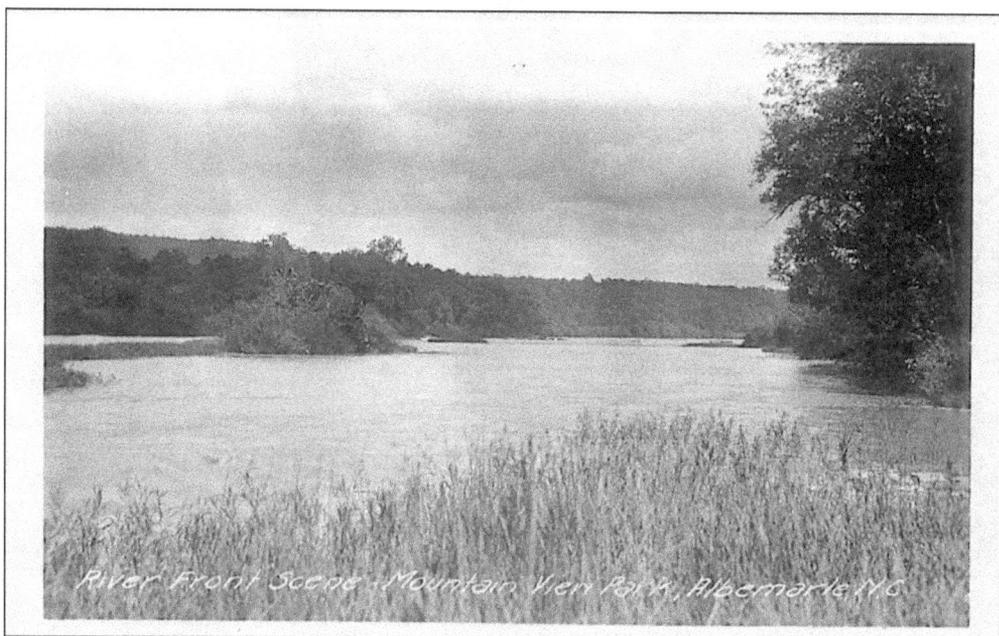

"River Front Scene—Mountain View Park," reads the caption on this 1930s-era postcard. The unspoiled area was formally designated as Morrow Mountain State Park in 1940. (Stanly County Museum.)

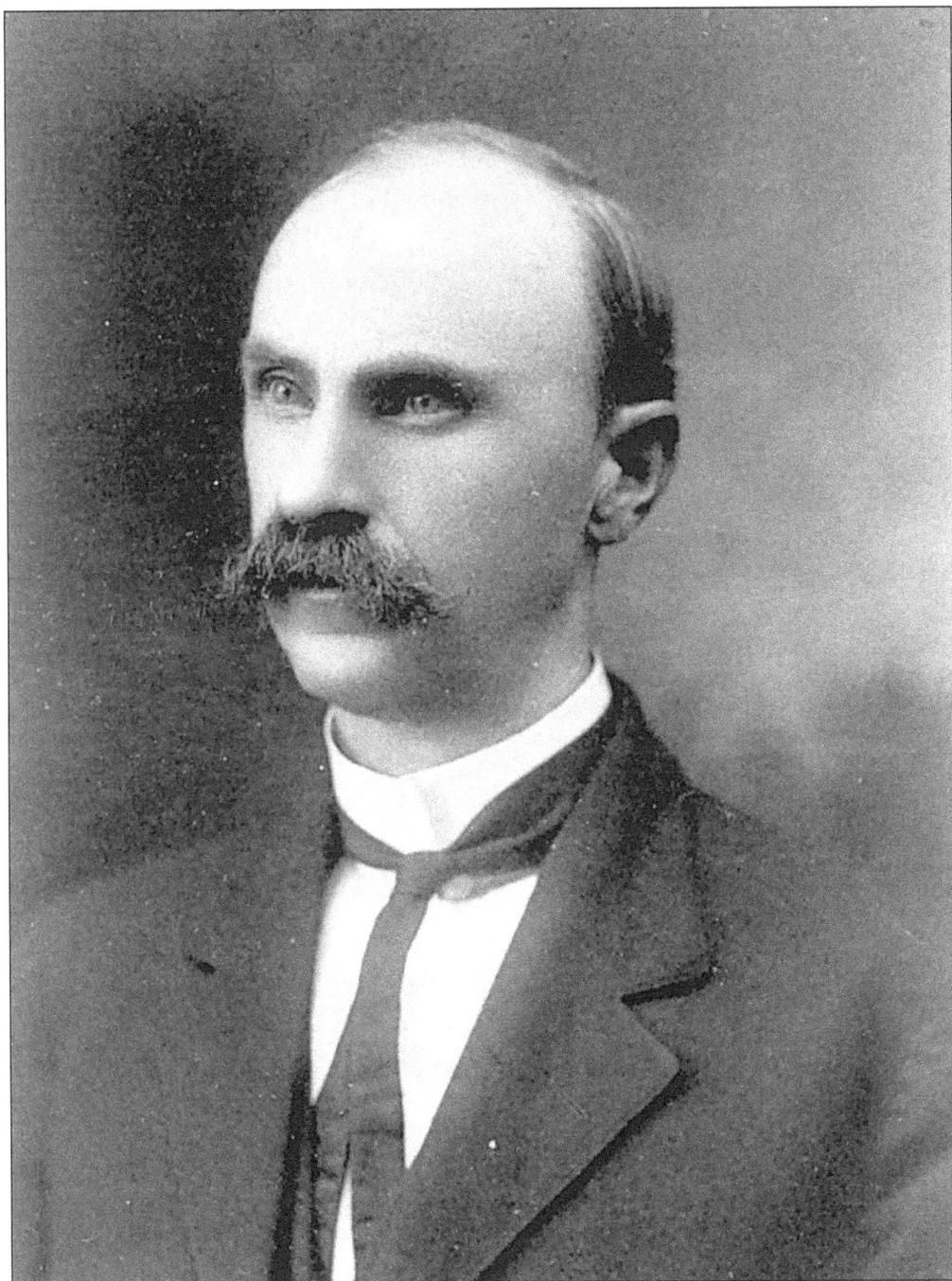

James McKnight Morrow saw great potential in his 1,800 acres of undeveloped land in eastern Stanly County—but not in an economic sense. Instead, Morrow donated his holdings to the State of North Carolina, forming the core of the park that today bears his name. (Stanly County Museum.)

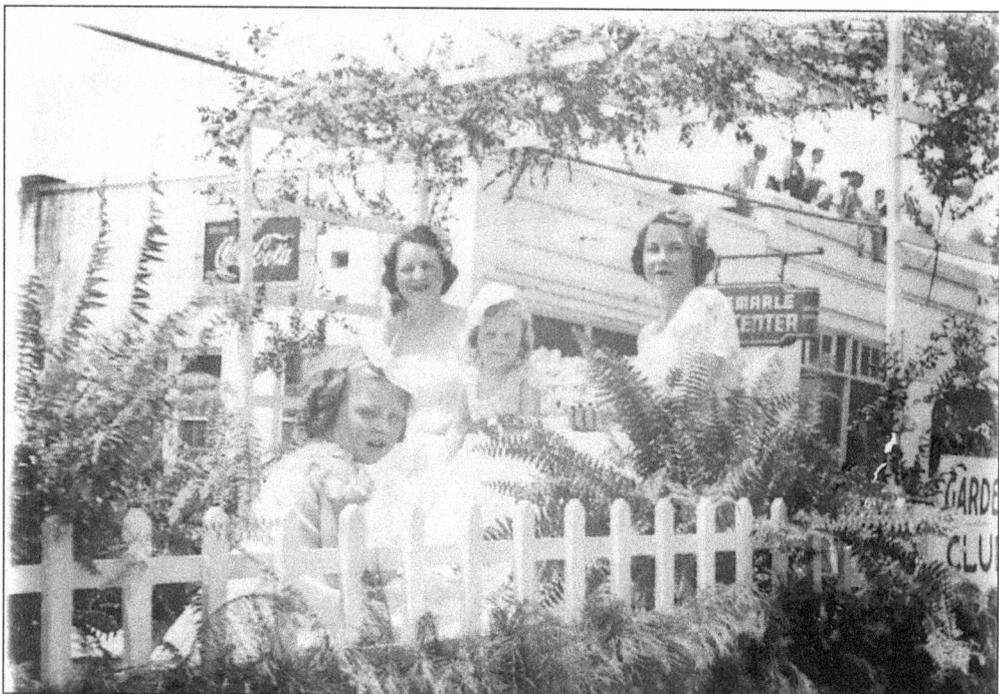

Spectators crowd a nearby rooftop as Stanly County residents celebrate the dedication of Morrow Mountain State Park in 1940. Lucky enough to ride a parade float down Albemarle's Main Street are, left to right, Ann Daniel, Annie Rae Harris, Martha Rae Harris, and Charlotte Brunson. (Stanly County Museum.)

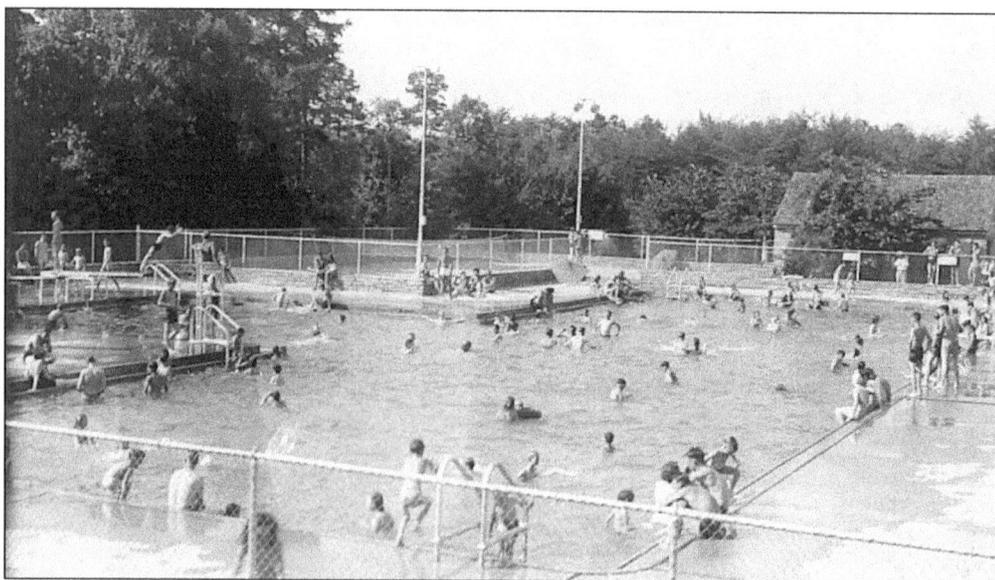

Open at last, Morrow Mountain State Park's pool fills with swimmers during the park's 1940 dedication weekend. (Stanly County Museum.)

Nine

ATHLETES

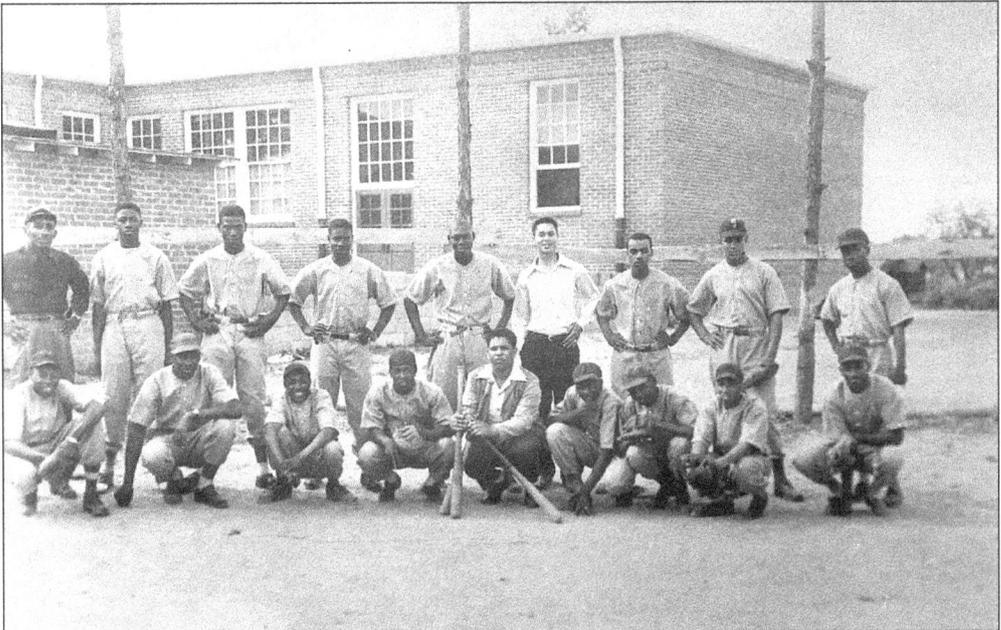

Kingville High School's baseball team assembles with Coach E.E. Waddell for a classic Stanly County sports image, c. 1950. They are, from left to right, as follows: (front row) Bo Ingram, Gene Willoughby, "Bunk" Ingram, Mack Bruton, Stanly Campbell, Phenlo Ellis, Earl Colston, Troy Waddell, and Howard Colson; (back row) Bill Stanton, Tommy Richardson, Odell Lilly, Thomas Smith, Fisher Wall, Coach Waddell, Arnold Flake, Owen Nance, and J.C. Rivers. (Stanly County Museum.)

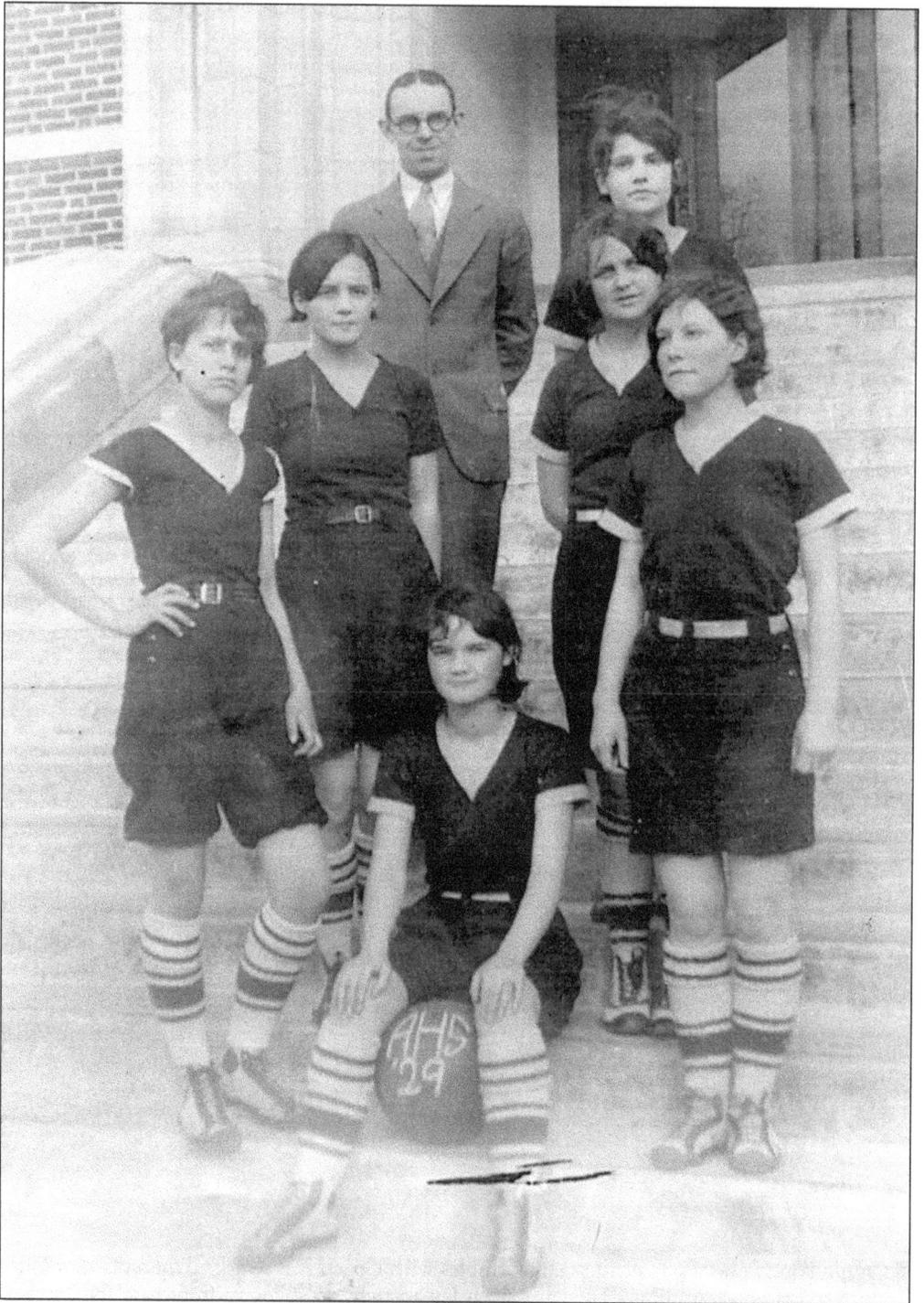

Athletes ahead of their time, Albemarle High's 1929 women's basketball team stands for a group photo. Clockwise from left to right are Lucille Neal, Loretta Kennedy, Coach Meadow, Lydia Lentz, Alma Aderholt, Margaret Casper, and Margurite Kennedy. (Stanly County Museum.)

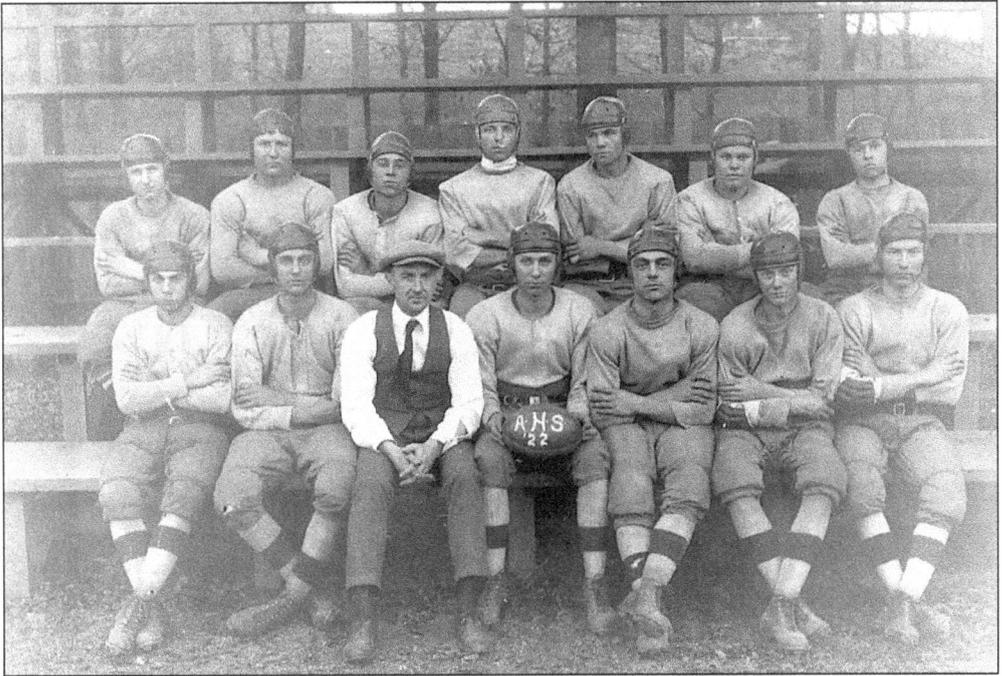

The Albemarle Bulldogs await the start of their 1922 season. They are, from left to right, as follows: (front row) Virgil Whitley, Hoyle Efird, Lee Morrow, Frank Marbry, Ralph Fagan, Steve Davis, and Eddie Crisco; (back row) Dan Boger, Tom Kimrey, Travis Coggins, Ren Burleson, Glenn Lowder, Edward Hinson, and Robert Cranford. Team members David Hinson and Marvin Huneycutt missed the picture. (Stanly County Museum.)

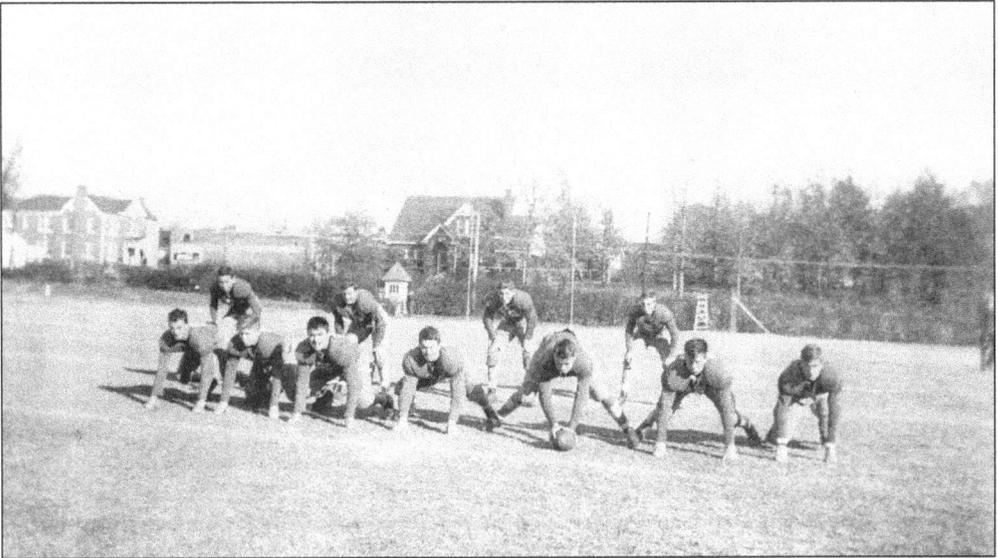

Albemarle High's 1941 football team sets up for gridiron action. Pictured on the line, left to right, are J.B. Long, Grady Brooks, John Kennedy, James Senter, Rembert Rogers, (?) Morton, and Roy Harward; playing the backfield, left to right, are (?) Thompson, William Morrow, Lloyd Skidmore, and Bob Furr. (Stanly County Museum.)

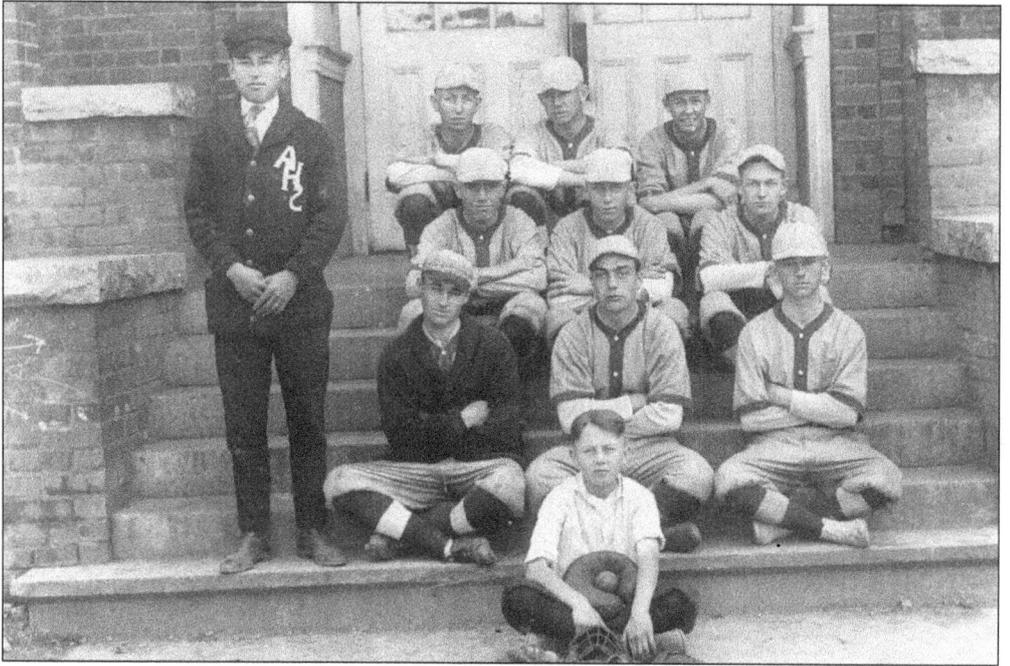

Much has changed in Stanly County since Albemarle High School's baseball team posed for this 1923 photograph; the county's love for the game, however, has not. Seated in the first row are Boyd Hatley, Ralph Fagan, and unidentified; in the second row are Robert Sides, Marvin Huneycutt, and unidentified; in the back row are Frank Marbry, Marvin Carter, and Dewey Fesperman. Ray Lowder stands at left; the young man in the foreground is unidentified. (Stanly County Museum.)

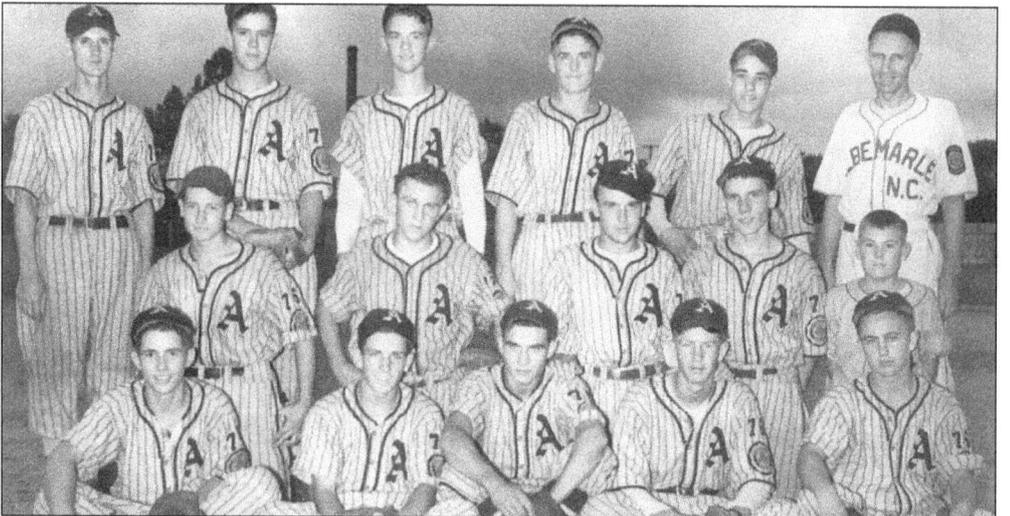

Albemarle's American Legion team snatched the Legion's World Series Championship from San Diego in 1940. They are, from left to right, as follows: (front row) Sherrill Cranford, Tommy Swanner, Clyde Hartsell, Craig Lisk, and Tommy Rabe; (second row) James McCarnes, Hoyle Boger, Bill Long, J.W. Lisk, and Frank Little; (back row) Porter Sheppard, Clyde Dick, Sam Andrew, John Little, Junior Holt, and Frank Marbry. Pitcher Lee Moir missed the snapshot. (Stanly County Museum.)

126

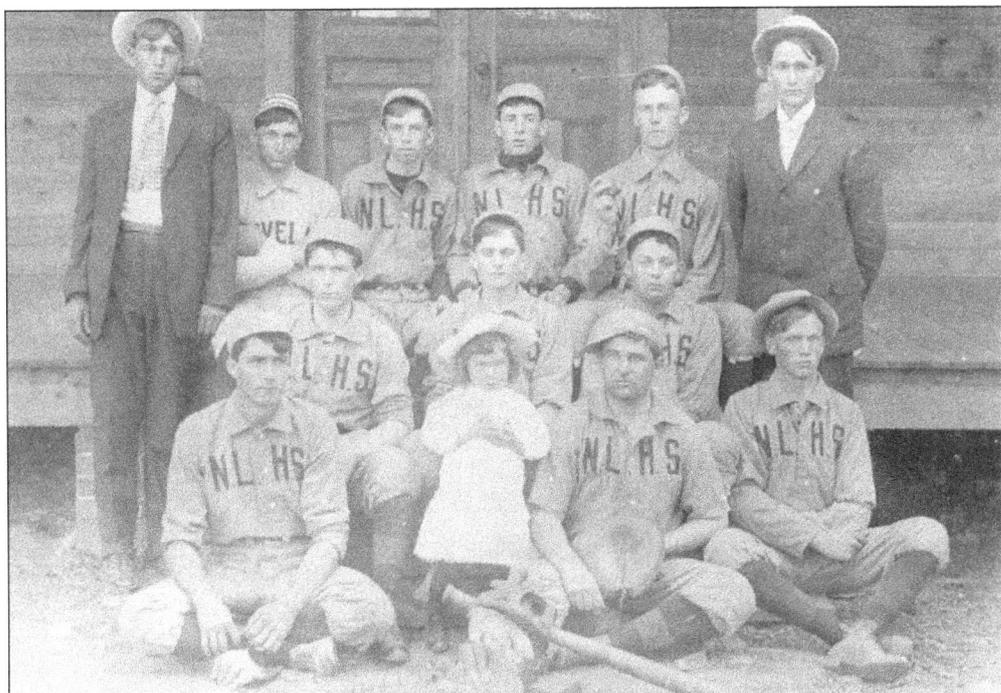

Babe Ruth was still a teenager when this portrait of New London High School's baseball team was made. The date is 1909. (Stanly County Museum.)

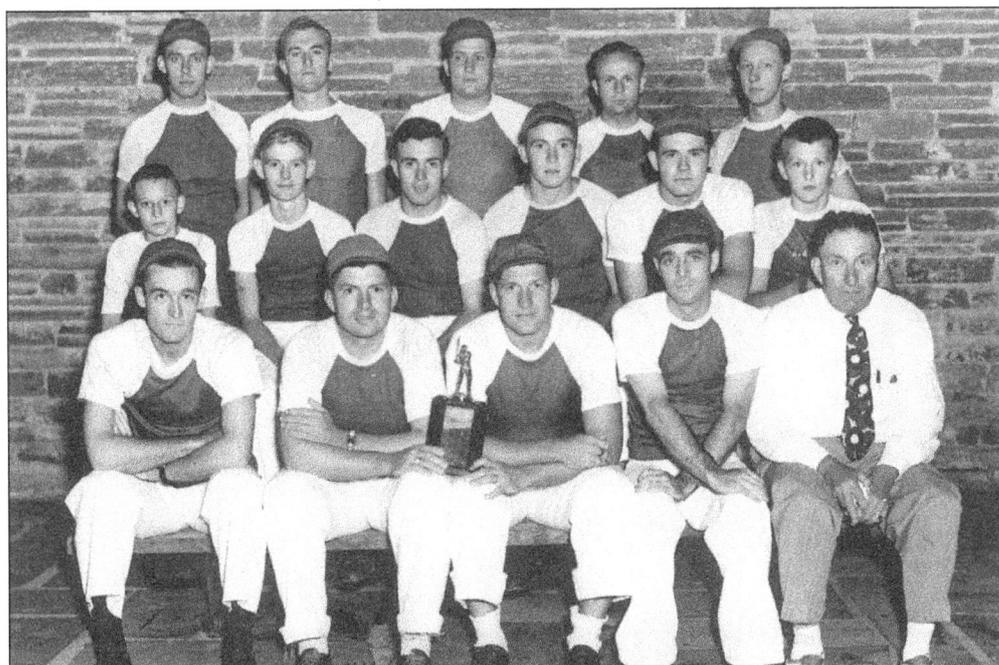

Albemarle's 1947 softball champions are, from left to right, as follows: (front row) Ike Williams, Alma Furr, Bill Furr, Sam Barrier, and A.A. Furr; (second row) Doug Davis, Roy Chance, Ted Furr, Jimmy Sifford, Ted Starr, and Whit Whitley; (back row) Newell Blalock, Tommy Hatley, Bob Blalock, (?) Shaver, and Laverne Ritchie. (Stanly County Museum.)

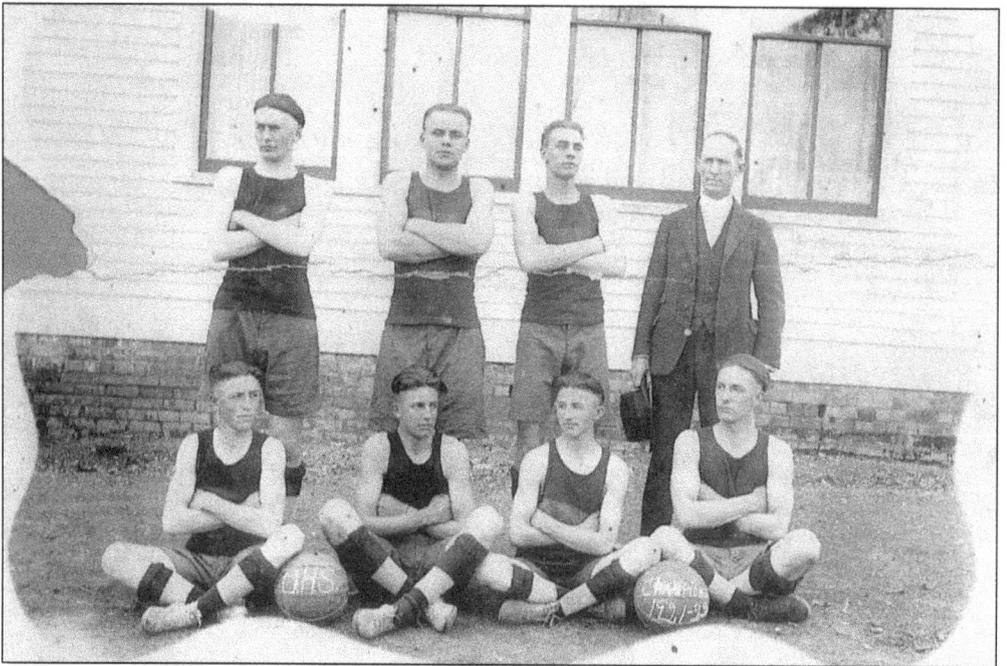

Confidence radiates from Oakboro High School's 1921–1922 basketball squad. The team is pictured, from left to right, as follows; (seated) Fred Hill, Arlie Curlee, Claude Goodman, and Q.E.C. Colvard; (standing) Harry Mills, Hoyle Efird, Horace Howard, and Cravon Efird. (Oakboro Regional Museum of History.)

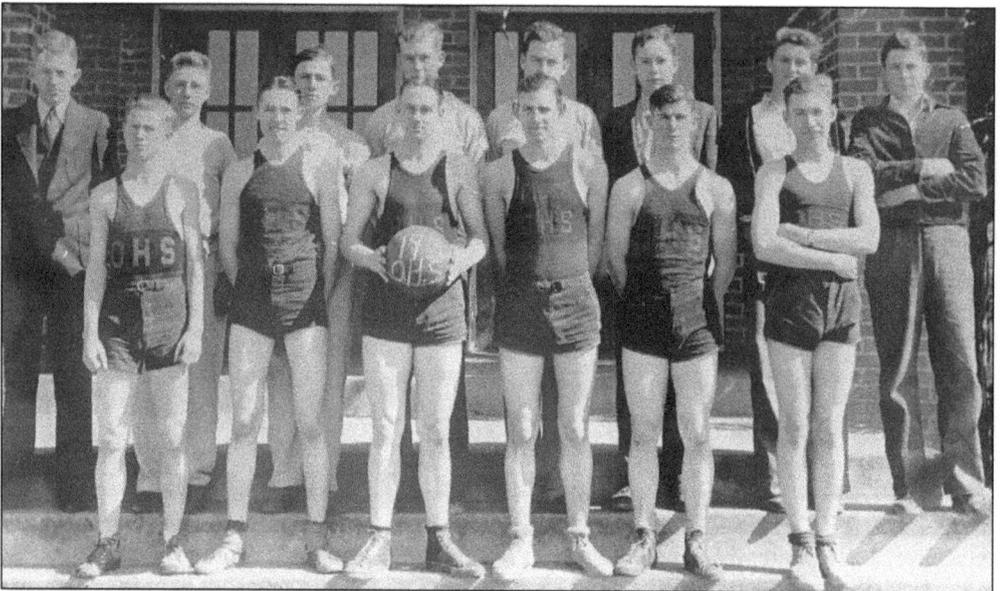

Over a decade later, a new generation of Stanly County athletes stands ready to hit the court for Oakboro High. (Stanly County Museum.)

www.ingramcontent.com/pod-product-compliance
Lightning Source LLC
Chambersburg PA
CBHW080908100426
42812CB00007B/2210